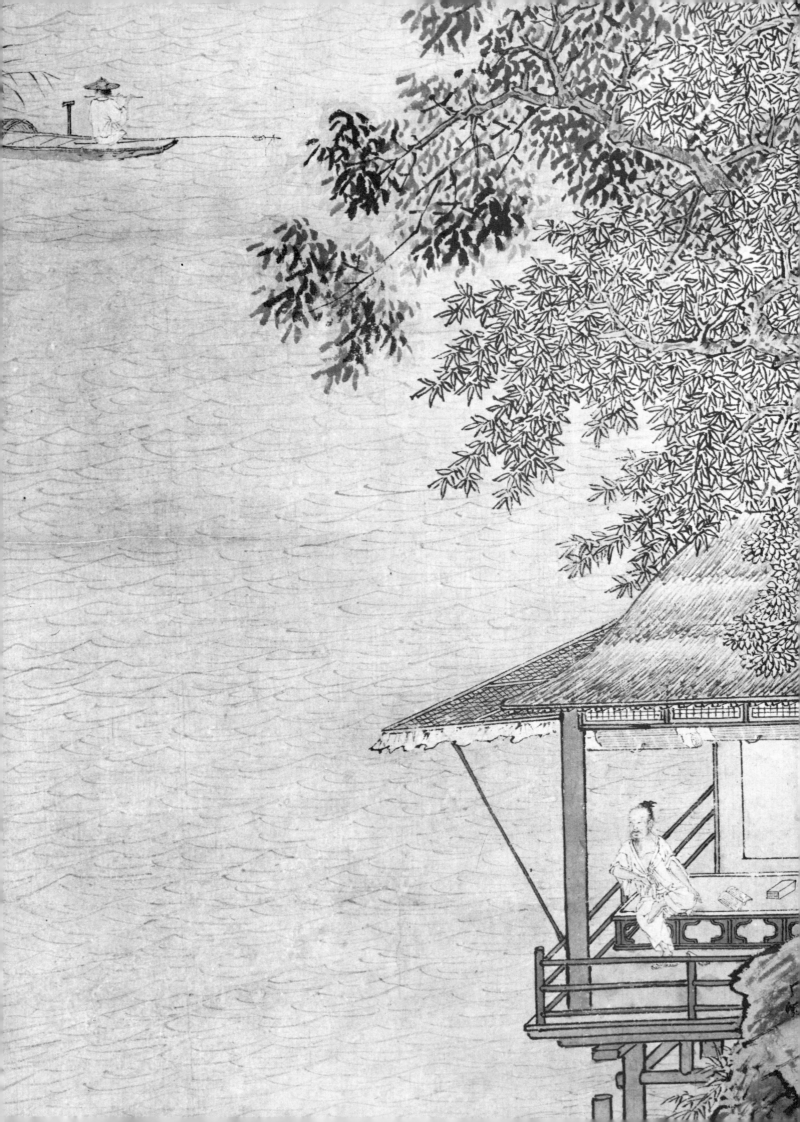

Wan-go Weng

CHINESE PAINTING AND CALLIGRAPHY
A Pictorial Survey

69 Fine Examples from the
John M. Crawford, Jr. Collection

With a Preface by
Thomas Lawton, Director of the Freer Gallery of Art

Dover Publications, Inc., New York

Frontispiece: Detail of item 38.

仇英滄浪漁笛畫軸(部份)

Published in Canada by General Publishing Company, Ltd.,
30 Lesmill Road, Don Mills, Toronto, Ontario.
Published in the United Kingdom by Constable and Com-
pany, Ltd., 10 Orange Street, London WC2H 7EG.

Chinese Painting and Calligraphy: A Pictorial Survey is a
new work, first published by Dover Publications, Inc., in 1978.

International Standard Book Number: 0-486-23707-9
Library of Congress Catalog Card Number: 78-57835

Manufactured in the United States of America
Dover Publications, Inc.
180 Varick Street
New York, N.Y. 10014

PREFACE

Western collectors who have specialized in Chinese painting are rare indeed. Even rarer are those who have assembled important holdings of Chinese calligraphy. As a discerning collector of both Chinese painting and Chinese calligraphy, John M. Crawford, Jr. occupies a special position in the rarefied world of connoisseurship. His extraordinary contribution to our knowledge of Chinese culture transcends that of the usual collector-connoisseur, in part because from the beginning of his interest in the arts of China, John Crawford realized that the true collector forms taste rather than being influenced by it. At the same time, he clearly recognized the obligation to catalogue and to publish his collection. In this, he was following in the tradition of the great Ming and Ch'ing dynasty collectors.

Always a man who seeks the very finest, John Crawford insisted upon obtaining scholarly contributions from the most distinguished specialists in the field. Then, drawing upon his own thorough knowledge of book design and fine printing, he personally guided the publication of his famous catalogue entitled *Chinese Calligraphy and Painting in the Collection of John M. Crawford, Jr.* That catalogue, published in 1962, established a new standard for Western scholarship on Chinese art, and its influence continues to be seen in those publications that have appeared subsequently.

Just as the catalogue of his Chinese painting and calligraphy reflects the taste of an enlightened and discriminating connoisseur, John Crawford is well known for his generosity in making his ever-growing collection available to scholars and to students. Specialists from throughout the world are always warmly received at his home and permitted to study his scrolls without restrictions of any kind. No one is more generous than he in encouraging scholars or in lending his objects for exhibitions. One result of his genuine support of scholarship is that John Crawford enjoys an international reputation equal to that of his Chinese collection.

As one would expect from so dedicated a collector-connoisseur, John Crawford welcomes new ideas and interpretations about objects in his collection. He respects serious scholarship and understands that with new research come fresh and enriching ideas essential to improving our knowledge of Chinese art history.

The constant quest for a more comprehensive understanding of Chinese connoisseurship in the West, exemplified by people like John Crawford, mirrors the situation that existed in traditional China, where reverence for the finest examples of ancient painting and calligraphy was such that poets were moved to compose odes of praise about particular works and collectors willingly faced bankruptcy to acquire them. In traditional China, as in our own society, only a few people were intimately included within the cultivated circle of the collector-connoisseur. Although China is a vast country, the world of the collector-connoisseur was always an extremely small and intimate one. Consequently, the few people involved were keenly aware of belonging to a select group. They regarded themselves as aristocrats in mind and in culture, who shared a responsibility in devoting most of their energies and abilities to perpetuating their cultural heritage. John Crawford follows in that tradition and shares a similar sense of responsibility.

In this new publication of Chinese painting and calligraphy from his collection, John Crawford is fortunate to have obtained the collaboration of Wan-go Weng, himself a distinguished collector. The introductory text and specific entries written by Wan-go Weng provide new information about those scrolls previously published. In addition, a number of works acquired since the appearance of the original Crawford catalogue in 1962 are being published for the first time. The design of this new catalogue reflects Wan-go Weng's good taste, as well as his personal understanding of Chinese art. He has carefully chosen details of individual works to illustrate significant nuances of brushwork and ink technique. By isolating details from the total composition, the scrolls are presented with a totally different, sometimes unexpected, emphasis, enabling the reader to regard them in new and exciting ways and, thereby, to appreciate them afresh.

For this latest presentation of works from his collection, everyone who shares an interest in Chinese art is again indebted to John Crawford. Once more, he has demonstrated his concern for scholarship and his awareness of the responsibility the serious collector owes to society.

THOMAS LAWTON
Director
Freer Gallery of Art
Smithsonian Institution
Washington, D.C.

CONTENTS

THE JOHN M. CRAWFORD, JR. COLLECTION

To be a major collector takes vision, conviction and courage. Vision is what makes a group of art objects meaningful as a whole as well as in their relationship to one another; conviction comes from years of accumulated knowledge, cultivated taste and refined judgment; courage, of course, is essential in swift decision-making and risk-taking. John M. Crawford, Jr. has demonstrated all these qualities in forming his collection of Chinese painting and calligraphy, one of the most important, private or public, in the Western world.

The evolution of Crawford as a collector shows the growth of his vision. During his student days at Brown University in the 1930s, he entered the field of bibliographical materials and, among other things, formed a unique collection of William Morris manuscripts, proofs and books, which he gave to the Pierpont Morgan Library in 1976. After a worldwide trip in late 1937 and early 1938, he looked eastward and directed part of his efforts toward Oriental art, especially Chinese porcelains, jades, sculptures and bronzes. These initial involvements with Western calligraphy and book design on the one hand and Eastern objects of art on the other served as training for his later single-minded project.

By his own account, 1955 was the turning point. Opportunity knocked at his door, and he was equal to it. The knowledgeable dealer Joseph U. Seo brought to his attention some very rare Northern Sung landscape paintings and later some examples of Sung calligraphy, and Crawford immediately saw the very essence of Oriental art. His vision now coincided with that of the Chinese collectors: in his own words, "It was perfectly natural to collect the twin arts of Chinese painting and calligraphy, for both arts use the same materials (ink, ink stones, paper or silk, and brushes) and both are essentially based on the individual brushstroke. They are the heart and soul of Chinese civilization—the oldest and most continuous our world knows—because they express the essence of Chinese culture. Chinese connoisseurs have always admired them, together with poetry, above all other arts: poetry, painting and calligraphy are the 'three perfections.' "[1]

In little more than a decade and a half Crawford was able to assemble nearly one hundred items of Chinese painting and calligraphy from the tenth

[1] John M. Crawford, Jr.: "Memories of Collecting," in *William Morris and the Art of the Book*. The Pierpont Morgan Library, New York, 1976; p. 14.

century to the eighteenth, including such rare treasures as Kao K'o-ming's *Streams and Hills under Fresh Snow* (item 2), Kuo Hsi's *Lowlands with Trees* (item 3), the Sung Emperor Hui-tsung's *Finches and Bamboo* (item 7) and Ch'iao Chung-ch'ang's *Ode on the Red Cliff* (item 8).

A milestone in the Western art world was the first public exhibition of this collection in 1962 at the Pierpont Morgan Library in New York, the Fogg Art Museum of Harvard University in Cambridge, Massachusetts and the William Rockhill Nelson Gallery of Art in Kansas City, Missouri. The catalog, under the editorship of Laurence Sickman, then director of the Nelson Gallery and now its director emeritus, is a brilliant production of scholarship and bookmaking. The Introduction written by Sickman for the catalog remains the most informative and well-written short essay about Chinese painting and its collecting in the English language. A smaller version of the exhibition then went to Europe: the Victoria and Albert Museum in London, the National Museum in Stockholm and the Musée Cernuschi in Paris.

The Crawford Collection also contributed the lion's share to the first exhibition devoted to Chinese calligraphy ever held in the west; appropriately entitled "Chinese Calligraphy," it was organized by Jean Lee, Curator of Oriental Art of the Philadelphia Museum of Art, with items selected and catalogued by Tseng Yu-ho Ecke. It opened in Philadelphia in 1971 and later traveled to the Metropolitan Museum of Art in New York and the Nelson Gallery.

Of works from the Ming period (1368–1644), the Crawford Collection is particularly strong in the circle of Wen Cheng-ming (items 32, 33 and 34); in 1974 an exhibition called "Friends of Wen Cheng-ming: A View from the Crawford Collection" was held in the China House Gallery in New York, with the catalog written by Marc Wilson and K. S. Wong. The show traveled to the Nelson Gallery, the Seattle Museum of Art and the Bell Gallery at Brown University, Providence, in 1975. Through these exhibitions, in addition to numerous private showings to scholars and connoisseurs, Crawford has put into practice the conviction that his pleasure in his collection should be shared with all who are seriously interested in Chinese art.

The Crawford Collection also forms a link in the long tradition of Chinese connoisseurship and collecting. Among the great collectors of painting and calligraphy in China, the following rank the

highest: Mi Fu (1051–1107), the Sung Emperor Hui-tsung (reigned 1101–1126), Chao Meng-fu (1254–1322) [all first-class calligrapher-painters and represented in this book (by items 6, 7 and 21–22, respectively)]; Chu Kang (1358–1398), a Ming prince; Hsiang Yüan-pien (1525–1590), whose work as a painter is represented in the Collection but not included in this book; Liang Ch'ing-piao (1620–1691), official and scholar; Sung Lo (1634–1713), official and poet; Keng Chao-chung (1640–1686), a relative of the imperial family; Kao Shih-ch'i (1645–1704), official and calligrapher; An Ch'i (1683–after 1742), a salt merchant; and Emperor Ch'ien-lung (reigned 1736–1795), whose unsurpassed imperial collection is now largely housed in the National Palace Museum of Taipei. Among contemporary collectors, Chang Ta-ch'ien is undoubtedly the best-known. The seals of all the foregoing collectors appear on one or more pieces in the Crawford Collection (see the entry on collectors' seals under each item in the List of Works Illustrated). According to the Chinese expression, these works of art show their "well-traced transmissions" (liu-ch'uan yu-hsü).

The scope of this volume embraces items whose visual impact can be transmitted by monochrome reproduction; thus it precludes a few items which are of high importance to art historians but need special reproduction techniques to be meaningful to the general reader. This applies, for instance, to a possibly tenth-century landscape handscroll entitled *Retreats in the Spring Hills* and an age-darkened mid-eleventh-century hanging scroll, *Winter Mountains*. At present the Collection has increased to nearly two hundred pieces and is still growing; however, the sixty-nine items in this volume represent a very choice view of "a collection of importance worthy of the great tradition."[2]

[2] Laurence Sickman, in his Introduction to the catalog *Chinese Calligraphy and Painting in the Collection of John M. Crawford, Jr.* The Pierpont Morgan Library, New York, 1962; p. 27.

INTRODUCTION

As recently as 1943, Western unfamiliarity with Chinese painting and calligraphy could still be flagrantly exemplified in a best-selling encyclopedic primer. In *The Arts*, Hendrik Willem Van Loon, the many-gifted popularizer of the creative efforts of mankind, sketched a few flowering branches in a vaguely Oriental manner and declared: "If, like a Chinese artist, you would spend a lifetime painting nothing but this sort of thing you might eventually acquire the same skill."[1] Such an astonishing opinion, probably shared by many in the West, did not stem from prejudices against Chinese art in general, for Chinese ceramics, jades and bronzes had long been held in high esteem in Europe and America. Van Loon's offhand dismissal could only have been caused by the inaccessibility of enough first-rate original Chinese painting and calligraphy in the Western world at that time. Fortunately, this situation has changed, thanks to the efforts of major American museums and a few private collectors such as John M. Crawford, Jr. But equally essential to the general appreciation of an unfamiliar art is its accessibility beyond museum walls in good inexpensive reproductions, with an interpretation substantial enough to provide a point of departure for further exploration. It is hoped that the present volume may serve this purpose.

A work of art, no matter how great, will not disclose its full potential unless the viewer knows its language. Naturally, even a first glance at the pictures in this book will reveal a large part of what the artists had to say, because the viewer will respond to such universal aspects of visual language as form, rhythm and recognizability of subject matter (another of these universal aspects, color, could not be included in the present volume). But this same first glance will bring the unfamiliar viewer up against a number of seemingly exotic and puzzling particularities in the Chinese artist's language. This introduction will attempt to explain many of these features by examining first, the physical aspects of Chinese paintings—materials, techniques, formats and seals—and second, the history of styles and traditions in Chinese painting and calligraphy.

THE PHYSICAL ASPECTS OF CHINESE PAINTING AND CALLIGRAPHY

Materials

The materials for both the pictorial and calligraphic arts are identical: silk or paper as a support, the brush as a tool and ink as a medium (paintings may also use colors). Silk has had a very long history; the fiber-producing capacity of silkworms was discovered in the Neolithic Age, and silk textiles were first woven no later than thirty-five hundred years ago. Examples of painting and calligraphy on silk, excavated from tombs, date back to the 5th to 3rd centuries B.C. Although the use of silk by artists reached its height in the Sung Dynasty (960–1279), high-grade paper was already sharing its dominance. After the middle of the 13th century, paper became the chief support for paintings. Among the first twenty items in this book, all predating 1279, when the Chinese Sung royal house succumbed to the invading Mongols, thirteen are silk-based, whereas among the remaining forty-nine items, which postdate 1279, only four are. Works on paper are more easily preserved than those on sized silk, and this factor may distort our notions about the relative proportion of silk and paper actually used by artists through the centuries; but the fact that more of the silk-based than the paper-based works from the pre-1279 period have survived to this day, in spite of the relative frailty of silk, clearly indicates the predominance of silk in the earlier pieces. From the technical point of view, work requiring fine brushstrokes, vivid colors and controlled washes—such as Emperor Hui-Tsung's *Finches and Bamboo* (item 7)—should use silk; whereas work with textured brushstrokes and with wet and spreading washes that create in-depth effects—as in T'ang Yin's *Ink-bamboo* (item 36)—should utilize the absorbent and textural qualities of paper. Furthermore, a porous paper can be sized with alum water to become relatively impervious and assume some of the properties of silk for detailed work. Durable and versatile, this newer medium has preempted the importance of silk, which is now used mainly to lend an air of antiquity and a sense of luxury to paintings of birds and flowers or to elaborate landscapes in blue and green.

The brush has a history even longer than that of silk. The decorations on Neolithic pottery betray the use of a soft and flexible drafting tool, most likely a proto-brush. Writings in red pigment on oracle bones some three thousand years ago were done with a refined version of that drafting tool. The strength and suppleness of a bundle of animal hair shaped to a pliant point and full body are demonstrated by paintings on silk fragments from

[1] Hendrik Willem Van Loon, *The Arts*. Simon & Schuster, New York, 1943; illustration with caption following p. 456.

about the 4th century B.C., on a large silk coffin covering of the 2nd century B.C., and on many tomb tiles and walls from the first two centuries after the birth of Christ. In a skillful hand, the brush can produce lines as hard as iron wires, as fine as floating threads or as rugged as old tree branches. The most popular raw materials have been goat, weasel and rabbit hairs. Goat-hair brushes are more flexible than others, but lack strength; weasel and rabbit hairs make brushes excellent in strength but a bit stiff. Brushes made from different blends give various degrees of balance to meet the artist's preference. Su Shih's *Bamboo* (item 4) may have been done with his favorite chicken-feather brush, made by the Chu-ko family of Hsüan-chou (south of the Yangtze River). After the 13th century the best brushes came from Wu-hsing, only seventy-odd miles east of Hsüan-chou. Wu-hsing was also the native town of the great painter-calligrapher Chao Meng-fu — represented here by his *Groom and Horse* (item 21) and *A Summer Idyll* (item 22)—whose achievements exerted an unparalleled influence for the next four hundred years until the rise of Tung Ch'i-ch'ang—represented here by his *Poem by Wang Wei* (item 43) and *Landscape with Trees, after Ni Tsan* (item 44). From all these examples it can be readily seen that the brush is truly an extension of the artist's hand, extremely responsive to his fingers, wrist and arm.

It is ink that is actually left on the paper or silk as the trace of the brush; the tool and the medium are equally important. The Chinese speaks of an artist's work as his "brush and ink." The origin of ink also goes back to the Neolithic Age, more than thirty-five hundred years ago, as evidenced by painted pottery dating from that period. The black pigment used then, however, has only its color in common with the ink known today. The principal modern type of ink cake, made from pine soot bound by glue, can only be traced back to the 4th century A.D. By the 10th century the art of ink making reached a new level of sophistication, using such exotic ingredients as pearl and jade powders as well as raw lacquer, thoroughly blended and pulverized with select pine soot. When ink cake is ground on a good stone slab with fresh water, the resultant fresh ink liquid can produce various shades of grey with either warm brownish tones or cold bluish tones, depending upon the extent of dilution and the amount of water held by the brush. The ink is so fine that no particle can be detected; the stroke is analogous to a photograph without any grain. The durability of a good ink is demonstrated by its sustained brilliance through hundreds of years as well as its tenacious hold on silk and paper, without spreading or washing out after repeated soakings during many remountings. Chinese ancients treasured their ink like gold, and old ink cakes and sticks, some dating from the Ming dynasty (1368–1644), are today worth more than their weight in gold. Another major type of

ink is made with lampblack derived from burning tung oil (extracted from the seeds of the tung tree) and lacquer; it is called "oil-smoke" by the Chinese. Its black tone usually surpasses that of the pine-soot variety. If used in undiluted form, it exudes lustrous darkness; thus it is the ink preferred by modern painters.

A word about colors is necessary, even though there are no color plates in this book. The Chinese pigments are extracted from plants and minerals. In the former category are rattan yellow, indigo blue and rouge; in the latter are brown from natural iron oxide, green from malachite and blue from azurite. In old times powders from calcinating seashells provided a source of white, superior to lead white which is subject to darkening through oxidation. The limitation of such "natural" colors has heightened the Chinese artist's sense of subtlety: suggestiveness and elegance became his desired goals. The binding agent for the natural pigments is glue; it is usually refined from oxhide or tree bark, with the first being preferred. For sketching a tentative design before the application of indelible ink, a singed willow twig works well with Chinese paper, for the charcoal particles can be easily wiped off. Faint traces of the original "willow-twig" sketches can be seen on the magnolia painting by Wen Cheng-ming (item 34), although these first attempts can hardly be detected in the reproduction.

Techniques

The Chinese painter's basic techniques are as simple as his materials, but refinements and ramifications become complex. Of first importance is the skill of using the brush. As a rule, training begins with the highly pliable but relatively flabby goat-hair brush, which is harder to use than the stiffer but more controllable weasel-hair. Thus, once an artist has tamed the goat-hair brush, he will command the other types with ease. The principle of holding a brush is termed "solid fingers and empty palm," which means gripping the brush handle tightly with the thumb, fore- and middle fingers and supporting it with the other two, but maintaining a hollow cavity in the palm. Such a hold gives maximum maneuverability. For close and detailed work, the wrist can rest on the table or an armrest; for broad strokes over a large area, the whole arm is called into play, with the shoulder joint as the fulcrum. Brushstrokes can be divided into two main categories: the "central point" (a stroke of the brush tip with the brush handle held perpendicular to the plane of the paper) and the "slanting point" (a stroke in which the brush handle forms an angle of about forty-five degrees with the paper). For example, in the snowy landscape by Kao K'o-ming (item 2), the trees, the outlines of the rocks and the buildings, and the dark dots under the trees (representing moss and other low growth on the ground) were done with "central points,"

while the textures on the rock surfaces were articulated with "slanting points." The free shapes of the rocks indicate that the artist drew them with an unsupported wrist, while the precise structure of the buildings suggests that these were drawn with a supported wrist. For large-scale calligraphy, such as Mi Fu's *Sailing on the Wu River* (item 6), there is no doubt that Mi had no support for his wrist and used the "central point" with a highly flexible brush, such as one made of goat hair. This represents the height of an artist's accomplishment: freedom with discipline. It is the beauty of paradox: swift and powerful strokes of an irrepressible spirit expressed through a totally controlled physical apparatus—wild in style, but mellow in feeling.

In calligraphy, a brush fully loaded with undiluted high-intensity ink is the norm; in painting, a brush can be either lightly or fully loaded with ink and then diluted with water to the desired degree of intensity. Brushstrokes can cover one another, layer by layer, to produce texture and tone, but their traces remain clear in each application, except in the case of wash. Such delightful ink effects can be readily observed in the landscape by Kung Hsien (item 53), an atmospheric mountain scene formed by powerful strokes built one upon another, beginning with diluted ink of lighter tones and ending with saturated ink of full intensity.

The choice of a particular kind of silk or paper predetermines the artist's choice of style and technique, for the interaction between the ground material and the ink or colors produces distinct effects. For example, *Light Snow on the Mountain Pass*, by an anonymous painter of the 11th or 12th century (item 1), is in color and ink on tightly woven silk of thin threads: to set off the snow-covered peaks against the sky, an all-prevailing wash of a dark bluish-grey tone had to be applied without leaving disturbing traces of individual strokes. This could only be done on a smooth and nonabsorbent surface. But the same silk also shows up intentionally distinct strokes very clearly and succinctly, as in the tree trunks, the foliage, the buildings and the bridge. Thus the artist contrasts the subtlety of snow-covered timeless formations with the boldness of weathered but persevering vegetation and artificial structures—fully justifying his choice of support and medium. On the other hand, the silk of another variety used in Chu Ta's *Birds in a Lotus Pond* (item 55), loosely woven with flat threads, provides the artist with a surface that produces clean lines from dry brushstrokes and fuzzy borders from wet brushstrokes. The great variety of paper affords the artist a much wider range than silk. The kind of paper most favored by painters can add another dimension to brushwork, that is, depth. This is created by the penetration of the paper surface by ink and color, producing a cushioning softness. Witness Wu Chen's *Fisherman* (item 24): the vertical cliff and the heavy foliage hanging from it exude a richness of grey and black tones embedded in the ground material. In Shen Chou's *Silent Angler in an Autumn Wood* (item 30) the dry and wet brushstrokes that articulate the tree bark and rock textures still appear moist and fresh to this day, thanks to the interplay of paper and ink. The leaves and stems of T'ang Yin's *Ink-bamboo* (item 36) have a mottled effect because parts of the paper surface lost their sizing and absorbed more ink than the rest. Finally, the flowers and leaves of Kao Feng-han's *Chrysanthemums by the Rock* (item 65) were formed by swift, wet brushstrokes and ink of varied intensity; this gives a pleasing look of "work in progress." The veins on the leaves are defined by a few bold, dark strokes in which the artist takes advantage of the fact that, once washed over by wet brushes, the paper no longer has the same absorbing ability and can thus support well-defined lines. These are only a few examples of how different kinds of paper react to brush and ink; the potential for innovation is virtually inexhaustible. In short, the mastery of brush handling, the skill of mixing water and ink and the knowledge of the characteristics of paper and silk are the three basic and interlocking requirements for commanding the technique of Chinese painting and calligraphy.

Formats

There are five major formats in Chinese pictorial art: hanging scrolls, screens, handscrolls, album leaves and fans. For calligraphy, two other formats exist: couplets and tablets. Hanging scrolls evolved from wall paintings; they are mostly in vertical proportions and only occasionally horizontal. Some of the numerous examples in this book are *Monk Riding a Mule* (item 18), Chao Meng-fu's calligraphy (item 22) and Ni Tsan's landscape (item 26). When four, six or eight hanging scrolls of equal size (the first and last may be slightly wider) are grouped together with contiguous scenes, matching subject matter or continuous texts, they are called a set of *p'ing*, or a "screen," clearly indicating their origin. Partitioning or wind-shielding screens, composed of silk or paper panels linked together, were first popular in China and then transmitted to Japan, but the use of more permanent materials such as lacquered wood (commonly known in the West as coromandel) and the introduction of grouped hanging scrolls have made the true screen format for painting and calligraphy rare since the advent of the Ch'ing dynasty (1644–1911).

The handscroll is a highly characteristic art form in the Orient. It developed from the stringing of wood or bamboo slips for writing which were rolled up for easy handling and storage. The Chinese "read" a handscroll from right to left, with the right hand rolling up the part already seen and the left hand releasing the part still to be seen. Unrolling can be either sectional, to allow for close study and concentrated and prolonged appreciation of the

displayed portion, or continuous, to create a sense of traveling through the scene depicted by the painter. The length of a handscroll is not restricted: it can be so short as to form almost a square image, as in *Groom and Horse* by Chao Meng-fu (item 21; actually one section of a longer scroll), or it can be many yards long, as in the *Odes of Pin* by an anonymous painter of the 13th century (item 19), of which forty-five feet remain of an even longer original.

Among the handscrolls in this book, the most important one is Kao K'o-ming's *Streams and Hills under Fresh Snow* of the 11th century (item 2), reproduced here on four double-page spreads. The proper way to look at this landscape is to begin with section 2d (pages 8 and 9) and to work your way "backward" to section 2a (pages 2 and 3). The scroll opens with a bridge across the mouth of an inlet, with the river in the background. This leads to a house composed of interconnected huts. Inside the hall an old man wearing a wind-shielding hood is being served tea; a boy servant stands by. The tall pines behind the house (section 2c, page 7) tower over a boat anchored by the shore; in the bow of the boat a man gazes toward the distant bamboo-covered riverbank and a small waterfall. By the waterfall stands a group of buildings partially supported on piles driven into the riverbed (section 2b, page 5). (In order to show the composition clearly, we have repeated half of page 6 on page 5.) A couple of boats in the foreground are moored under leafless willows. Tall evergreens screen the back of the buildings, but leave a clearing through which a footman carrying a shoulder pole is walking hurriedly toward the shelter. (Again, the last spread, pages 2 and 3, overlaps most of the preceding section in order to show the continuous composition of the painting.) This leads to the concluding part, where, at the upper left-hand corner, an elaborate group of buildings is partially revealed through the rocks. Reviewing the whole picture from beginning to end (pages 9 to 2), one now realizes that the humble huts near the bridge may be the servants' quarters or the gatekeeper's house, which is linked by boats to the summer lodgings of the noble family, located at a scenic spot by the waterfall and built out over the river. Past the thickly wooded area, and nestled in the heart of the rock formations, is the substantially constructed and elegantly designed main residence. What a setting for achieving seclusion and privacy! And how skillfully the artist leads us onward and inward, revealing inch by inch an intriguing and beautiful site composed of rocks, water and trees in a perfectly integrated complex of architecture—all enveloped in the wintry atmosphere after an early snow.

Album leaves are rectangular pieces of the same or almost the same size, mounted in series in a folding album, affording the viewer a leisurely leaf-by-leaf perusal. Some albums contain individual items from different sources and of various sizes, assembled by the collector, including albums of fans (described below). But usually albums contain four, eight, twelve or more leaves with a single theme or related subject matter, such as *Eight Scenes of the Hsiao and Hsiang Rivers* or *Twelve Landscapes after the Ancients* or simply *Flowers and Birds*. Such albums in their original form are meaningful assemblages, and the impact of the whole series is greater than that of individual leaves. Unfortunately, many old albums have been dispersed through the ravages of time or the greed of man, for the seller can often gain more by disposing of the leaves singly. The size and proportions of *Light Snow on the Mountain Pass* (item 1) suggest the possibility of its having been a leaf in an album containing landscapes of the four seasons, with this one, obviously, depicting winter.

Basically, there are two kinds of fans adorned with painting and calligraphy, the flat and the folding. The round or oval flat fans have a much longer history that the folding variety, which was introduced to China from Korea or Japan during the Sung dynasty (960–1279) and gained greatly in popularity during the Ming (1368–1644). Thus all the existing Sung fans, now mounted as album leaves, are of the first kind, such as items 10 through 17; the later fans of the Ming and Ch'ing (1644–1911) dynasties are of the folding type, such as items 40, 47, 58 through 62, and 66. It should be noted here that the characteristic shape of a folding fan, its creases and the smooth paper stock used in its manufacture present special problems to the artist. The ability to overcome these obstacles and produce a beautiful piece of work is a true measure of the artist's skill, making this seemingly minor format an extremely interesting category of Chinese art.

Couplets are a matching pair of "thin" hanging scrolls, with the height far exceeding the width. We have one example in item 46. This format, used only for calligraphy, can be better understood with some knowledge of Chinese language and literature. As a matter of fact, a brief excursion into the territory of words and poetry will enable the viewer to appreciate all Chinese calligraphy and paintings inscribed with calligraphy.

To begin with, the overwhelming majority of Chinese words are represented by single characters, read as single syllables. For calligraphy, a character is an independent structural unit. Some characters are complex and weighty with as many as twenty-nine strokes, some simple and light with as few as one (e.g., the character for the number one). For poetry, such monosyllabic units lend themselves to verse of regular and even formations; commonly used are four-, five-, six- and seven-word lines with four, eight or more lines per poem. These compact and self-contained words are ideal building blocks of parallelism. In a pair of poetic lines equal in length, each word or two-word combination in the first line is matched with the corresponding word or word combination in the second line in range of

meaning, part of speech and tonal relationship (the tonal elements in the pronunciation of Chinese words are not discussed here because of their complexity, which can only be explained through sound recordings).

Returning to our discussion of calligraphic couplets, in our example (item 46) Chang Jui-t'u has written two lines of seven words each on a pair of matching hanging scrolls. The first line (on the right) can be translated word for word as "Except/but/south/neighbor/call/wine/companion," that is, "Except for my southern neighbor(s) who call(s) me to be a drinking companion." The second line, accompanied by two small characters on the bottom constituting the artist's signature "Jui-t'u," can be translated word for word as "Decidedly/no/hitting/pecking/reach/bramble/gate," that is, "Decidedly there is no other knocking sound at my bramble gate." In terms of parallelism, "Except but" matches "Decidedly no"; "south neighbor" matches "hitting-pecking" (this is considered loosely matching); "call" matches "reach"; and "wine companion" matches "bramble gate." (In Chinese poetry, words like "me" and "my" are usually understood and omitted.) These two lines picture a very secluded and quiet life in the country, befitting a scholar's studio. Normally, couplets like those by Chang Jui-t'u are hung on each side of a large painting to decorate an important wall with symmetry and formality.

Tablets, the other format for calligraphy only, are horizontal pieces bearing a few characters in large-scale writing; the text may be the fanciful name of a pavilion, hall or studio, or else a laudatory epigram on a person or place composed by an exalted and respected personage. No specimen of the tablet format is represented in this book, but the two large characters "Enjoying/pines" (item 37), written as the frontispiece of a landscape handscroll, could have been a tablet above a "moon gate" in a garden, leading to a path flanked by towering pines.

To sum up, all the above-mentioned formats can be mounted into either scrolls, which are rolled up for storage, or flat pieces, which more often than not are assembled into albums. No framing is involved. The basic principle of mounting is to back the silk or paper bearing the artwork with one or more layers of thin paper attached by specially prepared water-thin paste. During the process, the artwork, facing down on a mirror-smooth board, is thoroughly moistened to make it adhere to the board surface, without bubbles or wrinkles. After the backing paper is pasted on its back, layer by layer, to the desired strength, it is left to dry through slow natural evaporation until the painting can be peeled off the board with ease. Decorative and protective borders, either of silk or paper, are then added around the artwork with the same kind of water-thin paste. In the case of scrolls, the backing is fairly thin and the result is a highly flexible piece fit for rolling and unrolling thou-

sands of times. In the case of flat album leaves, the backing is relatively thick, resembling cardboard. When cracks and creases have developed through use and age, a remounting job is recommended. In a state of complete wetness, the old backing papers are peeled off and new backing is applied in the same manner as the original mounting.

Seals

Seals were not part of the artist's concern until the 12th century, when the Chinese government was forced by northeastern invaders to move south, dividing the Sung dynasty into the Northern (960–1127) and the Southern (1127–1279). The next-to-last emperor of Northern Sung, Hui-tsung, painted the *Finches and Bamboo* (item 7), put his abbreviated cipher signature near the right border, and affixed his big square seal over it. This practice of using a seal was not yet common in his time. Not long afterward, artists began to employ their seals under signatures to attest to authorship and to add a decorative touch—a dash of vermilion seal ink on a painting, which is usually not heavily colored, if at all, or on a piece of calligraphy, which is almost always black on white.

In later periods, especially from the 16th century onward, collectors and writers of inscriptions added their seals to show appreciation, ownership and connoisseurship. There are about thirty such seals on Hui-tsung's painting near its right and left edges. The abuse of this practice became an offense to the original artwork in the case of Emperor Ch'ien-lung of the Ch'ing dynasty (reigned 1736–1795), whose large seals intruded into prime locations on many ancient masterpieces. Several of his successors followed suit to further display imperial insensitivity. Taste and sense of preservation, in addition to respect for the artwork, dictate the sparing usage of inconspicuous seals in the corners, to avoid marring any part of the original brushwork or disturbing the balance of the overall composition. Some discreet collectors place their seals on mounting strips around the painting or calligraphy proper.

The making of seals is an art in itself. The earliest known seals, attributed to the Shang dynasty and dating back to the 12th to 13th centuries B.C., and the great majority of seals from the Han dynasty (206 B.C. to 220 A.D.), were made of bronze. Some Han seals and many later ones were cut in jade, but the most popular material for artists' seals has been stone of various colors, hardness and composition. Since the primary function of a seal is to identify the owner, the text has the following range: name; sobriquet; title of hall, pavilion, studio or library; official position; place or year of birth; or the combination of a few of these elements. By late Ming (16th to 17th centuries), seals had become a medium of expression for the owner's convictions, sentiments or philosophy, and now included brief quotations from classics or poetry,

such as "My teachers are the ancients," "Clouds and smoke passing by my eyes" (referring to the temporary nature of possessing works of art) and "To part is easy, to meet is difficult."

Seals, although usually square and rectangular in shape, are occasionally round, elliptical or irregular; they range in size from great official chops of several inches square to miniatures of less than a quarter inch in height. The designs, sometimes created by painters and calligraphers, are so diverse as to warrant classification by periods and schools and study as a branch of Chinese art. The strokes of characters are carved either as raised ridges (printing as solid lines on a blank ground) or as grooves (printing as colorless lines on a solid ground); in other words, the characters are either "positive" or "negative." Some seals are carved in both ways, half positive and half negative.

Ever since the Han period, the predominant script chosen for seal designs has been that which had been normally used for writing in the Late Chou and Ch'in periods, roughly the 5th to 3rd centuries B.C. This style was subsequently named "seal script" because of that later usage. The two large characters "Enjoying/pines" (item 37) are an outstanding example of the seal script.

STYLES AND TRADITIONS IN CHINESE PAINTING AND CALLIGRAPHY

General Concepts

Having acquired this understanding of the physical aspects of the Chinese painter-calligrapher's art, we shall now briefly survey its historical styles and traditions. If there is any validity to considering a style of painting as being Chinese, its most salient feature must be that of supple lines made by a brush. The Western concept of painting does not exactly fit its Chinese counterpart, which is generally called *hua*. Although this term originally meant "to define by line," *hua* cannot be restricted to the Western concept of drawing, since it covers all kinds of brushwork, often going beyond mere delineation. Yet the overall style comprising *hua* does possess a decided linear quality, though its "line" can be as broad as a "plane." The handscroll narrative of the poet Su Shih's visit to the Red Cliff (item 8) is a good example of this blurring of the distinction between painting and drawing. The figures in this work are drawings but the landscape background ranges from the "drawing" of the buildings and the fence to the "painted" shading of the rocks. This particular line-dominated style, called *pai-miao* or "plain drawing," is the visualization of the concept *hua*, a tradition going back to the tracing of designs for wall paintings and utensil decorations. *Hua*, however, is complemented by a second Chinese term for painting, *hui*, which is used sometimes instead of *hua*. *Hui* originates from coloring,

the filling in with color of spaces bounded by contour lines. The visualization of the concept *hui* is the color-dominated style called *mo-ku* or "boneless," which is very close to watercolors as known in the West. The landscape *Light Snow on the Mountain Pass* (item 1) is of this style. The complete term for Chinese painting, therefore, is *hui-hua*, the combination of lines and color, with the line playing a more important role than color.

Beginnings

The foundation of Chinese painting was laid by craftsmen who decorated pottery, architectural elements, ritual vessels, musical instruments, palace and temple walls and many other objects of utility and ceremony. Though they worked with varied materials ranging from ceramics, wood and lacquer to stone and brick, their style of vigorous, flowing and descriptive lines, full of movement and grace, set the visual style for all times. Their subject matter included animals and figures, both natural and mythical, serving decorative, religious and political purposes, and devoid of literary or artistic pretensions. In the 2nd century A.D., some high officials of the Eastern or Later Han dynasty (25–220 A.D.) became the first known "name" painters and calligraphers, signaling the recognition of such artistic endeavors as a worthy pursuit for the intelligentsia.

Calligraphy, however, has always been associated with government functionaries: priests, clerks and historians. The script style changed from the angular lines of writings on oracle bones and shells of the 2nd millennium B.C. to the seal script of the 5th to 3rd centuries B.C., with its fuller, curvilinear lines of uniform thickness, and later, during the four following centuries up to the 3rd century A.D., to an informal script better adapted to the everyday use of clerks. This *li*, or clerical, script introduced lines of varied thickness, with a broadened, wavy stroke at the end of horizontal and downward-slanting lines. The four large characters at the upper right-hand corner of the landscape by Wen Po-jen (item 41, page 91) are an example of this style.

For both painting and calligraphy, the three millennia from the Neolithic Age to the end of the Han dynasty may thus be considered the first period of development.

The Six Dynasties (220–589 A.D.) and the First Masters

In the second period, from the 3rd to 6th centuries A.D., the principle of the art of brush and ink was established. Now theory followed practice. While the craftsmen continued to flourish and improve their functional art of decoration and display, the intellectual artists began to take painting and calligraphy seriously as art, even though career-minded scholar-officials would long continue to look down

upon painters as belonging to a lowly profession. Calligraphy was another matter; it was perfectly respectable as a gentleman's pastime. An elegant handwriting showed talent and culture, unattainable by workmen in their shops.

The first giants in Chinese art history lived in an age of political and military upheavals. Not long after the fall of the Han dynasty, "barbarians" (that is, non-Chinese) from the north and the west penetrated the Central Kingdom, bringing with them an Indian religion called Buddhism. The Chinese who retreated to the area south of the Yangtze River were able to carry on the nation's economic and cultural development. Agriculture thrived on well-irrigated rich soil; commerce prospered with improved transportation and abundant products. The privileged intellectual class enjoyed the finer things in life on a scale and level surpassing earlier times. The time was ripe for a new consciousness in the arts. With the literati entering the scene, it was natural for the marriage of literature and art to begin. Although historical episodes and personages as well as contemporary ways of life had been common subject matter since the 2nd century A.D., the use of narrative poetry, such as *The Nymph of the River Lo*, and moralistic verse, such as *The Admonitions of the Imperial Instructress*, as themes for paintings did not come into fashion until the 4th century. Landscape elements still served only as backgrounds, but they became more prominent and better integrated into the pictorial design. Certain historical notices suggest that pure landscapes may already have existed in this period. Stylistically, lines became refined into thin threads of even width, defining shapes with great exactitude and steely strength. This elegant display of skill was the hallmark of the great painter Ku K'ai-chih (ca. 345–406); nearly one thousand years later Chao Meng-fu modified the style with a more relaxed and "fatter" line in his *Groom and Horse* (item 21). Through direct contact with Central Asian painters, Chinese artists adopted modeling but never considered it more than a supplement to the dominant line.

Calligraphy progressed even more rapidly than painting under the Six Dynasties; these four centuries saw the transformation of the *li*, or clerical, script into the regular script that is still in use today (item 33 by Wen Cheng-ming is a good example of calligraphy in regular script). The writing now relaxed from the rigid structure and formalistic strokes of the *li*; the sizes of characters within the same piece of calligraphy varied to create a rhythmic flow. A further development, running script, reduced the number of strokes in each character and connected the remaining strokes to speed up writing. The calligraphy by Fan Ch'eng-ta in item 9 illustrates this type of script very well. The running script led logically to the most informal and time-saving style of all, the "cursive." The number of strokes within each character was reduced to the minimum; the strokes ran into one

another to become a continuous stroke; and the last stroke of one character sometimes reached out to form the first stroke of the next character (see item 5 for a good example). This script lends great freedom to the calligrapher, whose individual touches more often than not render the words unrecognizable. Artistic expression overpowers meaningful communication. To a great extent this problem is alleviated by observation of the conventions and traditions established by Wang Hsi-chih' (321–379), the most celebrated and influential calligrapher in Chinese history. His work in regular, running and cursive scripts made manifest the esthetic potential of the stroke-constructed characters and their compositional possibilities. No known originals of Wang Hsi-chih exist today; we can only see traced copies dating back to the 6th century and ink rubbings from stone carvings after his handwriting. The classical modes established by him have been transmitted and reinterpreted by every major calligrapher through the ages, right up to our time; Chao Meng-fu (item 22), Wen Cheng-ming (item 33) and Tung Ch'i-ch'ang (item 43) are no exceptions.

The first set of theoretical principles for painting was set forth by Hsieh Ho of the 5th century, who singled out the quality of liveliness as essential. Next in importance for him came technical aspects: inner structure and brushwork, outward likeness, natural coloring, composition design and transmission of traditions by copying older works. Thus, he stated, a good portrait should not just be realistic and recognizable, but must catch the spirit of the person. This indefinable quality is in the twinkle of the eye, the gesture of the hands or the grace of the posture. In the best of art there is life.

The T'ang Dynasty (618–907)

The third period of development, from the 7th century to the beginning of the 10th, corresponds to the dynasty of T'ang, best known in the West for its magnificent clay tomb figurines and horses. In calligraphy, the path blazed by Wang Hsi-chih was broadened by an outburst of creative energy, and several major new styles emerged; some of the rare originals still exist to communicate directly with us. In terms of influence on posterity, no calligrapher of this period could surpass Yen Chen-ch'ing (709–785). His characters have strong bones and ample muscles; they are monumental in weight and heroic in feeling. Many of his followers attained greatness in their own interpretations, attesting to the range of possibilities within the Yen manner. Yeh-lü Ch'u-ts'ai (item 20) is an outstanding example. His calligraphy exudes confidence, vision and leadership. This style is usually considered most suitable for large-scale work: a tablet for a huge wall or a city gate, a stele for a temple or a tomb. Masters of cursive script were Chang Hsü (ca. 700–750) and Monk Huai-su (ca. 735–800), both known for their excessive drinking as well as their genius in calligraphy. Wild in appear-

ance but extremely cultivated, their works share the same quality of dynamic balance. *Biographies of Lien P'o and Lin Hsiang-ju* by Huang T'ing-chien (item 5) reflects Huai-su's style in both spirit and form. Swinging arches and intricate knots flow from one character to the next, creating a perpetual motion in stillness.

We can sense some measure of the greatness and variety of T'ang painting by looking at the wall paintings in the princely tombs and cave temples, as well as a few silk scrolls of convincing pedigree. The great divide in painting styles, as formulated by later art historians, was traditionally traced back to this period: elaborately colored, meticulously designed figures and landscapes on the one side, and poetically conceived, ink-dominated works on the other. The former style, associated with the name of General Li Ssu-hsün (651–716), had deep roots in the decorative arts; the latter, traditionally considered the achievement of the poet-painter Wang Wei (701–761), is directly related to literature and calligraphy. In actuality, no such neat classification is possible. A visual delight in saturated blue and green with golden outlines can be just as poetic as a monochrome drawing. Paintings are created in various combinations of medium and technique, theme and style, and most of them cannot be pigeon-holed readily into one school or another.

The early T'ang rulers, as cosmopolitan in outlook as their Six Dynasties predecessors, continued to attract a number of Central Asian artists, who brought with them the technique of modeling. Their ability to create three-dimensional illusions by shading was much admired, but, as we have seen, Chinese painters preferred the line as the quintessential means of articulation, with or without benefit of the new "Indian method." The "painter-sage" Wu Tao-tzu (active in the first half of the 8th century) fashioned undulating lines, varying the width of the brushstroke to define shape and movement. He developed his style by practicing calligraphy in wild cursive scripts and by observing the gyrations of sword dancers. A celebrated story about Wu's competition with Li Ssu-hsün in painting the same Upper Yangtze river scene is significant: Wu dashed off the landscape on a temple wall in one day while Li labored over the same assignment for several months. The emperor praised both, for each had accomplished wonders in his own way. Yang Sheng, another painter serving the court in Wu's time, achieved fame in landscapes of the "boneless" technique, although he also excelled in portraiture and in figure and architectural paintings. *Light Snow on the Mountain Pass* (item 1), most likely a work of the 11th or 12th century, bears a spurious signature of Yang. On the whole, the dominant subject matter in this period was figure painting, fully developed with such subdivisions as ladies, Buddhist and Taoist personages, and portraiture. Horses and buffaloes, birds and flowers became specialties, as did architecture and landscapes, testifying to the broad advance of the pictorial art.

The Five Dynasties (907–960) and the Sung Dynasty (960–1279)

In the period extending from the 10th to the 13th centuries, corresponding to the Five Dynasties and Sung, the full flowering of landscape art began. Great landscape masters of the north portrayed rugged mountains and stark plains, while their counterparts in the Yangtze River valley depicted low hills covered with lush foilage, separated by interlocking shorelines and shrouded by shifting clouds. The first three items in this book represent northern scenes: the snowy mountains in item 1 and the streams and hills under fresh snow in item 2 look much more friendly than the lowlands with bare trees in item 3, yet all three present a grand vista without sentimentality. Kuo Hsi (second half of the 11th century) painted the bleak lowlands with a great feeling of space, illustrating one of the three perspectives that had been developed by Chinese landscapists up to that time. Called the "three distances," these spatial relationships were defined by Kuo as follows: a perspective from the foot of the mountain looking *up* to the top is "high distance"; a perspective from the front [a frontal plane] of the mountain looking *into* the back [a rear plane] is "deep distance"; a perspective from the near mountain looking *toward* the far is "level distance." (These three perspectives are also referred to as "height," "depth" and "breadth," respectively.) The treatment of "level distance," as Kuo demonstrates in item 3, depends on a series of receding planes stretched out horizontally from the right to the left (in this case) or from the left to the right. For an illustration of "deep distance," see the section of Kao K'o-ming's *Streams and Hills under Fresh Snow* on pages 2 and 3 (item 2a), where the viewer is led into the depth of the woods in a movement perpendicular to the paper surface. For an example of "high distance," see Wen Po-jen's *Dwellings of the Immortals amid Streams and Mountains* (item 41), where the line of vision sweeps naturally from the bottom to the top of the vertical composition and the viewer seems to travel from the ground to the peak.

The first three Northern Sung landscapes in this book (items 1–3) also offer an interesting variety in the use of colors, which play an important role in the first, a supplementary role in the second, but only an incidental one in the third. The practice of using only ink, or ink with very light colors, became a major trend. Toward the end of this period, in the 13th century, it was established as the principal mode of literati painting: the literati, poets and calligraphers who were also painters, championed this purist approach. Nothing, they felt, should distract from the beauty of brush and ink, whose rich tones were said to reveal five colors to the sensitive eye. The ink painting *Bamboo* (item 4) by the poet-painter-calligrapher Su Shih (1036–1101) illustrates this point, as well as another trend in the making, that of adding a signature and

date to one's own work. Conspicuous inscriptions are a declaration of the artist's self-expression and personality, not a tribute to authority nor a trademark for a product to be exchanged for rice and wine. Thus the polarity between literati-amateurism and academic-professionalism took shape at this juncture. Su Shih's much-quoted remark in praise of Wang Wei expressed the nature of the close relationship between literature and painting: "Reading Wang's poems one sees pictures; looking at Wang's pictures one senses poetry." Another major Sung calligrapher, Huang T'ing-chien (1045–1105), belonged to Su Shih's circle. His piece in this collection (item 5) has already been discussed. Most of his surviving works were done in running script, and this example, in the wild cursive script, is very rare.

Just as versatile as Su Shih was his friend Mi Fu (1051–1107), whose calligraphy is represented here (item 6). Mi earned a position in Chinese art history as the foremost connoisseur-painter-calligrapher and a strong proponent of literati-amateurism. His misty mountain scenes, formed by slanting brush dots, became the vision of mist and rain for all later artists, as evidenced by Wang Hui's landscape of the 17th century (item 57) and Wang Yüan-ch'i's of the early 18th century (item 64). The slanting dots forming the clouds under the mountain peaks in both paintings are called "Mi dots." In calligraphy, Mi Fu manipulated the brush in the round, using all sides of the tip to create a three-dimensional effect. The single large character *chan* (meaning "battle") on page 18 contains three triangular loops; the last two loops on the right side seem to have risen three-dimensionally above the paper surface.

The most gifted and accomplished artist-ruler in Chinese history was Emperor Hui-tsung (1082–1135), whose ill-fated end as a captive of northern invaders also ranked him high in the Chinese "hall of shame." Both his own paintings and calligraphy, and the paintings of the Academy artists under his direct patronage, exerted a major and lasting influence on posterity. Looking at his *Finches and Bamboo* (item 7), one immediately feels the Emperor's keen observation of nature, sensitive rendition of details and elegant arrangement of elements. His delicate colors, though not reproduced here, should be mentioned as an integral part of the overall design. No better bird-and-flower paintings have ever been produced in China than those of Hui-tsung and the Sung Academy.

After the sack of the Sung capital K'ai-feng in 1127, only one of Hui-tsung's thirty-one sons escaped to continue the royal house in Hangchow, south of the natural barrier of the Yangtze River. With the decline in the national fortunes there was a decided change of mood in Chinese landscape art: the grand vision of soaring heights and vast expanses contracted into sentimental views of fragmented hills and waters. The six fan paintings (items 12 through 17) of this Southern Sung period

are visual melodies with an undertone of melancholy, each a fleeting memory in search of permanence. Refining their style, these artists became highly selective in filtering nature through their eyes, making the distance more remote and the emptiness more poignant.

Among the stylistic innovations of the late 12th and early 13th centuries, the "ax-hewn" look of landscapes by Ma Yüan and Hsia Kuei and the "minimal" look of the later works of Liang K'ai are of lasting significance. The rocks at the lower left in Ma Yüan's *Plum Blossoms by Moonlight* (item 13) were formed by "ax-hewn" brushstrokes (made with a slanting brush tip), so called from their resemblance to the marks left by a swinging ax on wood. The tortured tree trunks and branches, as well as the ragged distant hills, are angular. This Ma-Hsia school came to full flowering in the fifteenth century, as we shall see later. Liang K'ai reduced his brushstrokes to a minimum to achieve maximum expressiveness with no loss of descriptive power. His *Strolling by a Marshy Bank* (item 14) imparts at once the feeling of the height and volume of the tremendous rock hanging over the distant shore and dwarfing the man in the foreground. The mist, cutting the rock in two, extends the picture horizontally beyond the onlooker's imagination.

Liang K'ai's style influenced greatly the Buddhist painters of the Ch'an sect (Zen is the Japanese form of the name), whose belief in self-enlightenment without the help of an organized church found expression in the inspired spontaneity and unadorned brevity of Liang's art. *Monk Riding a Mule*, with the inscription of Monk Wu-chun (ca. 1175–1249), fits perfectly the concept of "ink play" (item 18). The brush and ink carry charm and wit, and so does the inscription: "As rain darkens the mountain, [I] mistake a mule for a horse."

Paintings with literary themes came of age in the Sung period. The second of Su Shih's famous prose poems on the Red Cliff inspired Ch'iao Chung-ch'ang (1st quarter of the 12th century) to create a long handscroll as an illustration (item 8). Similarly, the *Odes of Pin*, by an anonymous poet (ca. 10th century B.C.), inspired an anonymous painter, probably of the 13th century A.D., to interpret the poem line by line in numerous scenes using costumes and architecture contemporary with the artist (item 19). Both painters worked in the *pai-miao* or "plain drawing" technique after the style of Li Kung-lin (ca. 1040–1106), who was another star in the glittering circle of Su Shih and is considered to be the best figure painter of the entire Sung dynasty. In the first section of Ch'iao's scroll (page 22) we see Su Shih in the center of his front yard, with a fish in one hand and a wine jug in the other. His wife stands at the door of the house, with a maid beside her holding a candle. In one wing of the house a servant slumbers beside his horse. A later section (page 24) depicts Su Shih sitting between friends at an evening picnic by the river. Based on the style of Li Kung-lin, Ch'iao's handscroll has an archaic

flavor; his figures are drawn with a studied awkwardness and the landscape backgrounds are composed of rocks, trees and buildings out of natural proportion to one another. Yet the brushstrokes are sophisticated and in tune with the artist's time. Such characteristics are even more prominent in the handscroll illustrating the *Odes of Pin*. For instance, in the section that depicts workers lopping off mulberry boughs (page 39), the figures dwarf the trees, and in the section showing crickets going under the bed (page 40), the insects are the size of cats. This would be called primitivism in the West; the Chinese usually term it *ku-ch'o*, or "archaic awkwardness," a distinctive quality appropriate for an ancient literary theme.

In calligraphy, Southern Sung practitioners continued the legacy of Northern Sung. A case in point is the very rare work of Fan Ch'eng-ta (1126–1193), who added a long colophon to a blue-and-green landscape entitled *Fishing Village at Mt. Hsi-sai* (item 9). Transforming the style of Mi Fu into his own, Fan uses strokes that display stops, kicks and sweeps in rapid cadence, inviting the viewer to sing and dance with them.

Although Northern China was occupied by militarily superior invaders in the latter part of the period under consideration, the Chinese cultural tradition there persisted. The Jurchens, or Chin Tatars, who captured the Chinese emperors in 1127 were in turn vanquished by the Mongols in 1234, and the new Mongol conquerors were a much harsher lot. Fortunately the successor to Jenghis Khan lent his ear to his chief civil administrator, Yeh-lü Ch'u-ts'ai (1190–1244), a Sinicized nobleman from a northeastern tribe called Khitan. Yeh-lü was a scholar in the Chinese classics and a first-rate calligrapher (item 20). It was his argument that living people can work and pay taxes, and this averted the massacre of the population. The dignity and forcefulness of Yeh-lü Ch'u-ts'ai's calligraphy shines through his brushwork.

The Southern Sung rulers carried on the artistic heritage of Emperor Hui-tsung. Not only did the founder of this precarious dynasty excel in calligraphy, but quite a few of his successors also left creditable works. The fan with two lines of a five-word poem (item 10) was probably inscribed by Ning-tsung, an emperor who reigned at the beginning of the 13th century; his style was influenced primarily by Yen Chen-ch'ing and Mi Fu. The poem is in praise of chrysanthemums, extolling their lofty character which defies the harshness of autumn and their pure beauty which competes with the charms of spring. A four-line seven-word poem by a hermit poet of the late 7th to mid-8th centuries is the text on another fan (item 11), which can be attributed to Emperor Li-tsung (reigned 1225–1264). Although he cannot match Fan Ch'eng-ta (item 9) in either talent or training, his calligraphy shows a great deal of flair and individuality. The poem may be rendered freely as follows: "In the meditation room on the mountain top hangs the monk's robe; outside

the window there is no one except birds flying over the stream. Half of the twilight has reached the path below the mountain. Hark! the sound of the bell merges into the deepening blue." This end-of-an-era feeling was shared by all the Chinese fifteen years after the reign of this emperor when in 1279 the Mongols terminated Sung rule in the south as well and Chinese art came to another great divide.

The Yüan Dynasty

The following, fifth, period of development corresponds to the Yüan dynasty founded by the alien invaders. This lasted from 1279 to 1368, barely a century, but was extremely important. At the risk of oversimplification, we may say that Chinese art history can be divided into pre-Yüan and post-Yüan. In the field of painting and calligraphy, the transitional figure is Chao Meng-fu (1254–1322), who summed up the pre-Yüan traditions and opened up the post-Yüan ones. His *Groom and Horse* (item 21) inherited techniques and styles from Ku K'ai-chih of the 4th century through Li Kung-lin of the 11th; and his calligraphy, as seen in the small regular script on the painting and in the running and cursive scripts of the *"Summer Idyll" Quatrain* (item 22), owes a great deal to Wang Hsi-chih of the 4th century and Li Yung of the 7th to mid-8th centuries. In Chao's tireless efforts to totally absorb the classical examples he admired, he set the highest standards for "pursuing antiquity." In his philosophy, the magnitude of an individual's talent can only be measured by the artist's ability to assert his own style in spite of such deep immersion.

Chao's friend Hsien-yü Shu (1257?–1302) excelled in regular, running and cursive scripts, and in the last category he probably even overshadowed Chao. His *Song of the Stone Drums* (item 23), a major work, easily upholds this reputation. His admiration and intensive study of the T'ang masters did not suppress the energy and vigor with which his brush seems to have cut and plowed into the paper.

A group of major Yüan artists directed the mainstream of Chinese painting into landscapes in ink only, often combined with their own poetry and calligraphy. Under the harsh alien rule, they became recluses and took to the mountains and rivers, befriended Buddhist monks and Taoist priests and devoted themselves to art and literature. Relieved of imperial patronage, they broke away from academic traditions and created a literati world of brush and ink. Foremost among them were the "Four Masters," as they became known later: Huang Kung-wang (1269–1354), Wu Chen (1280–1354), Ni Tsan (1301–1374) and Wang Meng (1301?–1385). Two of them are represented here, and the other two by followers to be mentioned later. The early tradition of paintings with literary themes had by now evolved into paintings integrated with poetry, which was not only "illustrated" by the picture but also "written" on it. Let us look at Wu Chen's *Fish-*

erman (item 24). As part of the composition, Wu's beautiful cursive script transcribes his poem: "West of the village, evening rays linger on the red leaves. By the shore, the faint moon appears among the yellow reeds. Lightly stirring the oar, seemingly homeward bound, he puts away his fishing pole and fishes no more." There is no doubt that the verbal images of the village, the lingering evening rays, yellow reeds and faint moon, as well as the homeward-bound mood, add physical and psychological dimensions to the simple but poignant picture. The abstract beauty of the calligraphy accentuates the expressiveness of the brushstrokes that form the trees and rocks.

Whereas Wu Chen's brush is moist and its strokes overlap one another to create a feeling of depth, Ni Tsan's brush is dry and its strokes are sparse and distinct. Nevertheless poetry and calligraphy are as perfectly integrated in Ni's *Wind among the Trees on the Stream Bank* (item 26) as they are in Wu's *Fisherman*. Ni's poem reads: "The evening tides have just receded from the little river island; the frosty leaves become sparse as wind blows through the trees. Leaning on a cane against the bramble gate in silence, I am longing for my friends while the hills darken." Looking at the picture again after reading the poem, one cannot cast off the spell of loneliness.

Yüan artists continued to produce paintings inspired by literary themes. *The Pavilion of Prince T'eng* by T'ang Ti (1296–ca. 1364) is based upon a verse by Wang Po of the 7th century (item 25). Although adhering to the traditions of Sung architectural painting in precision and correctness, T'ang loosened up his brushwork and varied his ink tones to create a nostalgic mood in a hazy atmosphere befitting the poem: in the glittering times of the Prince, the Pavilion reverberated with the music of song and dance; many an autumn has passed since; silent days are filled with reflections of idle clouds while the great river beyond the railings flows on in vain. Yes, the great river flows eternally in the vast space between the Pavilion and the distant shores in T'ang's exquisite scroll. Another architectural painting in this collection, attributed to Wang Chen-p'eng of the early 14th century, who is famous for this genre, is a dazzling performance and a stylistic curiosity (item 28). A very long handscroll depicting a fantastic palace with gates, towers, pavilions, fountains, streams and a lake with dragon boats, the painting displays tremendous inventive power, but the artist obviously lacked knowledge of architectural realities. He repeatedly substituted decorative designs for structural details. (Yet he was familiar with one feature of Chinese garden architecture which was introduced from the West, the multijet ornamental fountain.) His rendering of landscape elements also differs from the normal range of Chinese techniques: the rocks are roughly shaded in an impressionistic manner and the trees, whether bare-branched or densely foliated, tend to be cut-out patterns. Since many foreigners were then living and working in the Mongol Empire, could this in fact be the inspired piece of a Sinicized Mongol, Arab, Korean or Khitan? Chinese collectors in the past assigned to it the title of *The Ta-ming Palace*, a magnificent imperial residence and garden complex of the T'ang dynasty. Whether the unknown artist was Chinese or alien, his wondrous imagination certainly enriches our vision.

The Ming Dynasty

The sixth period of development follows the end of the Mongol Yüan dynasty and covers nearly three hundred years of the restoration of native rule under Ming (1368–1644). A sense of revival permeated all human endeavors in the Central Kingdom. In favor at the beginning of this new dynasty, both at the court and elsewhere, was the Sung style in its various schools, especially that of Ma Yüan and Hsia Kuei of Southern Sung. We have an excellent example here in *Mountain Landscape—the Four Seasons* (item 29). The technique of continuous composition of a long handscroll, which had reached maturity several centuries earlier, now acquired a fourth dimension through the superimposition of a progression in time over a progression in space. This painting thus operates not only geographically, as a panoramic view of a mountain landscape, but also chronologically, showing the change of seasons from spring to winter. Ingenious transitional devices lead from one sequence to the next: a span of water, over which a squall rages, separates spring from summer, a massive mountain after a cloud-filled valley begins the autumn, and winter reigns beyond a mountain cave. The two contiguous sections reproduced here belong to the autumn sequence, with item 29B (pages 62 and 63) preceding item 29A (pages 60 and 61) in the original order of viewing the scroll from right to left. In the left-hand corner of page 62, two gentlemen attended by a boy servant are looking back on summer from an advantageous viewing point, a cliff thrusting into the clouds, through which rises a chorus of jagged vertical peaks. Behind this relatively small cliff is an intricate mountain formation (pages 60 and 61), and within its fold snuggles a mist-shrouded house. Two towering pines with twisted branches pose like ballerinas in arabesque. Such elements in the vocabulary of this unknown painter are derived from Sung masters, but the sophistication in design and execution bear the stamp of Early Ming.

The mainstream of Ming painting, however, was a continuation of the literati movement of the Four Yüan Masters. This was the Wu School, founded by Shen Chou (1427–1509), whose native city, Su-chou, is also known by its ancient name Wu. Shen's mature style, as exemplified by *Silent Angler in an Autumn Wood* (item 30), has its origin in Wu Chen's blunt brushstrokes and moist ink (item 24). His work has a simple, essential dignity extracted from natural forms, accompanied by the warmth of a kind heart. Shen also excelled in calligraphy and

poetry, which are demonstrated at the upper right-hand corner of this painting. Again, as in all paintings of the literati, the poem adds a great deal to the enjoyment of the picture. In the short account following the poem, Shen mentions his long friendship with P'eng Chih-kang and P'eng's son, and the fact that he made the painting for P'eng under the candlelight during an evening spent in their company. The poem describes the evening: when P'eng anchored his boat amid mist and waves and came to visit him, they talked and laughed through Shen's bramble gate; in lamplight he painted with pale ink; in the mountains above the river they sensed their enduring friendship, which meant more than merely drinking together. The poet wishes that the friends grow white hairs together and share the leisure of casting fishing lines.

Shen's follower Wen Cheng-ming (1470–1559) diligently studied the past masters of T'ang and Sung but settled down in the house that Yüan masters built. Some of his works are vintage Shen Chou; others are heavily influenced by Ni Tsan (item 26), such as Wen's *Summer Retreat in the Eastern Grove* (item 32); still others bear the imprint of Chao Meng-fu. Wen's overall personal style is hard-edged in brushwork, disciplined in composition and elegant in atmosphere. The crystallization of typical forms in the rendering of rocks, foliage, clouds, water ripples and waves, as well as figures of scholars, woodsmen and servants, began to lead his followers into formalism. Wen, however, did not neglect nourishment from nature; his *Magnolia* (item 34) was obviously drawn from life. Its pale colors blend well with the rich cream paper; brown covers the branches, green forms the leaves and opaque white makes the blossoms stand out from the surface of the paper. As Wen noted in his inscription, this was the scene in his courtyard in early spring: a magnolia tree beginning to put forth fragrant and lovely blossoms—a touch of the painting brush for a touch of nature's poetry.

Wen's friend T'ang Yin (1470–1523) was as much a romantic as Wen was a disciplinarian, and his art shows it. T'ang's *Drunken Fisherman by a Reed Bank* (item 35) is best described by the artist's own playful poem, brushed in bold calligraphy at the top of the picture, which, by contrast, was done in pale ink for the most part:

> He ties the skiff to a pole planted near a reed-covered spit;
> The third-watch moon rises over the pole's tip.
> Dead drunk, the old fisherman wakes not to the call;
> When he arises, his grass cloak prints a shadow on the frost.

The same carefree mood pervaded the creation of his *Ink-bamboo* (item 36). The whole painting represents a shadow cast by the bamboo on his windows, as described in his poem set down at the beginning of the handscroll, again in bold calligraphy:

> Fourth watch, the moon lowers, paper windows a luminous void;

> Wakening from wine, read a while with head in hand.
> Can hardly bear the clear thoughts forced upon me—
> As ten stalks of chilly green spread their shadows.

The reader may recall Su Shih's ink painting of bamboo (item 4) and sense the long tradition behind this genre, which was founded by Su Shih's friend Wen T'ung. Over four centuries elapsed between Wen T'ung and T'ang Yin, and many great bamboo painters lived in the Yüan dynasty, including Chao Meng-fu. Thus T'ang Yin's art drew nourishment from tradition as much as from nature. The notion of an ink painting representing shadows is said to date back to Su Shih's time, when a monk artist was inspired by the slanting shadow of a branch of plum blossom during a moonlit night.

Completing the roster of Four Ming Masters with Shen, Wen and T'ang is Ch'iu Ying (probably 1494/5–1552). By force of his stylistic virtuosity and impeccable technique, he was accepted as an equal among literati painters although he was neither a poet nor a calligrapher. His *Fisherman's Flute Heard over the Lake* (item 38) has its roots in the Southern Sung master Li T'ang, from whom Ma Yüan and Hsia Kuei developed their own styles. Ch'iu Ying achieved just the right balance between refinement and strength, pictorial appeal and literary highmindedness. He was therefore appreciated by the elitists and the public alike. His popularity attracted swarms of imitators and forgers, who merely furnished pretty designs and colors without attaining Ch'iu's structural soundness and excellence of brushwork. Close study of item 38 will deepen one's appreciation of his mastery of both landscape and figure painting. The mass effect of the foliage, the clarity of the architectural details, the strength of the rocks and the liveliness of the water —in addition to the subtle interplay between the fisherman-musician and the scholar-listener—create a world of lyricism with no further need for words. In such a pristine performance, Ch'iu Ying has no equal.

The Wu School as dominated by Wen Cheng-ming continued to prosper until the end of the 16th century. Lu Chih (1496–1576), one of Wen's students, accentuated his teacher's angularity in painting rock formations. The folding fan of ink and blue and green on gold paper entitled *Brocaded Sea of Peach-blossom Waves* (item 40) harks back to the T'ang master Li Ssu-hsün, but the style is almost pure Wen. Lu's calligraphy, also after Wen's style, here carefully transcribes a poem alluding to a Taoist fantasy, a world of jade mountains and brocade waters.

There were many noted painters and calligraphers in the Wen family, from Wen Cheng-ming's own two sons down to lineal descendants and cousins in the fifth generation. His nephew Wen Po-jen (1502–1575) ranks as the most accomplished among them. *Dwellings of the Immortals amid Streams and Mountains* (item 41) illustrates well the style of the

Yüan master Wang Meng. The use of short and feathery strokes to articulate rock textures, the profusion of moss-dots made by split brush tips all over the rock formations, the casual manner in which buildings, trees and other structurally rigid forms are drawn, are all hallmarks of Wang Meng—as is also the complicated design, hardly containable within the borders of the painting. One design feature that enlivens and unifies the whole massive mountainscape is the stream flowing from the very top of the boulder-like peak down to the lower right and through the trees into the body of water at the lower left. This is a device often employed by the artist's uncle Wen Cheng-ming. Upon closer examination, the uncle's influence can be found everywhere: in the trees, the figures and the dots representing misty foliage at the upper right under the distant mountains.

Among the large circle of Wen Chen-ming's direct disciples and their followers, Hou Mou-kung (active ca. 1540–1580) is outstanding. The striking vertical composition of his *High Mountains* (item 42) demonstrates his inventive power. In brushwork, tree shapes and rock formations, he followed the Yüan master Huang Kung-wang as well as Wen Cheng-ming, but Hou's manipulation of the three classical perspectives—"height," "depth" and "breadth"—is ingenious. At the bottom of the picture, we have the "depth" of the woods (looking straight *into* the picture) through the tall pines and penetrating path; beyond the woods, in the middle of the picture, we have the feeling of "breadth," or "level distance," produced by the interlocking shorelines at the foot of the mountains, which rise in great "height" in the top third of the scroll. In addition, the vista proceeds from the body of water in the mid-section to the top right until it disappears between the dominant peak nearer to us and the distant mountains, creating a further feeling of "depth" into the unseen.

Turning to Ming calligraphy, we find that toward the end of the Mongol Yüan dynasty, that is, the middle of the 14th century, a branch of cursive script came into vogue that had its origin in the very formal clerical script. Sung K'o (1327–1387) was one of the foremost practitioners of this type of cursive. His *Seven-word Poem* (item 27) shows the use of heavy and light strokes to create a rhythm of density and space, as well as an emphasis on circular designs within the characters. The movement is lively but not slapdash, a virtue much appreciated by students of calligraphy. During the 15th century, interest in Northern Sung masters revived; for instance, Shen Chou modeled his calligraphy on that of Huang T'ing-chien, as can be seen in the inscription on *Silent Angler in an Autumn Wood* (item 30). (The Huang piece in this book, item 5, is a rare work in wild cursive script, not in his usual regular or running script, and thus cannot be used as a standard for comparison.) In Wen Cheng-ming's time, around the late 15th to the mid-16th centuries, the Chin and T'ang masters of the 4th to 8th cen-

turies again ruled supreme. The beautiful small regular script by Wen, a transcript of Lu Chi's *Art of Letters* (item 33), is in his typical style based upon Wang Hsi-chih's classical examples—Wang being the all-time great who lived in the 4th century. Aside from Wen's artistry, his amazing energy, consistency and perseverance can be readily appreciated if one compares the first section of this piece (page 71) with the last section (page 70)—they were done three years apart! The regular script, being the foundation for the running and cursive scripts, is considered the most difficult in which to reach perfection. Wen's calligraphic oeuvre, such as this piece, has placed him in the very small circle of supreme masters.

Chu Yün-ming (1461–1527), an older friend of Wen Cheng-ming and T'ang Yin, has been rated as the best calligrapher of this period; his *Prose Poem on Fishing* (item 31) is among the greatest of his works. This long handscroll, dashed off in one evening under lamplight, expresses his extreme pleasure in a day's flower-gazing and fishing in the garden of an affluent friend, for whom he made it. It illustrates well the method of the Chinese calligrapher, especially in the domain of cursive script: intensive daily practice for years, with conscientious copying and adapting of selected past masters to produce a reservoir of knowledge and skill which, at a spirited moment, can raise the intuitive performance to an incredible height, combining carefreeness and discipline. Chu must have chosen to use a worn-out brush, for his host surely had dozens of new brushes around. The blunt tip enabled the calligrapher to apply all his strength without worrying about embellishments, to dispose of superficialities and reveal his naked talent. Chu opted for such an unmerciful test and triumphed. Often equally revealing of an artist's true worth is a casual piece, a letter or note dashed off without any thought of posterity. Wang Ch'ung (1494–1533), a much younger friend of Wen, T'ang and Chu, is represented here by his *Letter to Nan-ts'un* (item 39). He was beseeching Nan-ts'un's help in urging a man of power and influence to complete an embankment at his estate. Wang's work has an authentic feeling of antiquity which could only be achieved by a sensitive and cultured mind. In terms of stylistic elegance, he has been ranked on a par with Wen by later critics. Wang's untimely death at forty deprived us of a calligrapher who had not yet reached his apex, and who might have surpassed the other great masters of his time.

In the circle of Wen Cheng-ming, the calligraphy of Wu I (1472–1519) was a specialty. The seal script had long become an archaic style reserved for seals or for "display type," in the jargon of modern typography. The two large characters in item 37 representing "enjoyment" (page 81) and "pines" (page 80) were Wu's contribution as a frontispiece to a landscape handscroll. These measured strokes of even width and strength, sustained over a sizable area, must be beautifully spaced and constructed.

The characters should look deliberate and natural, perfect but not mechanical—reminding one of a champion skater doing a figure exercise.

By the end of the 16th century, the vitality of the Wu School, that is, the school of Shen Chou and Wen Cheng-ming, was ebbing. A weak formalism crept in; the stage was set for another fresh direction. By now a new dimension was added to the role of artist, that of thinker. We find this formidable combination—painter, calligrapher, writer (though not poet) and theorist—in the person of Tung Ch'i-ch'ang (1555–1636). Tung learned how to paint by studying the Yüan masters, then searched for remoter origins in Sung and T'ang. Personal taste and preference led him to worship Wang Wei of the 8th century and Tung Yüan of the 11th. Concurrently he embarked upon a philosophical quest, ranging from the Neo-Confucianist idea of reaching into one's inborn knowledge to the Ch'an Buddhist principle of "gradual cultivation and sudden enlightenment."

Through an association of ideas Tung Ch'i-ch'ang came to believe that there was a division of Southern and Northern schools in painting analogous to the division that existed in Ch'an Buddhism, the Northern artistic school being that of professional painters emphasizing craftsmanship, decorativeness, academism and realism, and achieving success gradually through accumulated effort, and the Southern being that of literati artists stressing naturalness, poetic ideas, amateurism and inspiration, attaining brilliance in moments of revelation. Specifically, Tung placed Wang Wei (699–759) on the highest pedestal as the founder of the Southern School, and proclaimed many major painters of his liking to be artistic lineal descendants down to himself; in the other camp, Li Ssu-hsün (8th century), who excelled in landscapes of blue, green and gold, was considered by Tung as the founder of the Northern School, with a number of very accomplished academicians linked to him, including Ma Yüan (item 13), Hsia Kuei and their followers, among them the anonymous painter of *Mountain Landscape—the Four Seasons* (item 29). The whole Wu School of Shen Chou (item 30) and Wen Cheng-ming (items 32–34) belonged to the Southern School according to Tung.

It was to correct the excesses of the Wu School—the ultra-refinement resulting in fragmented forms and effete brushstrokes—that Tung created a brave new vision in Chinese landscape art. He simplified the elements of rock formations and tree groups but arranged them in situations of potential movement, or what may be called dynamic equilibrium. His brush-and-ink pieces achieved grace and interest so that they can be appreciated as abstractions on their own merits, without regard to their representational content. His *Landscape with Trees, after Ni Tsan* (item 44) is not a typical piece, but his comments regarding simplicity of design and quality of brush-and-ink work apply. Tung's calligraphy exerted as great an influence as his painting and theory of art. In *Poem by Wang Wei* (item 43), one

can readily see the impact of Chao Meng-fu (item 22), whom Tung aimed to emulate and then surpass. Although Tung's art theory is more inventive than scholarly, it made history by defining and directing the mainstream of Chinese painting and calligraphy, within which he himself became a pivotal figure. As we shall see later, because of Tung Ch'i-ch'ang the first third of the following dynasty, Ch'ing, is generally considered a continuation of Tung's period.

Only one generation younger than Tung Ch'i-ch'ang but not within his orbit, Chang Jui-t'u (1570–1641) painted largely in the style of the Yüan master Huang Kung-wang, but with a drastic reduction of pictorial elements in accordance with the prevailing trend of his time. For example, Chang's interpretation of the *Ode on the Red Cliff* (item 45) is what a Chinese critic would call "all bones with little flesh," structurally striking and atmospherically stark. It stands in sharp contrast to Ch'iao Chung-ch'ang's painting on the same theme five hundred years before (item 8), which is a pictorial narrative rich in details. In calligraphy Chang was unique among his peers; not content with pursuing classical examples of famous masters, he based his style on the stone engravings of Northern Wei steles of the 5th to 6th centuries. Every character seemed to be constructed of sturdy beams, and each stroke carved with chisel and cut with ax. The *Couplet* (item 46), already discussed in connection with the nature of Chinese words and writing, represents Chang's work at its best.

In contrast to the sparse world of Chang Jui-t'u, Hsiang Sheng-mo (1597–1658) wove tapestries of an enchanted land with dense vegetation and intricate settings. At first working within the confines of Wen Cheng-ming, who was probably a friend of his grandfather, the great collector Hsiang Yüan-pien, the artist later expanded his vision to embrace the multifaceted Sung landscapes. In a painting like *Scholar in the Woods* (item 48), we detect especially the influence of an early Sung work entitled *Ten Views from a Thatched Lodge*, in which compact tree groups, solid rock structures, varied foliage and textured water ripples all contribute to create an image at once archaic and real. (Hsiang Sheng-mo lived into the Ch'ing period, and his painting has been placed under Ch'ing in the List of Works.)

The Early Ch'ing Period

The seventh period of development, the last to be covered by this book, corresponds to the first hundred years of Ch'ing (1644–1911). The second emperor of this Manchu dynasty took a personal liking to the art of Tung Ch'i-ch'ang and legitimized this "revolution" of late Ming into the "orthodoxy" of early Ch'ing. But with a new emphasis. The pursuit of antiquity was intensified—to work "after ancients" became fashionably modern. With such training, the artist became also an art historian in the Tung school. The lineage of orthodoxy was well defined: from the alleged founder of the South-

ern School, Wang Wei (8th century), to Tung Yüan and Monk Chü-jan (11th century), to the Four Yüan Masters (especially Huang Kung-wang, 13th to 14th centuries), to Shen Chou and Wen Cheng-ming (15th to 16th centuries), down to Tung Ch'i-ch'ang.

In this post-Tung period, six masters with the collective title of "Four Wangs, Wu and Yün" inherited the mantle of orthodoxy and expanded its realm. The leader of this group, very properly, was a student of Tung Ch'i-ch'ang's. Wang Shih-min (1592–1680) began by practicing in the manner of Tung's sketches of trees and rocks and listening to Tung's remarks about the painting techniques of the great masters in the Southern School. *Landscape after Huang Kung-wang* (item 47) is a typical mature work of his. Wang Chien (1598–1677), the second of the Four Wangs, studied together with him and introduced a new talent, Wang Hui (1632–1717), to the circle. Under the tutelage of the two older Wangs, Wang Hui advanced rapidly in the art of painting and earned his place as the third Wang. His early work *Clearing after Rain over Streams and Hills* (item 57), already showing his tremendous wealth of brush technique and versatility, acknowledges his indebtedness to the Sung master Monk Chü-jan; his mature piece *Mountain after Rain Passes*, on a folding fan (item 58), displays his own style, which was formed by a conscientious effort to sum up what he had learned from Sung and Yüan masters of both the Northern and Southern Schools. The last of the four Wangs, Wang Yüan-ch'i (1642–1715), was a grandson of Wang Shih-min. He continued to develop the ideals of Tung Ch'i-ch'ang by concentrating on the Southern School. Mining the treasures in Huang Kung-wang's repertoire, he explored the unlimited variations in amassing simple building blocks to fashion hills and valleys. *Fishing in a River in Blossoming Time* (item 63) is a blue-and-green landscape after Chao Meng-fu, but stylistically it is pure Wang Yüan-ch'i. A stream of white clouds flows into the folds of green mountains—a play between two simple elements, one of airy movement and the other of massive stability. In the inscription on his vertical composition *Summer Mountains* (item 64), Wang Yüan-ch'i's invocation of two Yüan masters serves only to affirm the principle of innovation through continuity. Yün Shou-p'ing (1633–1690) considered himself no match for his friend Wang Hui in landscape painting, so he devoted his efforts to flowers and plants, mainly in the "boneless" technique of forms without outline, as in *Two Garden Plants* (item 60). Among these six masters, Yün ranks first in achieving the ideal of three perfections—in painting, calligraphy and poetry. *After Three Rubbings* (item 59) pays homage to Chin and T'ang masters, but the whole composition is a splendid expression of Yün's own style of calligraphy. Comparing his painting with his calligraphy, the similarity in the brushwork becomes apparent: in both genres, it combines leisurely pace with graceful agility. Besides Wang Chien, the other one among the six not represented

here is Wu Li (1632–1718), a landscapist. Wu and Wang Hui hailed from the same town, were born in the same year and studied under the same mentors, the first two Wangs, but Wu's concentration on perfecting a single style differed sharply from Wang Hui's desire for eclectic versatility.

These six masters belonged to an intimate circle and represented the loftiest efforts of orthodoxy, but they lived in an unusually creative age, in which a host of other exceptional artists practiced in areas far beyond their realm. For want of a better term, the catch-all label of "individualists" has been accorded by art historians to these painters and calligraphers outside the orthodox pale.

Before discussing the prominent individualists, mention should be made of one eccentric personality who complied with orthodox requirements to gain a high official position but used an unorthodox approach to art. Not content with following the steps of ancient masters, Fa Jo-chen (1613–1696) drew nourishment from nature and transformed his vision into dreamlike landscapes. His calligraphy was natural and casual, without pretensions or self-consciousness. In *Discourse on Painting* (item 49) he satirized the common opinion that scholar-officials were the cleverest of men, and painters the stupidest. The cleverest might harm others, Fa stated, by abusing power and leading themselves to ruin; the stupidest, however, with proper spirit and conception can combine scholarship and art. For a man of both worlds, his insight has a ring of authority.

The most important group of individualists shared an unyielding loyalty to the preceding dynasty, Ming. Five of these brilliant "recluse" artists are represented here: Hung-jen, K'un-ts'an, Kung Hsien, Chu Ta and Tao-chi. Hung-jen (ca. 1610–1663) was a lonely and austere person devoted to his mother; after her death he found solace in Buddhism. His art reflects his character, the cool and calm appearance masking intense feeling, as in his *River Scene in Winter* (item 50). The source of his style is readily identifiable as that of the Yüan masters Huang Kung-wang and Ni Tsan (item 26); it is illuminating to compare Ni's piece and those of his followers (items 32, 44 and 45) down to Hung-jen to sense the relationship between the original style and its variations.

The world of K'un-ts'an (active 1655–1686) is as dense and crowded as Hung-jen's is sparse and light. After the fall of Ming, K'un-ts'an escaped into monkhood. His "heavy" style can be traced to the other two of the Four Yüan masters, Wu Chen and Wang Meng. *Wooded Mountains at Dusk* (item 51) portrays a rugged and secluded corner of the earth, daring common souls to plant their feet on the edge of unfathomed depths or set their sights toward the escalating heights. Under the natural stone bridge, at the bend of the cascade, sits a meditating monk, perhaps the artist himself. The light coloring covers the multilayered ink with an overall tone of twilight; as darkness closes in and the

screams of monkeys penetrate the air, can one fence off the foreboding tremor and remain calm in the heart that is Buddha? The turbulent look of K'un-ts'an's pictures may shield a tranquility that he found in the monastic life.

Kung Hsien (ca. 1620–1689) neither tried to get along with people nor wished to associate with the past or future. His use of ink in depth to create atmosphere can be called unprecedented, although the Yüan masters and the founder of the Wu School, Shen Chou, had been his guide in the first part of his journey to find a new path. Kung's *Wintry Mountains* (item 53) is like a glimpse afforded by the temporary lifting of the thick mist that still enshrouds the top of the picture and gives the artist a blank space to brush his poem: "Where are the homes for the farmer, the cowherd, the fisherman and the woodsman? The houses with yellow thatched roofs at the foot of the mountains and the edge of the waters. Returning, carefree and dead drunk; wine fills jugs and cups—no need to ask for credit."

In exploring the dynamics of asymmetry and the delight of whimsy, Chu Ta (1626–1705) has no equal in Chinese art history. *Fish and Rocks* (item 54) conveys a sense of surrealist transformation: the rocks are poised in the air, watching the frolicking fish. In *Birds in a Lotus Pond* (item 55), the two large black birds have a mischievous look while the nestling on its mother's back cries out in response to the chattering of two other young birds in the middle section of the handscroll (not reproduced here). The lotus leaves facing the birds loom like a dark cloud, placing undue weight on their stems, which seem to be on the verge of transformation into something else—say, the legs of a heron. The sense of instability in composition is subtly balanced by the authority of Chu's bold and sparing brushwork, with each stroke giving definition, volume and texture at the same time. Chu Ta, a member of the Ming royal line who saw the dynasty fall within his lifetime, was burdened with sorrow, bitterness, fear and cynicism. Yet his art did not suffer from his feigned insanity or his forced escape into priesthood. The tragic circumstances only deepened his disdain for orthodoxy and necessitated an enigmatic disguise for rebellious expression. His calligraphy is more tradition-bound but just as individualistic as his painting. *After "The Preface to the Orchid Pavilion Gathering"* (item 56), though closely based on the famous piece by the "calligrapher-sage" Wang Hsi-chih of the 4th century, cannot be mistaken for the work of anyone else. Drawn with a torn, blunt-tipped brush, his characters echo the asymmetry in Chu's pictorial compositions.

Tao-chi (1641–ca. 1717) was a distant relative of Chu Ta, sharing the same tragic personal and national loss. Early in his life he entered the protective gate of Buddhism and led a life of brush and ink. His independent spirit moved him to champion the theory of "one single stroke" as the beginning of all paintings and the motto "no method is my method," which essentially means wiping the slate clean and starting from zero. This was a rebellion against the shackles of the past, an all-out quest for originality and a declaration of artistic independence. Tao-chi traveled widely and assembled sketches of strange and grand views. Whereas Tung Ch'i-ch'ang had rebelled against the decadence of the Wu School, returning to earlier sources for authority and restructuring the painter's vision with simplicity as his goal, Tao-chi rebelled against all authorities and sought his beginning in primordial nothingness. Yet Tao-chi's means and techniques were traditional and his work betrayed subconscious acceptance of the ancient masters. His revolutionary zeal and creative power, however, made him a true original in Chinese art, exerting an influence as great as that of the orthodoxy. In *Landscape on a Gold-paper Fan* (item 62), Tao-chi's rendering of trees and rocks has a childish naïveté at first glance, but shows a sophisticated freshness upon sustained examination. The calligraphy of *Five Poems* (item 61), with text composed by himself, shows his work at its conservative best, a regular script derived from the clerical script of the Han dynasty. Tao-chi was a man of great scope, ranging from the wild and free to the scholarly and iconographic, but never without imagination and flair.

Eight outstanding individualists shared the same geographical location, the Southern capital Nanking; they are thus known in Chinese art history as the "Eight Masters of Nanking." Kung Hsien, the important "recluse" artist already discussed, is also considered the leading figure of this group, which includes Fan Ch'i (born 1616, still alive in 1692). Fan's landscapes are intricate; they entice the viewer into mental excursions through deep caverns, under overhanging cliffs, along twisting paths or across meandering streams—a journey through an enchanting mixture of dream and reality. His small compositions, such as the *Album of Eight Leaves* (item 52), are gems created in a most appealing miniature technique. Their affinity to the Southern Sung fan paintings (items 12 through 17) shows how Fan Ch'i bypassed the Yüan and the Ming and sought inspiration in an earlier time, when pictorial interest was still as important as the mystique of brush and ink.

In the second decade of the 18th century, the remaining three of the six orthodox masters, Wang Hui, Wang Yüan-ch'i and Wu Li, passed from the scene, as did the great "individualist" Tao-chi. Now the congregation of major talents shifted to Yangchou, an ancient river capital that had developed into a commercial center. Salt merchants with huge fortunes enjoyed the role of art patrons, and artists rich only in their talents enjoyed the merchants' patronage. With the Chinese fondness for auspicious numbers, another grouping came to be known as the "Eight Eccentrics of Yangchou," four of whom are represented in this book.

Kao Feng-han (1683–1748) was linked to the Yangchou Eccentrics by style rather than place. In some versions of the traditional groupings he is not included in the Eight, but that is immaterial. By his time Tao-chi's theory and practice had gained wide acceptance and attracted a following among the best talents while the orthodox school associated with the court withered. *Chrysanthemums by the Rock* (item 65) is a dashing performance of an uninhibited mind and hand; the brush is swift and the ink wet. To this day it has an appealing work-in-progress look, fresh and moving. The monumental solidity of the rock contrasts with the frail but lively plant. Kao Feng-han's calligraphy at the upper right-hand corner is integrated with the picture; its rhythm echoes that of the chrysanthemum leaves and its overall texture serves to set off the simple bulk of the rock. (As a result of an injury, the artist did the painting with his left hand.)

Chin Nung (1687–1764) occupies the dominant position among the Yangchou group, for the sum of his achievements in the three arts of painting, calligraphy and poetry reached a loftier height than the others. The *Three Poems* (item 66), his own compositions, are brushed in neo-clerical script, square and heavy—what the modern typographer would call boldface. This can be compared to Tao-chi's style (item 61), which had the same origin with a quite different result. Both helped to set the trend among Ch'ing dynasty calligraphers to search for inspiration in a time earlier than that of Yüan, Sung or even T'ang masters; they immersed themselves in rubbings of stone-engraved ancient scripts and enriched their calligraphy with an archaic flavor. While Chin Nung as a painter excelled in landscapes, figures, animals and plants, his plum trees gained special renown. *Blossoming Prunus* (item 67), dated 1759, represents his lighter side in this genre. The heavy-stroked calligraphy, intentionally formal in close formation, accentuates by contrast the feeling of sinuous branches swaying in the spring breeze. The second inscription, at the left, in much more delicate, small regular script, was done by a connoisseur forty years later; the addition is careful and modest, to show respect to the artist.

Li Shan (1686–ca. 1762) left a number of brilliant works but very little is known about the details of his life. He once served at the court as a painter and was later appointed a magistrate. *Bamboo and Calligraphy* (item 68) can be called a painting with a long inscription, or calligraphy with an illustration, or more correctly, an integrated work of the three noblest arts—for the words constitute a long poem by the artist in praise of bamboo. A marked development in the work of the individualists since the late 17th century had been the use of the same kind of brushwork in the lettering and in the strictly pictorial areas of their paintings, making the presence of written words on a picture natural and harmonious. For instance, the character *chu* ("bamboo") appears many times in Li Shan's poem here; it was brushed in the same manner as the bamboo leaves in the painting. It took more than half a millennium to reach this stage, as we can see by comparing the bamboos in ink by Su Shih (item 4) and T'ang Yin (item 36) with this piece.

Cheng Hsieh (1693–1765) knew Li Shan well. One of the poems Cheng left celebrates a drinking party at Li's house, and several other lament the passing of Li from the Yangchou scene. Cheng Hsieh was not far behind Chin Nung in the mastery of the three arts, but he limited his subjects to bamboos, orchids and rocks. His calligraphy is a hybrid of the clerical and running scripts; its stroke forms are almost interchangeable with those used in his paintings of orchid petals and bamboo leaves. This is well demonstrated in *Orchids on Rocks* (item 69). This concept of unifying the three arts was expressed by defining the art of painting as "writing ideas," that is, "writing" in the pictorial form of "ideas." The ideas, of course, are poetic; Cheng's idea in this case, inscribed at the upper left, can be translated as follows:

> Orchids are originally a mountain plant;
> Let us plant them back in the mountains.
> The multitudes everywhere put them in pots
> and jars—
> Why not leave them with the mist and clouds!

By the eighteenth century, the essence of Chinese art can no longer be compartmented into painting, calligraphy and poetry. It is now the poetic idea expressed in brush and ink. The choice is with the artist: write a poem and put it into calligraphic form, or write a wordless painting with poetic feeling, or write a poem and brush it calligraphically over a picture. All that he has learned from the past in terms of styles and traditions, all that he has seen in his natural environment, and all that he has experienced in life can be brought out under his brush tip and left as traces of ink. Henceforth his best works will be high among the mist and clouds, never to be imprisoned in pots and jars.

LIST OF WORKS ILLUSTRATED

Dimensions are given in inches and feet, and in centimeters, height before
width. JMC = John M. Crawford, Jr.

NORTHERN SUNG (960–1127)

1. ANONYMOUS. ATTRIBUTED TO YANG SHENG (AC-
TIVE 713–741).
Light Snow on the Mountain Pass. Ink and color
on silk; album leaf. [page 1]
11⅞ x 9½ in. (30.2 x 23.5 cm.)
Spurious signature of Yang Sheng.

COLOPHON (i.e., subsequently added inscription):
an unidentified collector, probably dated 1666, with
twin seals.

COLLECTORS' SEALS: one of Hsiang Yüan-pien
(1525–1590), three of JMC, one unidentified.

2. KAO K'O-MING (B. CA. 980, STLL LIVING 1049).
Streams and Hills under Fresh Snow. Ink and
color on silk; handscroll. [pages 2–9]
16⅛ in. x 7 ft. 11 in. (41 x 241.3 cm.)
Signed and dated by the artist, 1035.

COLOPHONS: (1) the artist's name at the begin-
ning of the painting, probably by a Southern Sung
calligrapher, 13th century; (2) a collector with the
surname of Mou, near the end of the painting; (3)
Wu K'uan (1435–1504) with one seal, undated, at-
tached to the painting.
COLLECTORS' SEALS: twenty-nine, including two of
Chu Kang, Prince of Chin (1358–1398), one of
Wang Shih-chen (1526–1590), several each of
Ch'ing Emperors Ch'ien-lung (reigned 1736–1795),
Chia-ch'ing (r. 1796–1820) and Hsüan-t'ung (r.
1909–1911).

3. KUO HSI (B. CA. 1020, STILL LIVING 1078).
Lowlands with Trees. Ink on silk; handscroll.
[pages 10–13]
13¾ in. x 3 ft. 5¼ in. (34.9 x 104.8 cm.)
Unsigned.

COLOPHONS: (1) Feng Tzu-chen (1257–after 1327)
with three seals; (2) Chao Meng-fu (1254–1322)
with one seal; (3) Yü Chi (1272–1322); (4) K'o
Chiu-ssu (1290–1343); (5) Liu Kuan (1270–
1342) with one seal; (6) Yen Yao-huan (probably
14th century) with three seals; (7) Monk Tsu-ming
(14th century), dated 1350, with two seals; (8)
Wang Shih-chen (1526–1590) with two seals; (9)
Ch'en Yen (d. 1644) with one seal; (10) Chang
Ta-ch'ien (contemporary) with four seals.

COLLECTORS' SEALS: sixty-nine, including one of
Sung Emperor Hui-tsung (r. 1101–1126), many of
Liang Ch'ing-piao (1620–1691) and several of Em-
peror Ch'ien-lung (r. 1736–1795).

4. SU SHIH (1036–1101).
Bamboo. Ink on paper; vertical painting
mounted as handscroll. [page 14]
21¼ x 13 in. (54 x 33 cm.)
Signed and dated by the artist, 1094.

COLOPHONS: twelve writers of the 19th and 20th
centuries with twenty-one seals.
COLLECTORS' SEALS: seventeen, of seven collectors
including Hsiang Yüan-pien (1525–1590); another
two unidentified.

5. HUANG T'ING-CHIEN (1045–1105).
Biographies of Lien P'o and Lin Hsiang-ju. Ink
on paper; handscroll. [pages 15–17]
12 13/16 in. x 59 ft. 9 in. (32.5 x 1822.4 cm.)
Unsigned.

COLOPHONS: (1) Hsiang Yüan-pien (1525–1590)
with two seals; (2) Chang Ta-ch'ien (contempo-
rary), dated 1956, with two seals.
COLLECTORS' SEALS: one hundred ninety-seven, of
fourteen collectors including Sung Emperor Kao-
tsung (r. 1127–1162), Chia Ssu-tao (1213–1275),
Ou-yang Hsüan (1283–1357), Fang Ts'ung-i (ca.
1301–ca. 1380), Hsiang Yüan-pien (1525–1590),
An Ch'i (1683–after 1742), Emperor Ch'ien-lung (r.
1736–1795) and Chang Ta-ch'ien (contemporary);
another five seals unidentified.

Note: This text was written by Ssu-ma Ch'ien
(145–before 86 B.C.) about General Lien P'o and
Minister Lin Hsiang-ju who served under King
Hui-wen of Chao (r. 298–266 B.C.); an abridged and
slightly altered version of the first part of *Shih-chi*,
chapter 81.

6. MI FU (1051–1107).
Sailing on the Wu River. Ink on paper; hand-
scroll. [pages 18 & 19]
12 5/16 in. x 18 ft. 4¼ in. (31.3 x 559.8 cm.)
Signed by the artist, undated.

COLOPHONS: (1) Sun K'uang (1542–1613) with
three seals; (2) Wang To (1592–1652), dated 1643,
on mounting silk preceding Mi Fu's calligraphy.

COLLECTORS' SEALS: twenty-two, of six collectors including Chu Kang, Prince of Chin (1358–1398) and Emperor Ch'ien-lung (r. 1736–1795); one Ming official seal.

Note: Mi Fu's five-word-per-line poem tells of his boat trip up the Wu River, the struggle against the wind and the demand of the boatmen for more money; given additional pay, the men overcame the wind. The section reproduced here contains the line "[they] shout as if in battle."

7. SUNG EMPEROR HUI-TSUNG (1082–1135; R. 1101–1126).
Finches and Bamboo. Ink and color on silk; handscroll. [pages 20 & 21]
11 x 18 in. (27.9 x 45.7 cm.)
Signed by the artist with his cipher, with two imperial seals.

COLOPHONS: (1) Chao Meng-fu (1254–1322) with one seal; (2) Huang Chung (16th century) with one seal; (3) Hsiang Yüan-pien (1525–1590) with three seals; (4) Sung Lo (1634–1713) with one seal; (5) Hsiang Yüan-pien.
COLLECTORS' SEALS: numerous, including those of Chao Meng-fu; Chu Kang, Prince of Chin (1358–1398); Hsiang Yüan-pien; Keng Chao-chung (1640–1686); Sung Lo; and Chang Ta-ch'ien (contemporary).

8. CH'IAO CHUNG-CH'ANG (ACTIVE FIRST QUARTER OF THE 12TH CENTURY).
Ode on the Red Cliff, Part II. Ink on paper; handscroll. [pages 22–25]
11⅝ in. x 18 ft. 4⅝ in. (29.5 x 560.3 cm.)
Unsigned.

COLOPHONS: (1) Chao Ling-chih (11th to 12th century); (2) Wu An-tao (unidentified); several others without importance.
COLLECTORS' SEALS: sixteen on the painting, of five collectors—Liang Shih-ch'eng (d. 1126), Liang Ch'ing-piao (1620–1691), Emperor Chia-ch'ing (r. 1796–1820), Emperor Hsüan-t'ung (r. 1909–1911) and JMC.

Note: Judging from the brushwork and ink, the text of the *Ode*, placed at appropriate locations on the painting, was brushed by the artist. The *Ode*, a prose poem by Su Shih (1036–1101), is one of the most celebrated literary pieces in Chinese history. The first part was written in the seventh month of *jen-hsü* (1082); the second part, written in the tenth month, tells of poet Su Shih's moonlight excursion to the Red Cliff with two friends on a winter night, similar to one they had made three months before. They enjoyed a picnic at the base of the Cliff, after which Su climbed to the top alone. He was saddened by the strange and wild sound of the wind and descended. The three friends floated with the current in a small boat and saw a single crane fly by. In Su's dream after returning home, a Taoist priest appeared as the transformation of the crane. The two sections of the handscroll illustrate: first, Su Shih carrying fish and wine from his home on the way to meet his friends; and second, Su and his two friends at the picnic, with two boy servants in attendance (one hidden behind the rock).

SOUTHERN SUNG (1127–1279)

9. FAN CH'ENG-TA (1126–1193).
Colophon to "Fishing Village at Mt. Hsi-sai."
Ink on silk; handscroll. [pages 26 & 27]
15⅞ in. x 9 ft. 15/16 in. (40.3 x 276.7 cm.)
Signed and dated by the artist, 1185, with five seals.

COLOPHONS: eleven colophons follow Fan's.
COLLECTORS' SEALS: numerous, including those of Liang Ch'ing-piao (1620–1691) and Chang Ta-ch'ien (contemporary).

Note: The painting, in ink and color on silk, was done by an unknown artist commissioned by Li Chieh, a friend of Fan Ch'eng-ta. Li asked Fan and other friends to write colophons in celebration of his retreat at Hsi-sai. According to one of the other colophons, the picture of the villa portrayed Li's dream place, not yet an actuality.

10. A SOUTHERN SUNG EMPEROR (12TH–13TH CENTURY).
Couplet by Han Yü. Ink on silk; round fan mounted as an album leaf. [page 28]
8⅜ x 8¼ in. (21.3 x 21 cm.)
Unsigned.

COLLECTORS' SEALS: nine—three of P'an Cheng-wei (1791–1850), four of JMC and two unidentified.

Note: The emperor may be Ning-tsung (r. 1195–1224). Han Yü (768–824) is a great essayist and poet of the T'ang dynasty.

11. A SOUTHERN SUNG EMPEROR (13TH CENTURY).
A Seven-word [per line] *Poem by Meng Hao-jan.* Ink on silk; round fan mounted as an album leaf. [page 29]
9 x 9⅝ in. (22.9 x 24.7 cm.)
Unsigned; one imperial seal.

COLLECTORS' SEALS: ten, including those of An Ch'i (1683–after 1742) and P'an Cheng-wei (1791–1850).

Note: The emperor is most likely Li-tsung (r. 1225–1264). Meng Hao-jan (689–ca. 740) is a major T'ang poet known for his lyrical verse about fields and gardens.

12. ANONYMOUS (12TH CENTURY).
River Hamlet. Ink and color on silk; round fan mounted as an album leaf. [page 30]
9½ x 10 in. (24.3 x 25.4 cm.)
Unsigned.

COLOPHON: Wang To (1592–1652), dated 1650;

he attributed this painting to Yen Wen-kuei (967–1044).

COLLECTORS' SEALS: four—one of a descendant of Mu Ying (1345–1392); two of JMC and one unidentified.

13. MA YÜAN (ACTIVE 1180–1230).
Plum Blossoms by Moonlight. Ink and color on silk; round fan mounted as an album leaf. [page 31]
9⅞ x 10½ in. (25 x 26.8 cm.)
Signed by the artist, undated.

COLLECTORS' SEALS: two of JMC.

14. LIANG K'AI (ACTIVE EARLY 13TH CENTURY).
Strolling by a Marshy Bank. Ink on silk; round fan mounted as an album leaf. [page 32]
8⅞ x 9¼ in. (22.5 x 23.9 cm.)
Signed by the artist, undated.

COLLECTORS' SEALS: two of JMC.

15. ANONYMOUS (13TH CENTURY). ATTRIBUTED TO LI T'ANG (CA. 1050–AFTER 1130).
Gentlemen Gazing at a Waterfall. Ink and color on silk; round fan mounted as an album leaf. [page 33]
9⅞ x 10⅛ in. (25.2 x 25.8 cm.)
Unsigned.

COLLECTORS' SEALS: three of JMC.

16. ANONYMOUS (13TH CENTURY). ATTRIBUTED TO LIU SUNG-NIEN (LATE 12TH CENTURY).
Evening in the Spring Hills. Ink and color on silk; round fan mounted as an album leaf. [page 34]
9¾ x 10¼ in. (24.8 x 26.1 cm.)
Unsigned.

COLLECTORS' SEALS: two of JMC.

17. ANONYMOUS (13TH CENTURY). ATTRIBUTED TO YEN TZ'U-YÜ (SECOND HALF 12TH CENTURY).
Boats Moored in Wind and Rain. Ink and color on silk; round fan mounted as an album leaf. [page 35]
9¾ x 10¼ in. (24.8 x 26.1 cm.)
Unsigned.

COLLECTORS' SEALS: two of JMC.

18. ANONYMOUS (13TH CENTURY).
Monk Riding a Mule. Ink on paper; hanging scroll. [pages 36 & 37]
25¼ x 13 in. (64.1 x 33 cm.)
Unsigned.

COLOPHON: Monk Wu-chun (ca. 1175–1249) with one seal.

COLLECTORS' SEALS: three of JMC.

Note: It is possible that Wu-chun not only inscribed the painting but also painted it.

19. ANONYMOUS (13TH CENTURY). ATTRIBUTED TO LI KUNG-LIN (CA. 1040–1106).
Odes of Pin (Occupations of the Months). Ink on paper; handscroll. [pages 38–41]
8⅜ in. x 45 ft. (21.3 x 1371 cm.)
Unsigned.

COLOPHONS: (1) Anonymous—title "Pin-feng t'u" as frontispiece; (2) Tung Ch'i-ch'ang (1555–1636), 1627, with one seal.

COLLECTORS' SEALS: sixty-five, including those of Wang Kou (1245–1310), Wang Shih-min (1592–1680), Liang Ch'ing-piao (1620–1691), An Ch'i (1683–after 1742), Emperor Ch'ien-lung (r. 1736–1795), Emperor Chia-ch'ing (r. 1796–1820) and Emperor Hsüan-t'ung (r. 1909–1911).

Note: These odes were written by an anonymous poet in the Western Chou period, between the 11th and the 8th centuries B.C. This painting illustrates every segment of the odes except the first two, indicating that the beginning is missing. On the whole, the *Odes of Pin* concern the occupations of the months for workers serving their lord—farming, weaving, winemaking, hunting and house repairing. The two sections of the long handscroll reproduced here are: first, workmen pruning the mulberry trees, the leaves of which are used to feed the silkworms; and second, crickets going under the bed, a sign of the beginning of cold weather.

20. YEH-LÜ CH'U-TS'AI (1190–1244).
A Seven-word Poem. Ink on paper; handscroll. [pages 42 & 43]
14⅜ in. x 9 ft. 3⅛ in. (36.5 x 282.3 cm.)
Signed and dated by the artist, 1240.

COLOPHONS: (1) Sung Lien (1310–1381) with three seals; (2) Li Shih-cho (18th century), 1743, with two seals; (3) Tai Liang (1317–1383), 1349, with four seals; (4) Li Shih-cho, a comment; (5) Cheng T'ao (14th century), 1352; (6) Kung Su (1266–1331), 1321, with two seals; (7) Li Shih-cho with one seal; (8) Yüan Li-chun (1875–1936), 1934, with two seals; (9) Teng Pang-shu (20th century), 1936, with three seals.

COLLECTORS' SEALS: twenty-three, including those of Liu Ching-an (14th century?) and Chin Ch'eng (19th to 20th centuries).

Note: Yeh-lü Ch'u-ts'ai wrote the poem for Liu Man, who requested it at his departure for a new post. Yeh-lü, a noble statesman as well as a great calligrapher, praised Liu for his administrative ability. Reproduced here is the last line and a half of the poem, mentioning Liu's fame as a good official, as high as Mount T'ai in Shantung province.

YÜAN (1279–1368)

21. CHAO MENG-FU (1254–1322).
Groom and Horse (First Section of "Men and Horses by Three Generations of the Chao Family"). Ink and color on paper; handscroll. [pages 44 & 45]

11⅞ in. x 5 ft. 9¾ in. (30.3 x 177.2 cm.) for all three sections.

Signed and dated by the artist, 1296, with one seal.

COLOPHONS: (1) Shen Ta-nien, 1403, with three seals; (2) Hu Ch'eng, 1405, with three seals; (3) Ch'en An with four seals; (4) Tsou Hui with three seals; (5) Monk Shan-chu with four seals; (6) Liu Yo; (7) Li Chü-kung with three seals; (8) Yüan Heng, 1425, with three seals (the eight foregoing writers were men of the 14th to 15th centuries); (9) Ch'en Hung-shou (1599–1652) with two seals.

COLLECTORS' SEALS: forty-three, including those of An Ch'i (1683–after 1742), Emperor Ch'ien-lung (r. 1736–1795), Emperor Chia-ch'ing (r. 1796–1820), Emperor Hsüan-t'ung (r. 1909–1911) and Chang Ta-ch'ien (contemporary).

22. CHAO MENG-FU (1254–1322).
 A Summer Idyll (Quatrain). Ink on silk; hanging scroll. [pages 46 & 47]
 4 ft. 4⅛ in. x 20 13/16 in. (132.5 x 52.9 cm.)
 Unsigned, two seals of the artist.

 COLOPHON: Sa-ying-a (d. 1857), 1855, with one seal; a title slip by Prince Yung-hsing (1752–1823).

 COLLECTORS' SEALS: thirteen, including those of Ch'eng Yao-t'ien (1725–1814) and Chang Ta-ch'ien (contemporary).

23. HSIEN-YÜ SHU (1257?–1302).
 The Song of the Stone Drums by Han Yü. Ink on paper; handscroll. [pages 48 & 49]
 17⅝ in. x 11 ft. 11½ in. (44.8 x 364.7 cm).
 Signed and dated by the artist, 1301, with two seals.

 COLOPHONS: (1) Hsiang Yüan-pien (1525–1590); (2) Kao Shih-ch'i (1645–1704), 1699, with three seals; (3) Hsiang Yüan (19th century), 1831, with two seals; (4) Shen Yin-mo (1882–1968), 1938, with one seal.

 COLLECTORS' SEALS: numerous, including those of Hsiang Yüan-pien, Wang Shih-min (1592–1680), Chang Heng (1915–1963) and T'an Ching (20th century).

 Note: Han Yü (768–824) extolled the symbolic significance of the Stone Drums, which bore inscriptions he thought dated back to the time of King Hsüan of Chou (reigned 827–782 B.C.), who restored the power and dignity of the ruling house. According to modern scholar Chang Kuang-yüan, the inscriptions were engraved ca. 768 B.C. in the western state of Ch'in, which eventually united China and founded a new dynasty in 221 B.C.

24. WU CHEN (1280–1354).
 Fisherman. Ink on paper; handscroll. [pages 50 & 51]
 9¾ x 17 in. (24.8 x 43.2 cm.)
 Signed and inscribed (a poem) by the artist with two seals.

COLLECTORS' SEALS: seventeen, including those of Keng Chao-chung (1640–1687), Emperor Ch'ien-lung (r. 1736–1795) and Chang Ta-ch'ien (contemporary).

25. T'ANG TI (1296–CA. 1364).
 The Pavilion of Prince T'eng. Ink on paper; handscroll. [pages 52 & 53]
 10¾ in. x 33¼ in. (27.3 x 84.4 cm.)
 Signed and dated by the artist, 1352, with one seal.

 COLOPHONS: (1) Yeh Kung-ch'o (1880–1968), 1940, with one seal, a frontispiece preceding the painting; (2) Chang Ta-ch'ien (contemporary), 1939, with two seals.

 COLLECTORS' SEALS: seventeen, including those of Keng Chao-chung (1640-1687) and Prince Yin-hsiang (1686–1730).

 Note: The Pavilion of Prince T'eng is in central China (present-day Kiangsi province), facing the Yangtze River. It was built by Prince T'eng of the T'ang dynasty in the mid-7th century, when he governed the region. Poet Wang Po (649–676) wrote a famous poem and preface at a party given in the Pavilion by a succeeding governor. He expressed a feeling of loneliness among the pleasure-seeking crowd and the thought that people change but time and the river flow on forever. This poem has become a favorite theme for painters and calligraphers ever since.

26. NI TSAN (1301–1374).
 Wind among the Trees on the Stream Bank. Ink on paper; hanging scroll. [pages 54 & 55]
 23½ x 12½ in. (59 x 31 cm.)
 Signed, dated and inscribed (a poem) by the artist, 1363.

 COLOPHON: Yü Hang (18th to 19th centuries), 1826.

 COLLECTORS' SEALS: twenty-three, including those of Sung Lien (1310–1381), Hsiang Yüan-pien (1525–1590), Sun Ch'eng-tse (1592–1676), Kao Shih-ch'i (1645–1704), Wang Shu (1668–1739) and Miao Yüeh-tsao (1682–1761).

27. SUNG K'O (1327–1387).
 A Seven-word Poem. Ink on gold-flecked paper; handscroll. [pages 56 & 57]
 10½ x 27¼ in. (26.7 x 69.2 cm.)
 Signed by the artist.

 COLLECTORS' SEALS: fourteen, including those of Miao Yüeh-tsao (1682–1761) and K'ung Kuang-t'ao (mid-19th century).

 Note: The poem, most likely composed by the calligrapher, describes his recluse life with children and grandchildren in a country house without outside intrusions.

28. ANONYMOUS (14TH CENTURY?). ATTRIBUTED TO WANG CHEN-P'ENG (ACTIVE EARLY 14TH CENTURY).
 The Ta-ming Palace. Ink on paper; handscroll. [pages 58 & 59]

12⅛ in. x 21 ft. 11 in. (30.6 x 668 cm.)
A spurious signature of Wang Chen-p'eng, dated 1312, with one seal.

COLOPHONS: (1–3) Huang Yüeh (1751–1841), 1831, 1834 and 1839, with a total of six seals; (4) Hsiang Kuan (19th to 20th centuries), 1903, with three seals.

COLLECTORS' SEALS: fourteen.

MING (1368–1644)

29. ANONYMOUS (EARLY 15TH CENTURY). ATTRIBUTED TO LI T'ANG (CA. 1050–AFTER 1130).
Mountain Landscape—the Four Seasons. Ink and slight color on silk; handscroll. [pages 60–63]
13¾ in. x 18 ft. 8¾ in. (34.9 x 570.9 cm.)
Spurious signature of Li T'ang.

COLOPHONS: (1) Lo Chen-yü (1866–1940) with two seals; (2) Nagao Kinoe (N. Uzan, 1864–1942) with two seals; (3) Chang Ta-ch'ien (contemporary).

COLLECTORS' SEALS: ten—two of JMC, all others unidentified.

30. SHEN CHOU (1427–1509).
Silent Angler in an Autumn Wood. Ink and slight color on paper; hanging scroll. [pages 64 & 65]
4 ft. 11 in. x 24 in. (150.2 x 62.7 cm.)
Signed, dated and inscribed (a poem) by the artist, 1475.

COLLECTORS' SEALS: eleven, including five of Chang Ta-ch'ien (contemporary).

31. CHU YÜN-MING (1461–1527).
Prose Poem on Fishing. Ink on gold-flecked paper; handscroll. [pages 66 & 67]
12⅞ in. x 26 ft. 9¼ in. (32.7 x 816.5 cm.)
Signed and dated by the artist, 1507, with three seals.

COLLECTORS' SEALS: three of JMC.

Note: This prose poem was written by Sung Yü (3rd century B.C.), who compared the art of governing to that of fishing.

32. WEN CHENG-MING (1470–1559).
Summer Retreat in the Eastern Grove. Ink on paper; handscroll. [pages 68 & 69]
12½ in. x 3 ft. 6½ in. (31.8 x 107.8 cm.)
Signed by the artist with one seal, ca. 1512.

COLOPHONS: (1) Wu I (1472–1519), title of this painting in seal script, frontispiece; (2) Wen Cheng-ming, a series of three poems; (3 & 4) Wen Cheng-ming, the latter one dated 1515 with two seals; also four more of Wen's seals on seams; (5) P'an Po-ying (20th century) with two seals.

COLLECTORS' SEALS: sixteen, including those of three emperors—Ch'ien-lung (r. 1736–1795), Chia-ch'ing (r. 1796–1820) and Hsüan-t'ung (r. 1909–1911).

33. WEN CHENG-MING (1470–1559).
The Art of Letters. Ink on paper; handscroll. [pages 70 & 71]
9⅛ in. x 3 ft. 10¼ in. (23.2 x 117.5 cm.)
Signed and dated by the artist, 1544–1547, with two seals.

COLOPHONS: (1) Lu Shih-tao (active ca. 1522–1566) with one seal; (2) Wang Shu (1668–1743), 1727, a twin seal; (3) Chiang Heng (1672–1743) with one seal; (4) Liang Chang-chü (1775–1849), a twin seal.

COLLECTORS' SEALS: fifteen, including three of Ch'en Tsun (18th to 19th centuries) and one of Jean-Pierre Dubosc (contemporary).

Note: The Art of Letters is a prose poem written by Lu Chi (261–303).

34. WEN CHENG-MING (1470–1559).
Magnolia. Color on paper; handscroll. [pages 72 & 73]
11 in. x 4 ft. 4¼ in. (28 x 132.5 cm.)
Signed and dated by the artist, 1549, with two seals.

COLOPHONS: (1) Wen Cheng-ming's letter to Hua Yün (1488–1560), to whom he sent this painting as a gift; (2) Ho Kuan-wu (contemporary), 1957, with one seal.

COLLECTORS' SEALS: twenty-seven, including one each of Hua Hsia (16th century), Wang Shih-chen (1526–1590) and Chu I-tsun (1629–1709).

35. T'ANG YIN (1470–1523).
Drunken Fisherman by a Reed Bank. Ink on paper; hanging scroll. [pages 74 & 75]
28½ x 14½ in. (72.4 x 36.8 cm.)
Signed and inscribed (a poem) by the artist with two seals.

COLLECTORS' SEALS: ten, including one of Wu Hu-fan (1894–1968) and four of Chang Ta-ch'ien (contemporary).

36. T'ANG YIN (1470–1523).
Ink-bamboo. Ink on paper; handscroll. [pages 76–79]
11¼ in. x 4 ft. 11 in. (28.6 x 149.9 cm.)
Signed and inscribed (a poem) by the artist with two seals.

COLLECTORS' SEALS: six—two of Ho Kuan-wu (contemporary), three of JMC and one unidentified.

37. WU I (1472–1519).
Enjoying the Pines. Ink on gold-flecked paper; handscroll frontispiece. [pages 80 & 81]
12½ x 35¼ in. (32.1 x 89.4 cm.)
Signed by the artist with one seal.

COLLECTORS' SEALS: two, unidentified.

38. CH'IU YING (PROBABLY 1494/5–1552).
Fisherman's Flute Heard over the Lake. Ink and color on paper; hanging scroll. [pages 82 & 83]

5 ft. 2⅞ in. x 33⅛ in. (159.8 x 84.1 cm.)
Signed by the artist with two seals.

COLLECTORS' SEALS: eight, including three of Chang Ta-ch'ien (contemporary).

39. WANG CH'UNG (1494–1533).
Letter to Nan-ts'un. Ink on paper; album leaf. [pages 84 & 85]
10⅛ x 13⅜ in. (25.7 x 34 cm.)
Signed by the artist.

COLLECTORS' SEALS: four—two of JMC, two unidentified.

40. LU CHIH (1496–1576).
Brocaded Sea of Peach-blossom Waves. Ink and color on gold paper; folding fan mounted as an album leaf. [pages 86 & 87]
6½ x 18⅜ in. (16.2 x 46.7 cm.)
Signed by the artist with one seal.

COLLECTORS' SEALS: two of JMC.

41. WEN PO-JEN (1502–1575).
Dwellings of the Immortals amid Streams and Mountains. Ink and color on paper; hanging scroll. [pages 88–91]
5 ft. 10 in. x 24¾ in (177.7 x 62.8 cm.)
Signed and dated by the artist, 1531, with two seals; title inscription also by the artist.

COLLECTORS' SEALS: nine—two of JMC, seven unidentified.

42. HOU MOU-KUNG (FL. CA. 1540–1580).
High Mountains. Ink and light color on paper; hanging scroll. [pages 92 & 93]
3 ft. 10½ in. x 11 in. (118.1 x 27.9 cm.)
Signed and dated by the artist, 1569, with two seals.

COLLECTORS' SEALS: three of JMC.

43. TUNG CH'I-CH'ANG (1555–1636).
Poem by Wang Wei. Ink on paper; hanging scroll. [pages 94 & 95]
6 ft. 3 in. x 29⅜ in. (189.3 x 74.4 cm.)
Signed by the artist with three seals.

COLLECTORS' SEALS: seven, including three of Chu Hsin-chai (20th century) and one of Alice Boney (contemporary).

Note: Wang Wei (699–759) excelled in both poetry and painting. He was considered by Tung Ch'i-ch'ang as the founder of the Southern School. This short verse was inspired by the departure of Wang's friend on the mountain at dusk, the poet wondering whether his friend would be back when the grass turned green again.

44. TUNG CH'I-CH'ANG (1555–1636).
Landscape with Trees, after Ni Tsan. Ink on paper; hanging scroll. [pages 96 & 97]

3 ft. 9½ in. x 18 in. (115.6 x 45.8 cm.)
Signed by the artist with two seals.

COLOPHONS: (1) Ch'en Chi-ju (1558–1639) with two seals; (2) Wang Wen-chih (1730–1802), 1786, with two seals.

COLLECTORS' SEALS: three of JMC.

Note: Ni Tsan (1301–1374) was one of the Four Yüan Masters. See item 26.

45. CHANG JUI-T'U (1570–1641).
Ode on the Red Cliff, Part II. Ink on silk (satin weave); handscroll. [pages 98 & 99]
11 in. x 10 ft. 6 in. (27.9 x 320 cm.)
Signed and dated by the artist, 1628, with two seals.

COLOPHONS: (1) Chang Jui-t'u, irregular poem (*tz'u*) entitled "Nostalgia for the Past at the Red Cliff" by Su Shih (1036–1101), who also wrote the "Ode on the Red Cliff"; Chang transcribed this poem with a short note dated 1629 and two seals; (2) Nagao Kinoe (N. Uzan, 1864–1942), 1921, with two seals.

COLLECTORS' SEALS: three.

Note: See item 8, a much earlier painting illustrating the same ode.

46. CHANG JUI-T'U (1570–1641).
Couplet. Ink on paper; a pair of hanging scrolls. [pages 100 & 101]
9 ft. 2½ in. x 18 in. (280.7 x 45.7 cm.) each.
Signed by the artist with two seals.

COLLECTORS' SEALS: five—one of Chu Hsin-chai (20th century), two of Alice Boney and two of JMC.

CH'ING (1644–1911)

47. WANG SHIH-MIN (1592–1680).
Landscape after Huang Kung-wang. Ink and color on paper; folding fan mounted as an album leaf. [pages 102 & 103]
6 3/16 x 19½ in. (15.6 x 49.8 cm.)
Signed and dated by the artist, 1677, with one seal.

COLLECTORS' SEALS: two of JMC.

Note: Huang Kung-wang (1269–1354) was the first of the Four Yüan Masters.

48. HSIANG SHENG-MO (1597–1658).
Scholar in the Woods. Ink and color on paper; hanging scroll. [pages 104 & 105]
3 ft. 11 in. x 23½ in. (119.3 x 59.8 cm.)
Signed and inscribed (a poem) by the artist with two seals.

COLLECTORS' SEALS: four—one of Alice Boney, three of JMC.

49. FA JO-CHEN (1613–1696).
Discourse on Painting. Ink on paper; handscroll.
[pages 106 & 107]
12¼ in. x 12 ft. 2 in. (28.6 x 370.8 cm.)
Signed and dated by the artist, 1667, with three
seals.

COLLECTORS' SEALS: one of JMC.

50. HUNG-JEN (D. 1663, FORTY-ODD YEARS OLD).
River Scene in Winter. Ink on paper; handscroll.
[pages 108–111]
11¼ in. x 12 ft. 8¼ in. (28.6 x 386.7 cm.)
Signed and dated by the artist, 1661, with three
seals.

COLOPHONS: (1) Chang Ta-ch'ien (contemporary),
title of the painting, 1953, with two seals; (2)
Chang Ta-ch'ien, postscript, 1953, with two seals;
(3) Ts'ao Yüan-chung (unidentified) with one seal;
(4) Tseng Hsi (1861–1930), 1925, with one seal.

COLLECTORS' SEALS: thirty-one, including those of
Mei Ch'ing (1623–1697), Tsou I-kuei (1686–
1772) and Chang Ta-ch'ien.

51. K'UN-TS'AN (ACTIVE 1655–1686).
Wooded Mountains at Dusk. Ink and color on
paper; hanging scroll. [pages 112 & 113]
4 ft. 1 in. x 23⅝ in. (124.4 x 60 cm.)
Signed, dated and inscribed (a poem) by the
artist, 1666, with three seals.

COLLECTORS' SEALS: five—three of JMC, two un-
identified.

52. FAN CH'I (B. 1616, STILL LIVING 1692).
Landscapes. Ink and color on paper; an album of
eight leaves (reproduced here are leaves 4 and 5).
[pages 114 & 115]
6 x 7 7/16 in. (15 x 18.8 cm.) each.
Signed and dated by the artist on the last leaf,
1673, with one seal; two seals on leaf 4 and two seals
on leaf 5.

COLLECTORS' SEALS: A total of ten on the first and
last leaves, including those of Chiang Ku-sun (20th
century) and Ma Chi-tso (contemporary).

53. KUNG HSIEN (CA. 1620–1689).
Wintry Mountains. Ink on paper; hanging scroll.
[pages 116 & 117]
5 ft. 5 in. x 19¼ in. (165.1 x 48.9 cm.)
Signed and inscribed (a poem) by the artist with
one seal.

COLLECTORS' SEALS: ten—three of JMC, the others
unidentified.

54. CHU TA (1626–1705).
Fish and Rocks. Ink on paper; hanging scroll.
[pages 118 & 119]
4 ft. 5 in. x 23⅞ in. (134.6 x 60.6 cm.)
Signed and inscribed (two characters) by the art-
ist with three seals.

COLOPHON: Lo An-hsien (19th century), 1874,
with one seal.

COLLECTORS' SEALS: six—three of Chang Ta-ch'ien
(contemporary) and three of JMC.

55. CHU TA (1626–1705).
Birds in a Lotus Pond. Ink on silk (satin weave);
handscroll. [pages 120–122]
10⅜ in. x 6 ft. 8¾ in. (27.2 x 205.1 cm.)
Signed and inscribed (four characters) by the art-
ist with three seals.

COLLECTORS' SEALS: nine, including four of Chang
Ta-ch'ien (contemporary) and three of JMC.

56. CHU TA (1626–1705).
*After "The Preface to the Orchid Pavilion Gath-
ering."* Ink on paper; hanging scroll. [page 123]
18½ x 10⅛ in. (47 x 25.7 cm.)
Signed by the artist with two seals.

COLLECTORS' SEALS: three of JMC.

Note: Wang Hsi-chih, on the occasion of a liter-
ary gathering at the Orchid Pavilion, sensed a deep
sorrow for man's fleeting existence. With wine flow-
ing from the cups floating down the stream and the
sound of poetry filling the air, he longed for the an-
cients and asked the future generations to remember
this event. Chu Ta inscribed only an excerpt from
Wang's essay: the section describing the fine spring
day and the delights of the moment.

57. WANG HUI (1632–1717).
Clearing after Rain over Stream and Hills. Ink on
paper; hanging scroll. [pages 124 & 125]
3 ft. 8½ in. x 17¾ in. (113 x 45.1 cm.)
Signed, dated and inscribed (the title) by the art-
ist, 1662, with one seal.

COLLECTORS' SEALS: four—one of Chang Ta-ch'ien
(contemporary) and three of JMC.

58. WANG HUI (1632–1717).
Mountain after Rain Passes. Ink and light color
on paper; folding fan mounted as an album leaf.
[pages 126 & 127]
6 7/16 x 19⅜ in. (17.3 x 50.2 cm.)
Signed, dated and inscribed (a poem) by the
artist, 1695, with one seal.

COLLECTORS' SEALS: three—two of JMC, one un-
identified.

59. YÜN SHOU-P'ING (1633–1690).
After Three Rubbings. Ink on paper; folding fan
mounted as an album leaf. [pages 128 & 129]
6 11/16 x 20 in. (17 x 50.8 cm.)
Signed and dated by the artist, 1680, with two
seals.

COLLECTORS' SEALS: three—one of Lin Hsiung-
kuang (d. 1971) and two of JMC.

Note: Ink rubbings from stone engravings of an-
cient calligraphy have long served as examples for
studying and copying.

60. YÜN SHOU-P'ING (1633–1690).
Two Garden Plants. Color on paper; folding fan mounted as an album leaf. [pages 130 & 131]
6 11/16 x 20 in. (17 x 50.8 cm.)
Signed by the artist with two seals.

COLLECTORS' SEALS: seven, including several of K'ung Kuang-t'ao (mid-19th century).

Note: The two plants are *Amarantus gangeticus,* called by the Chinese "old youth," and *Dianthus chinensis,* a species of pink, or carnation.

61. TAO-CHI (1641–CA. 1717).
Five Poems. Ink on paper; folding fan mounted as an album leaf. [pages 132 & 133]
6⅞ x 17½ in. (17.4 x 44.5 cm.)
Signed by the artist with two seals.

COLLECTORS' SEALS: four—one of Ho Kuan-wu (contemporary), two of JMC, one unidentified.

Note: Tao-chi here copies for Shü Huang five poems that he had composed in the past. The first two deal with the poverty of an artist's life, such as the shortage of firewood and rice in the depth of winter but also the pleasures of painting and poetry. The third was written for Mei Ch'ing (1623–1697), a famous painter and the brother of Mei Keng, to whom this fan was given. The fourth and fifth were written for other friends, expressing admiration for their accomplishments in the arts.

62. TAO-CHI (1641–CA. 1717).
Landscape on a Gold-paper Fan. Ink and color on gold paper; folding fan mounted as an album leaf. [pages 134 & 135]
6⅞ x 17½ in. (17.4 x 44.5 cm.)
Signed, dated and inscribed (a poem) by the artist, 1699, with two seals.

COLLECTORS' SEALS: seven, including one of P'an Cheng-wei (1791–1850).

63. WANG YÜAN-CH'I (1642–1715).
Fishing in a River in Blossoming Time. Ink and color on paper; handscroll. [pages 136 & 137]
10¼ in. x 4 ft. 9½ in. (26 x 145.5 cm.)
Signed and dated by the artist, 1709, with one seal.

COLOPHONS: (1) Wang Yüan-ch'i with three seals; (2) Weng Wan-go (contemporary), with two seals.
COLLECTORS' SEALS: six—two of Jean-Pierre Dubosc (contemporary), three of JMC, one unidentified.

64. WANG YÜAN-CH'I (1642–1715).
Summer Mountains. Ink on paper; hanging scroll. [pages 138 & 139]
3 ft. 4 in. x 18 in. (93.8 x 45.6 cm.)
Signed, dated and inscribed (a comment) by the artist, 1713, with three seals.

COLLECTORS' SEALS: four—one of Alice Boney, two of JMC, one unidentified.

65. KAO FENG-HAN (1683–1748).
Chrysanthemums by the Rock. Ink and slight color on paper; hanging scroll. [pages 140 & 141]
3 ft. 9¾ in. x 21½ in. (115 x 54.7 cm.)
Signed and inscribed (a poem) by the artist with three seals.

COLLECTORS' SEALS: two of JMC.

66. CHIN NUNG (1687–1764).
Three Poems. Ink on paper; folding fan mounted as an album leaf. [pages 142 & 143]
6⅝ x 18 in. (17.1 x 45.7 cm.)
Signed and dated by the artist, 1750, with four seals.

COLLECTORS' SEALS: two of JMC.

Note: The first poem may be the calligrapher's own composition; the second was written by Cheng Ku (9th century); the third, in lines of unequal length called *tz'u* form and containing two verses, was written by Yao Kuang-hsiao (1335–1419). They are word-pictures of (1) a night scene of a lonely bridge and an empty pavilion; (2) a rainy landscape with a fisherman in a grass cloak returning to shore; and (3) a river landing in early spring flanked by a new bridge and weeping willows (in the first verse), and a mountain path in the woods with returning travelers and birds at dusk (in the second verse).

67. CHIN NUNG (1687–1764).
Blossoming Prunus. Ink on paper; hanging scroll. [pages 144 & 145]
4 ft. ⅞ in. x 16⅞ in. (124.1 x 42.9 cm.)
Signed, dated and inscribed (a comment) by the artist, 1759, with one seal.

COLOPHON: Chu Hsiu-tu (1732–1812), 1804, with one seal.
COLLECTORS' SEALS: five, one of Ma Chi-tso (contemporary), three of JMC and one unidentified.

68. LI SHAN (1686– CA. 1762).
Bamboo and Calligraphy. Ink on paper; hanging scroll. [pages 146 & 147]
4 ft. 4 in. x 29¼ in. (132.4 x 74.1 cm.)
Signed, dated and inscribed (a long poem) by the artist, 1749, with two seals.

COLLECTORS' SEALS: four—one of Hsü Tsan-fu (dates unknown) and three of JMC.

69. CHENG HSIEH (1693–1765).
Orchids on Rocks. Ink on paper; hanging scroll. [pages 148 & 149]
4 ft. 7¼ in. x 14⅝ in. (140.4 x 37.2 cm.)
Signed and inscribed (a poem) by the artist with three seals.

COLLECTORS' SEALS: two—one of Alice Boney and one of JMC.

1 Anonymous (Northern Sung period, 960–1127), *Light Snow on the Mountain Pass.*

北宋人関山蒲雪畚

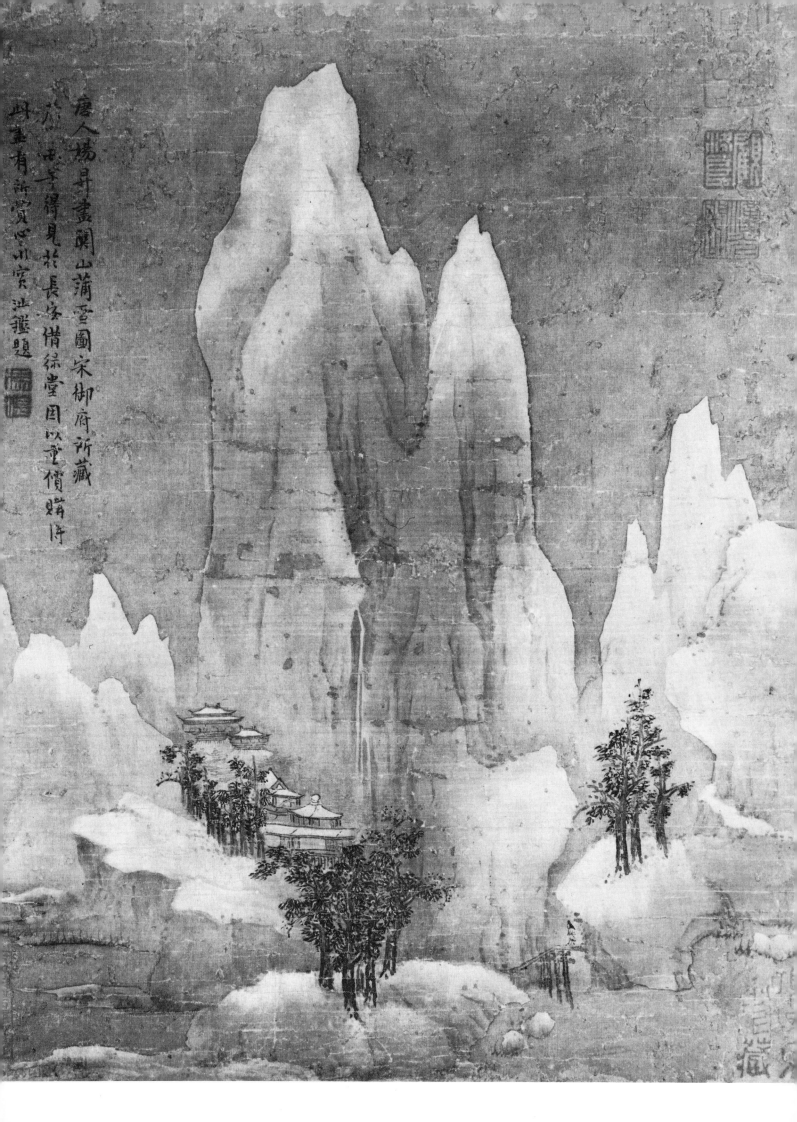

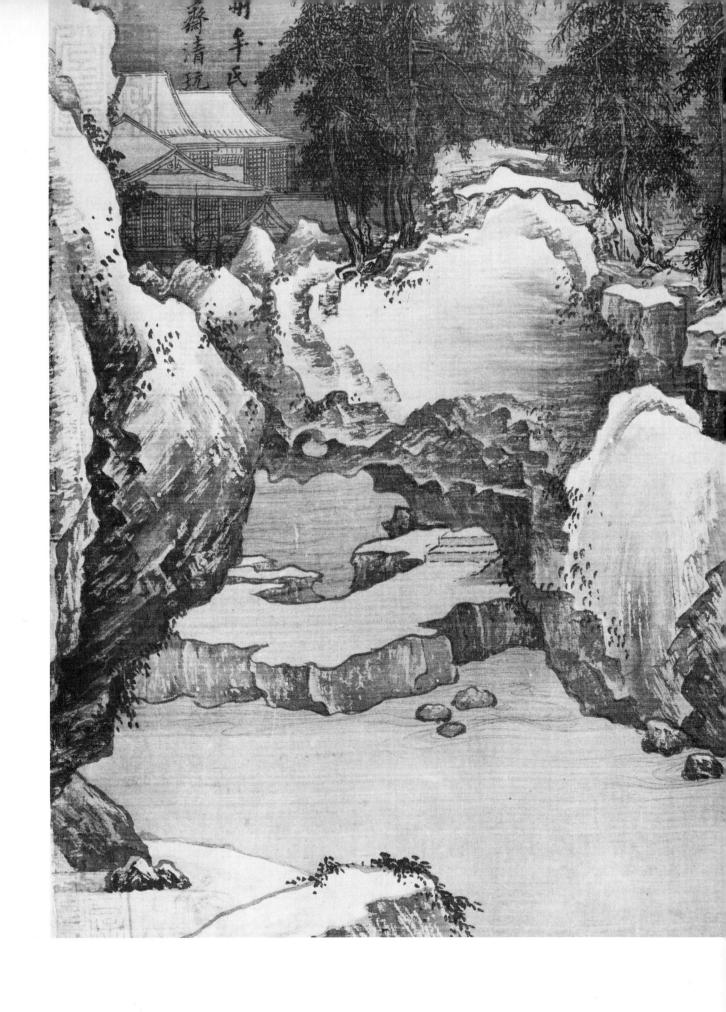

2a Kao K'o-ming (b. ca. 980, still living 1049),
Streams and Hills under Fresh Snow.
Last section of handscroll.

高克明溪山雲意畫卷

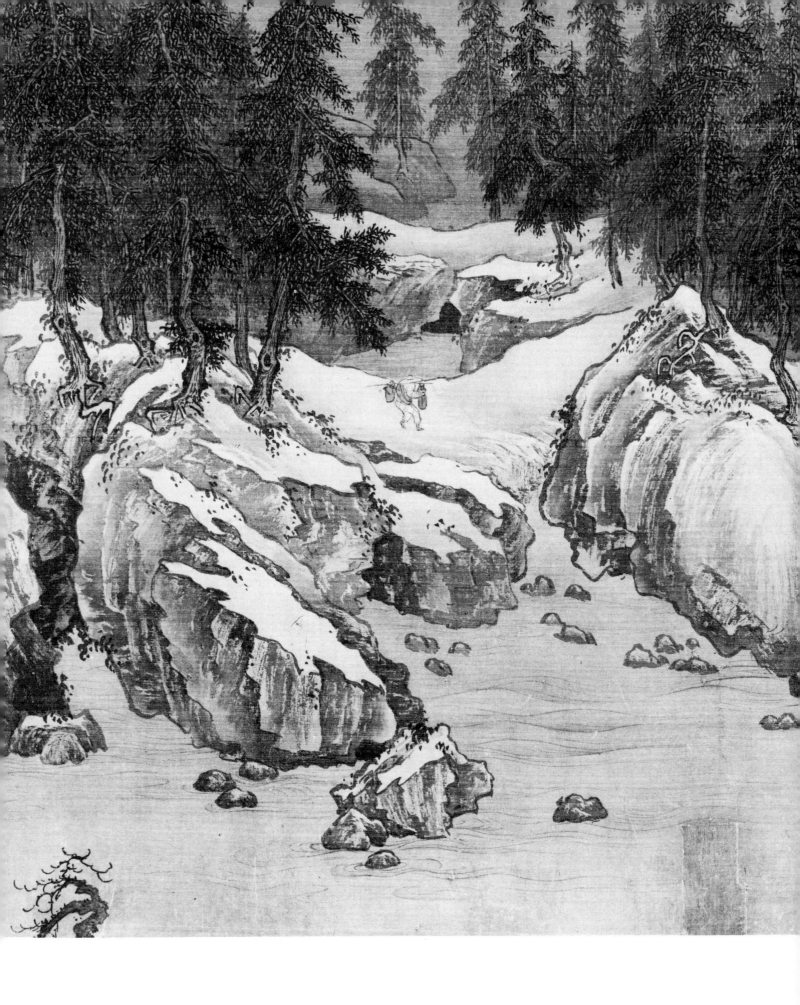

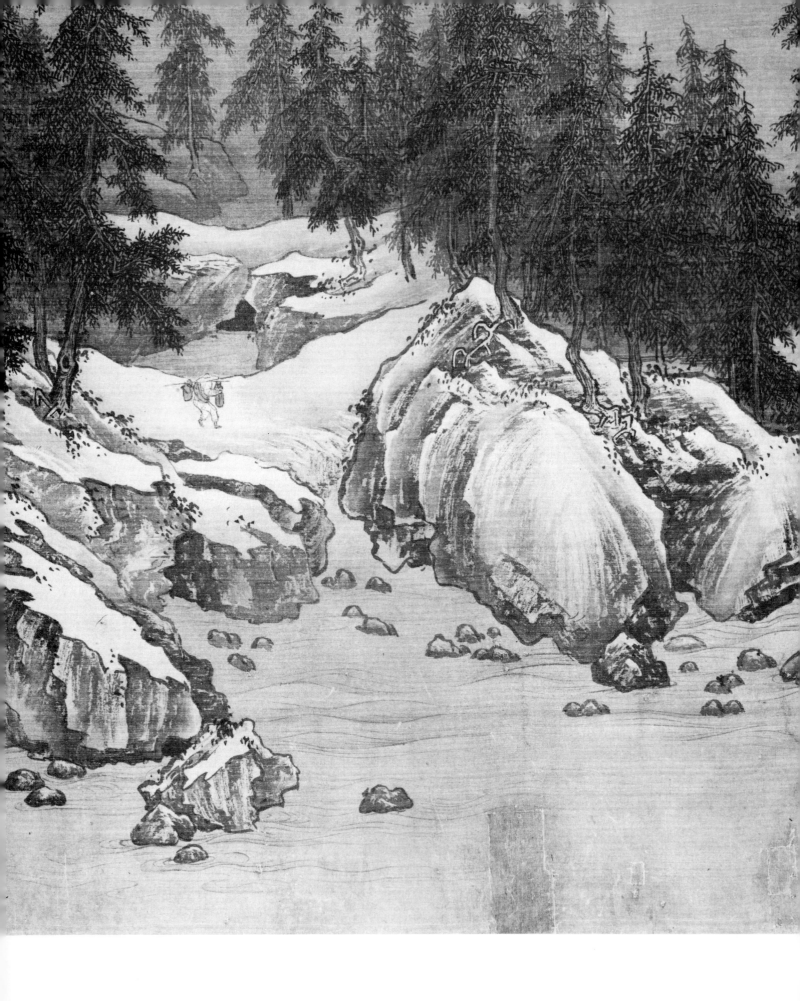

2b Kao K'o-ming (b. ca. 980, still living 1049),
Streams and Hills under Fresh Snow.
Section of handscroll.

高克明溪山雪意畫卷

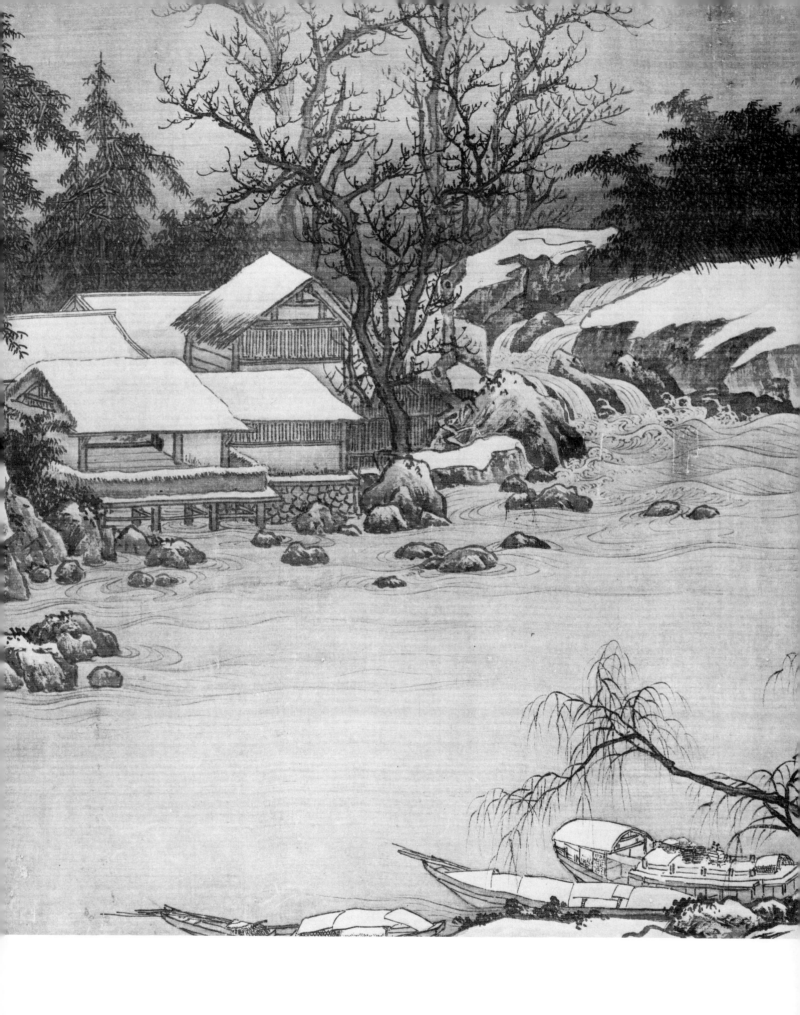

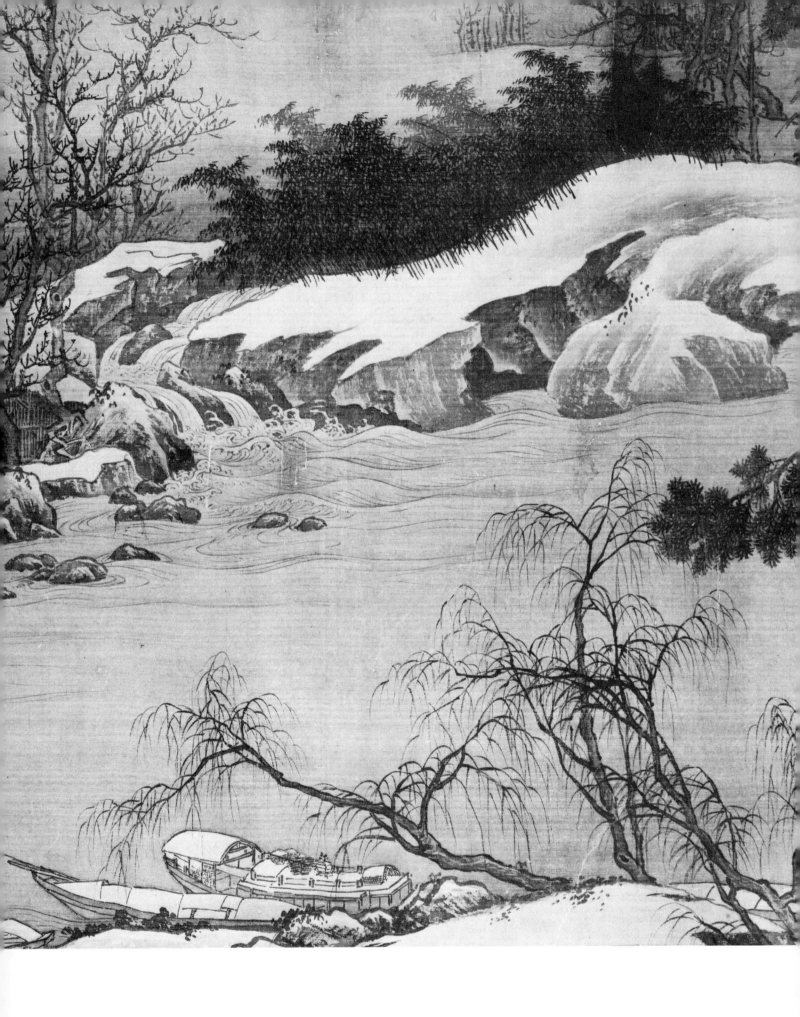

2c　Kao K'o-ming (b. ca. 980, still living 1049),
Streams and Hills under Fresh Snow.
Section of handscroll.

高克明溪山雪意畫卷

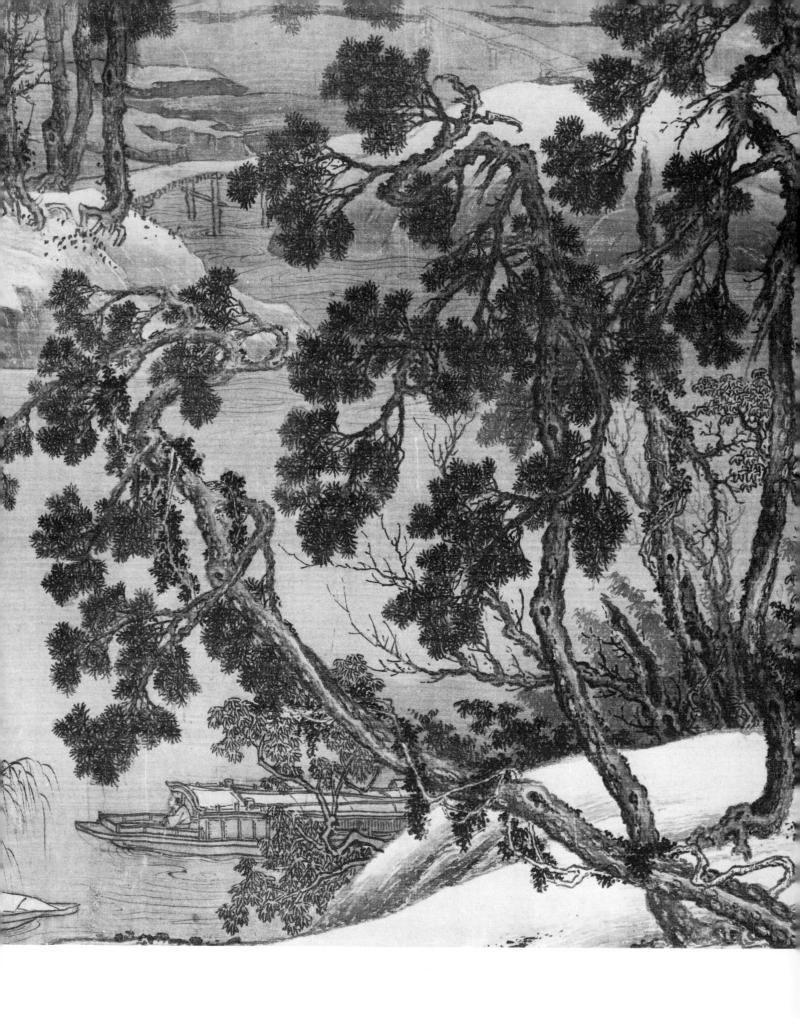

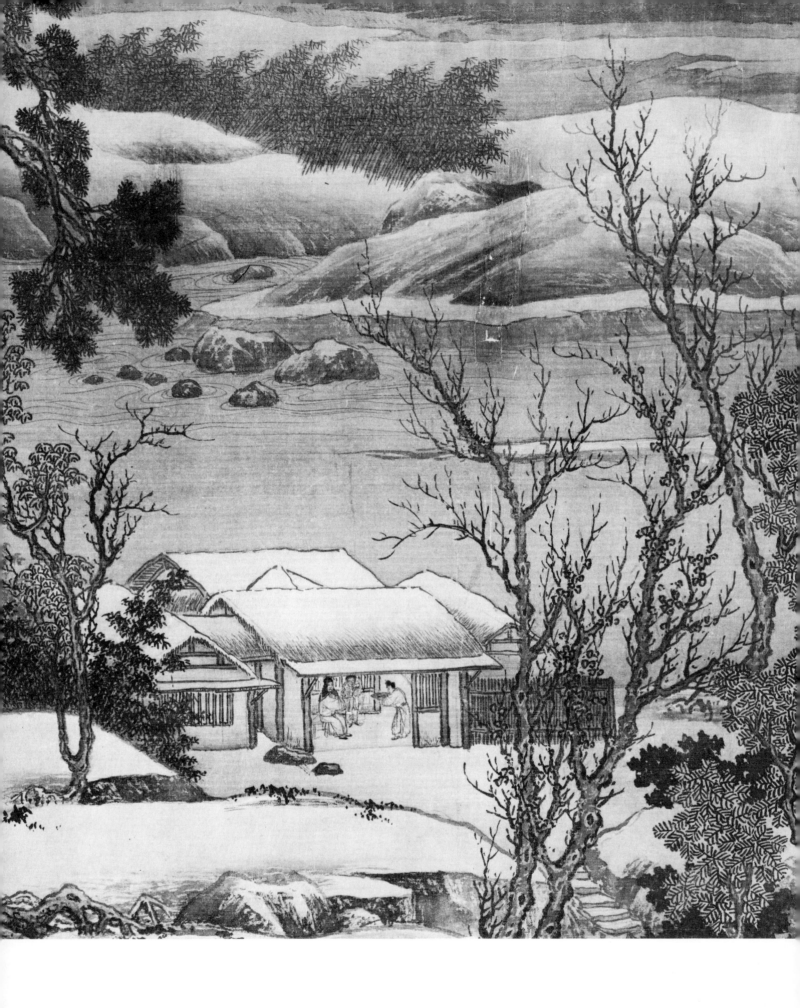

2d Kao K'o-ming (b. ca. 980, still living 1049),
Streams and Hills under Fresh Snow.
First section of handscroll.

高克明溪山雪意畫卷

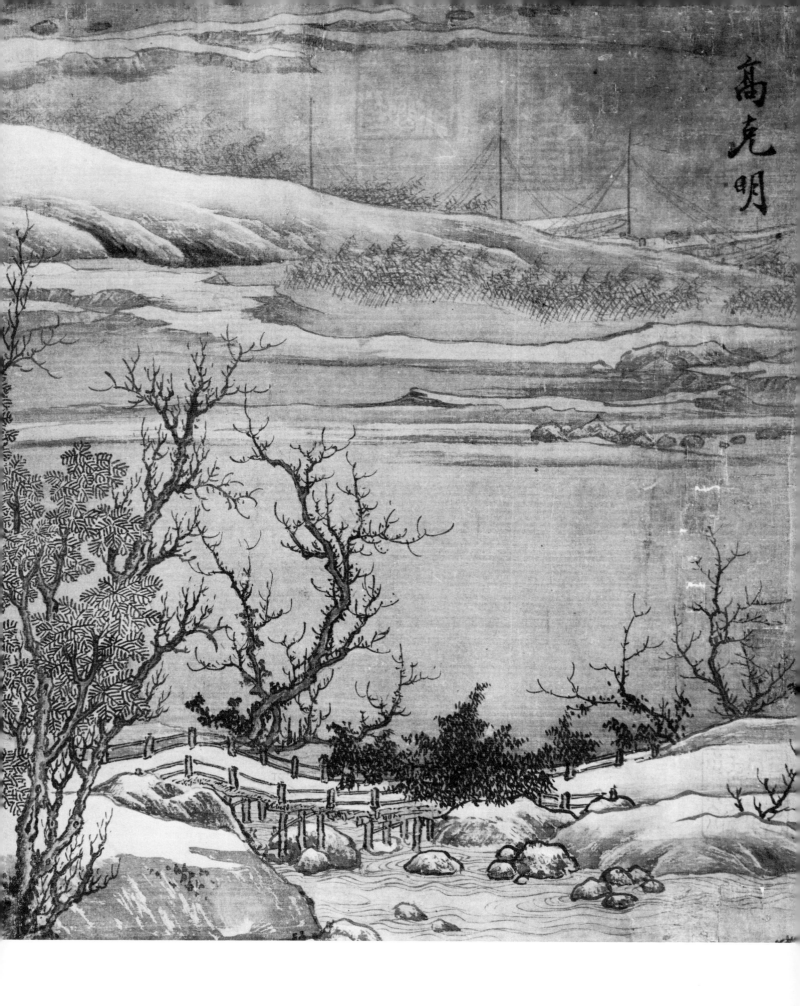

高克明

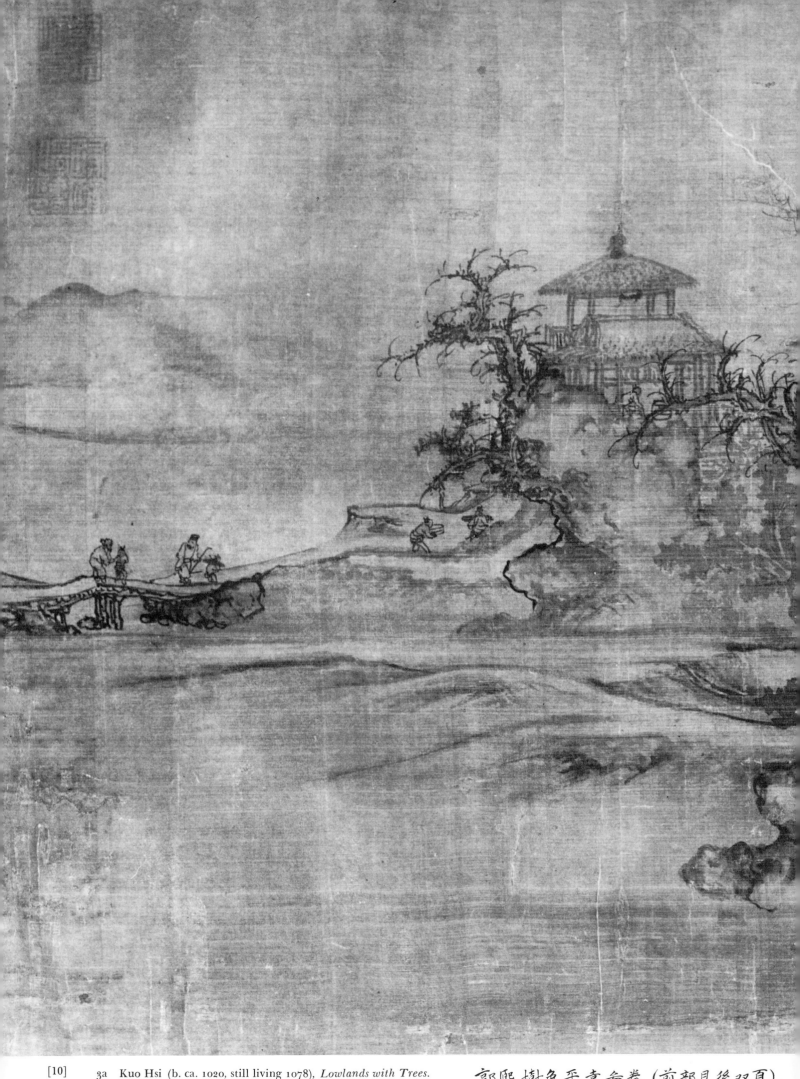

[10]　　3a　Kuo Hsi (b. ca. 1020, still living 1078), *Lowlands with Trees*.
　　　　Last section of handscroll.

郭熙樹色平遠畫卷 (前部見後双頁)

3b FOLLOWING SPREAD
Detail of the first section of the above handscroll.

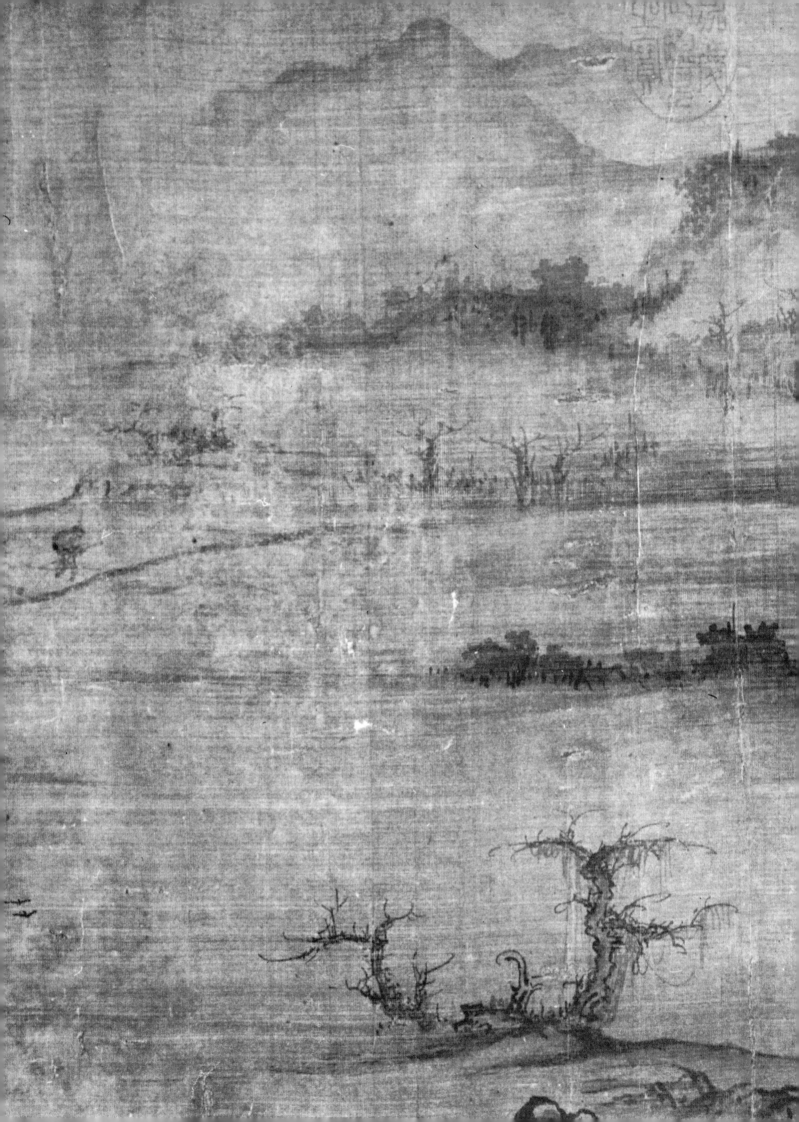

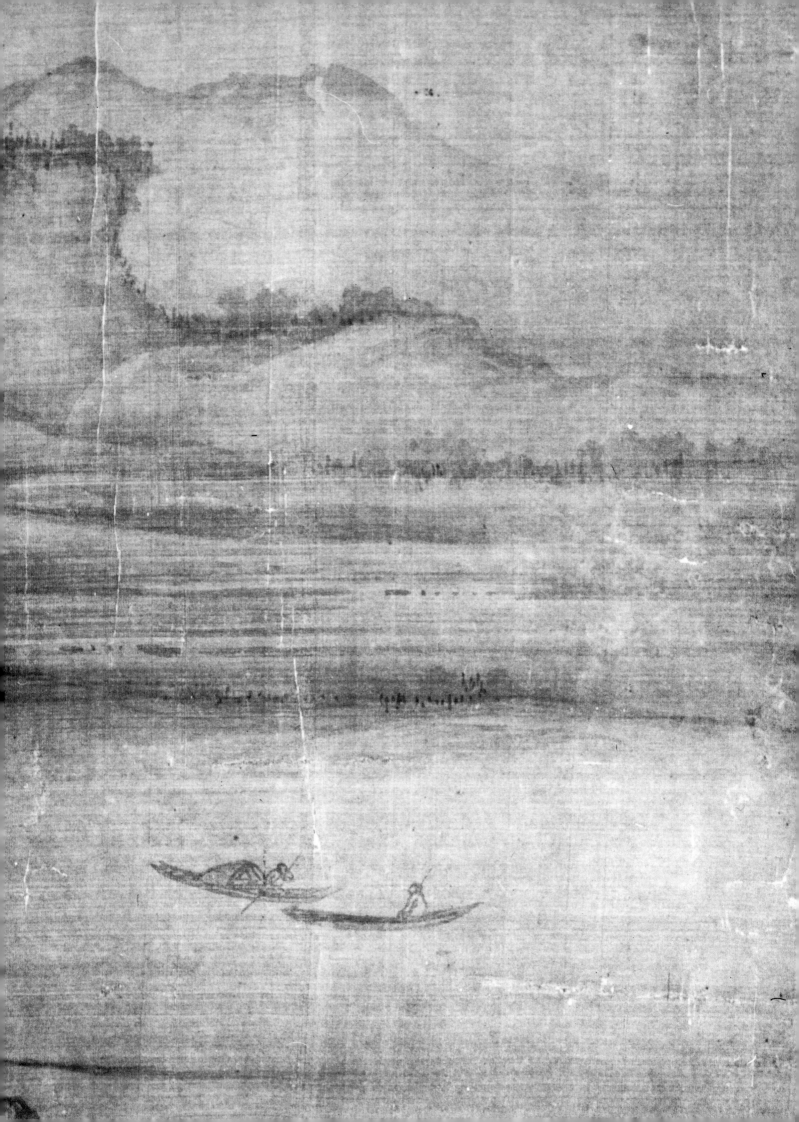

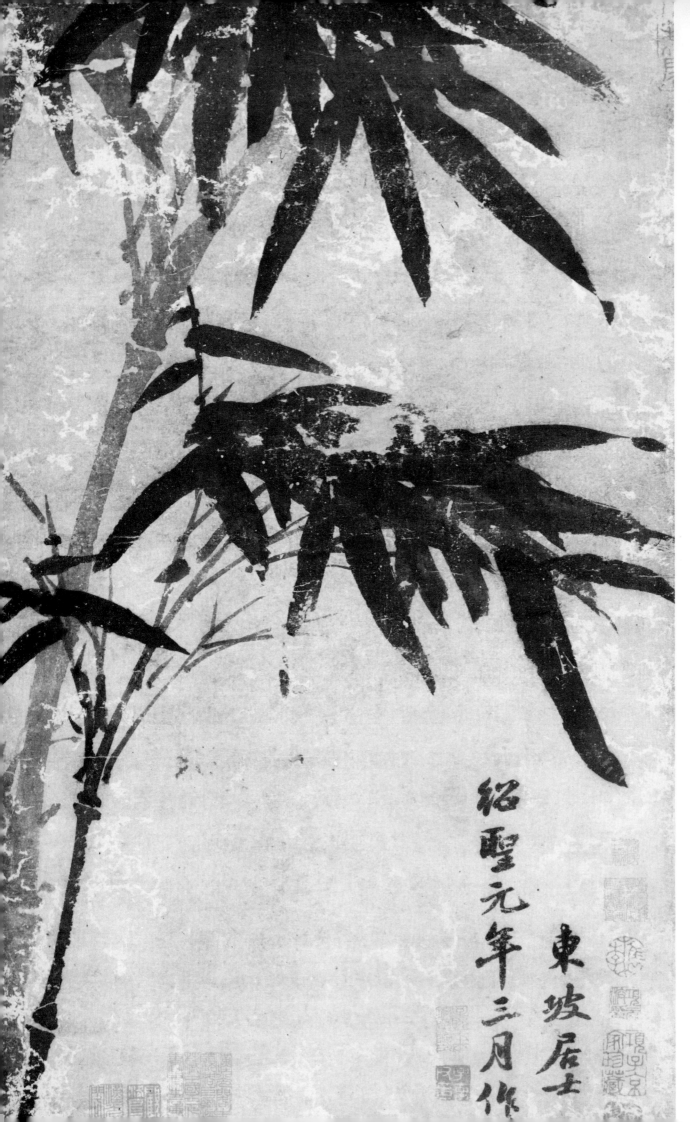

紹聖元年三月作

東坡居士

4 LEFT
Su Shih
(1036–1101),
Bamboo.
Inscription
dated 1094.

蘇軾墨竹畫

5 OPPOSITE &
FOLLOWING
SPREAD
Huang T'ing-chien
(1045–1105),
*Biographies of
Lien P'o and
Lin Hsiang–ju.*
Sections of
handscroll.

黃庭堅草書廉頗藺相如合傳卷
（右頁及後雙頁）

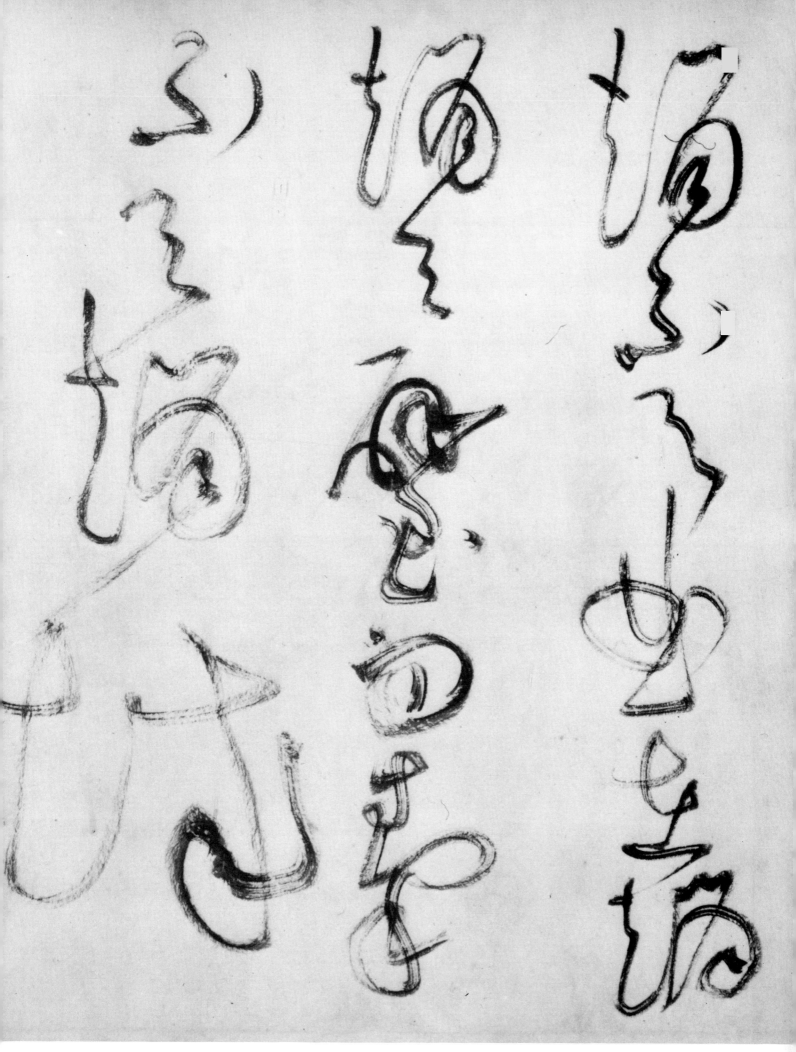

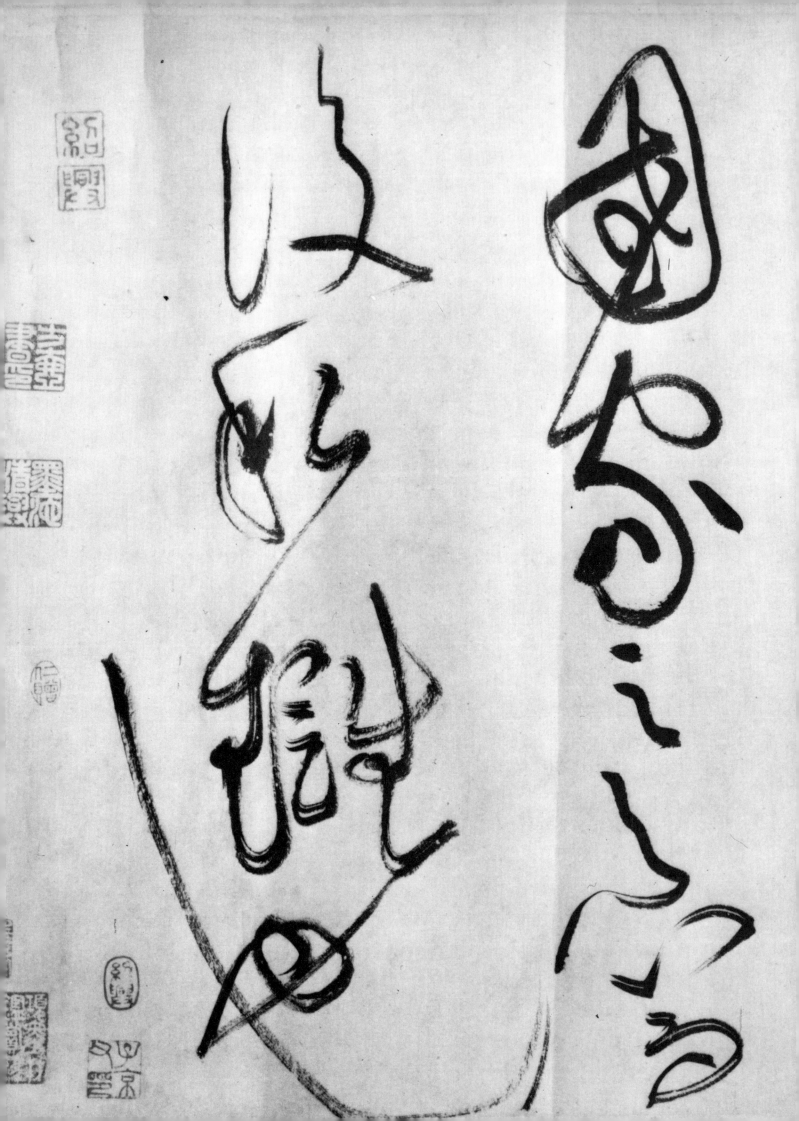

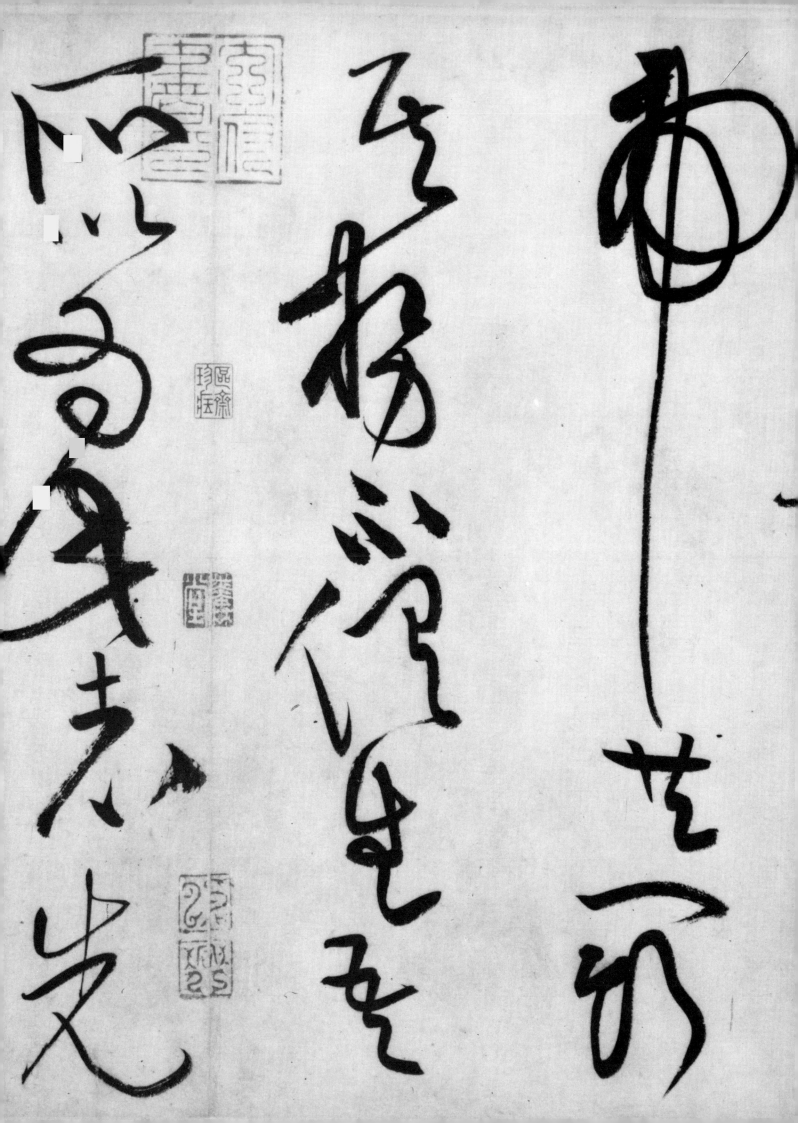

6
Mi Fu
(1051–
1107),
*Sailing
on the
Wu River.*
Section of
handscroll.

米芾草書吳江舟中詩卷

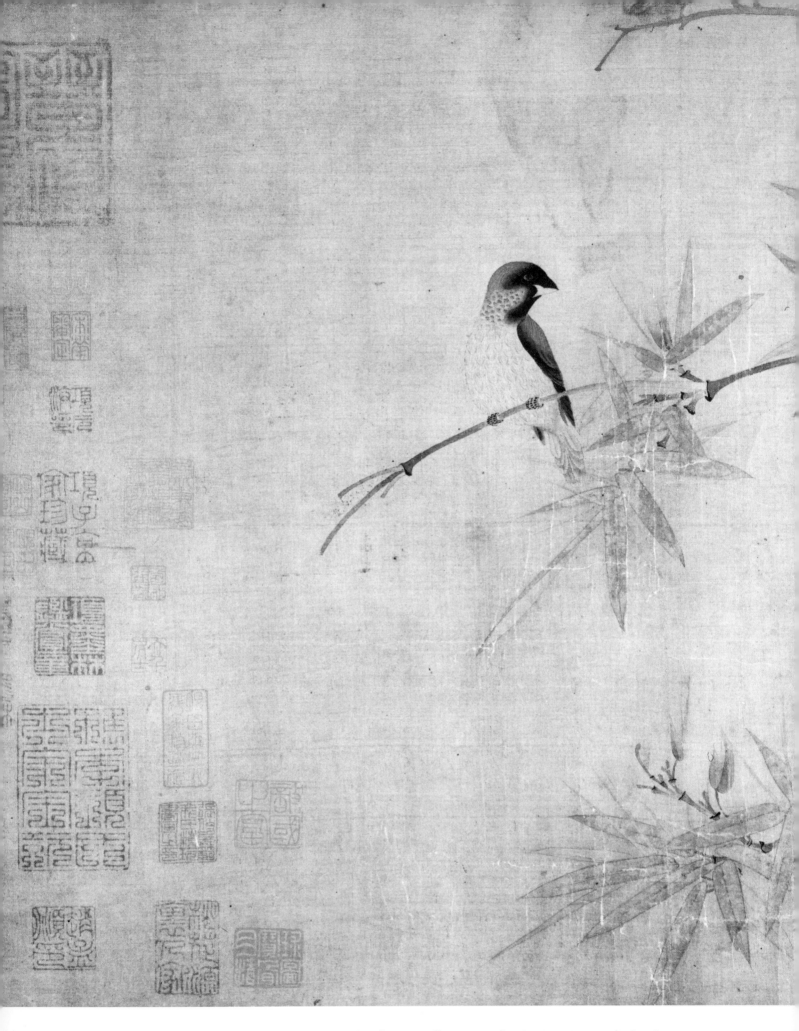

7 Sung Emperor Hui-tsung (1082–1135; reigned 1101–1126),
Finches and Bamboo.
Approx. actual size.

宋徽宗翠竹雙禽畫卷

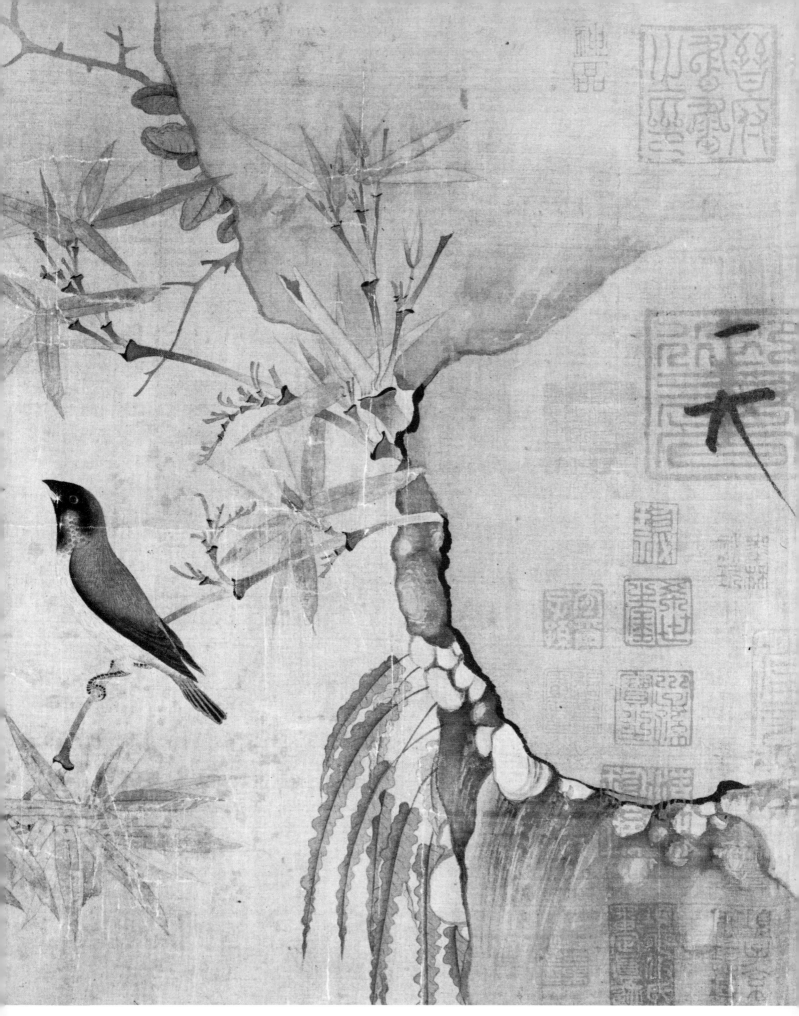

8a & 8b THE NEXT TWO SPREADS
Ch'iao Chung-ch'ang (active 1st quarter of 12th century),
Ode on the Red Cliff, Part II. Two sections of handscroll.

喬仲常後赤壁賦畫卷(後二双頁)

[21]

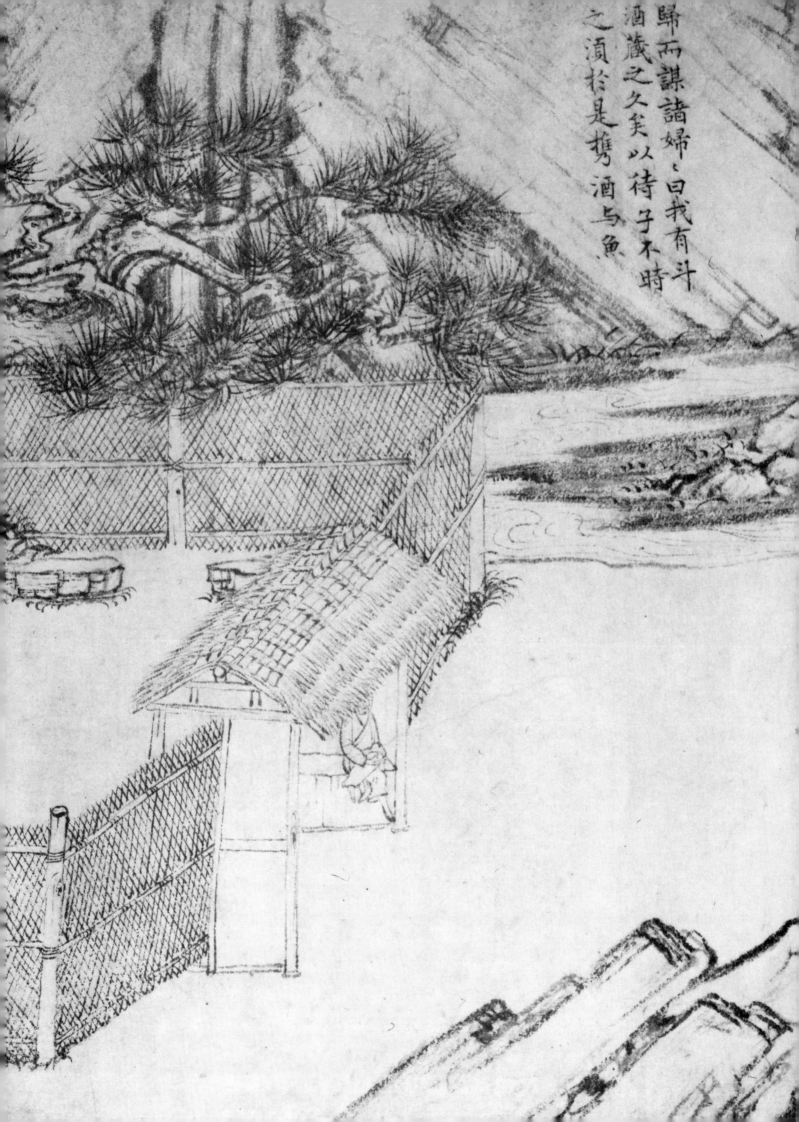

歸而謀諸婦　婦曰我有斗
酒藏之久矣以待子不時
之須於是攜酒與魚

9
Fan Ch'eng-ta
(1126–1193),
*Colophon to
"Fishing Village
at Mt. Hsi-sai."*
Detail of
handscroll,
approx. actual size.

范成大西塞漁社畫跋

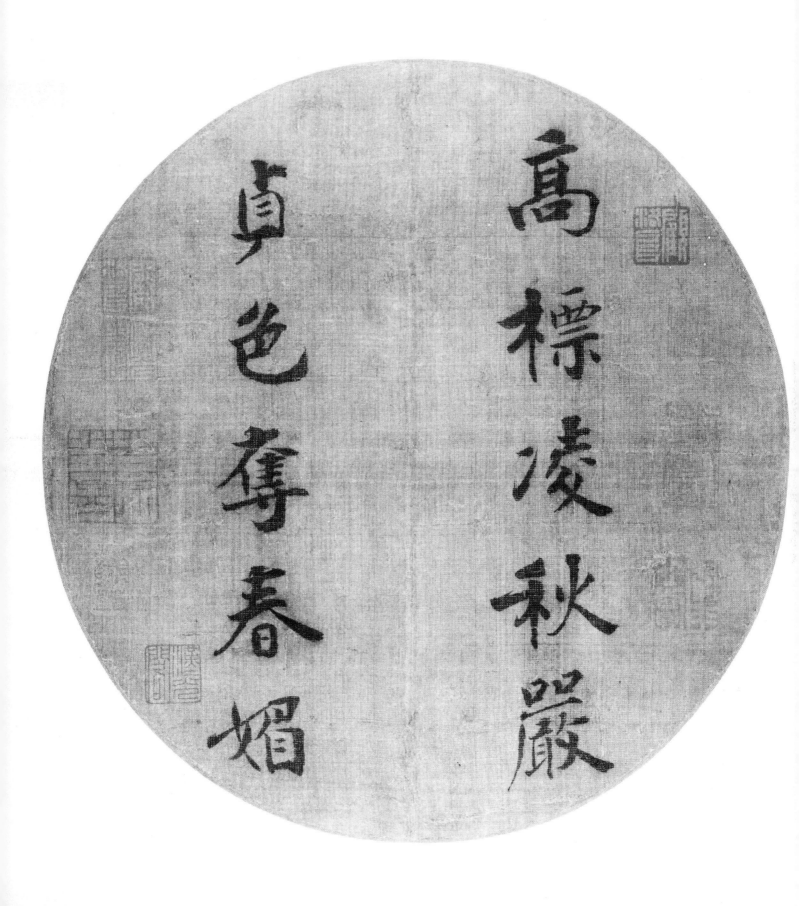

高標凌秋嚴
真色奪春媚

10 A Southern Sung Emperor (12th–13th century),
 Couplet by Han Yü.
 Approx. actual size.

宋寧宗書扇（韓愈詩句）

盛况汹涌使

青平歌而和声

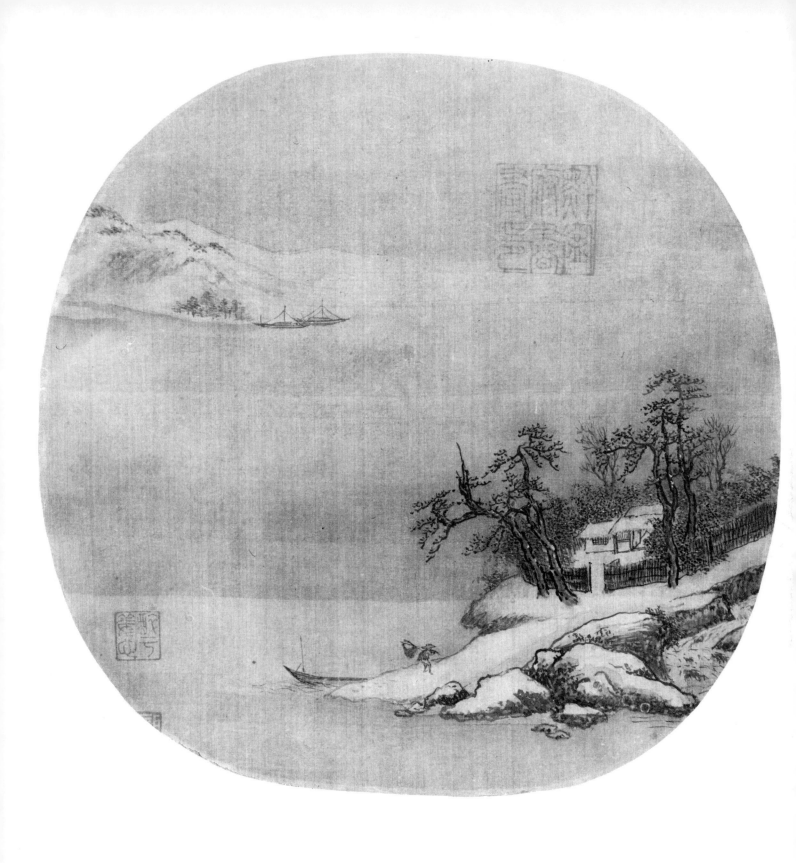

12 Anonymous (12th century), 南宋人江邨畫
 River Hamlet.

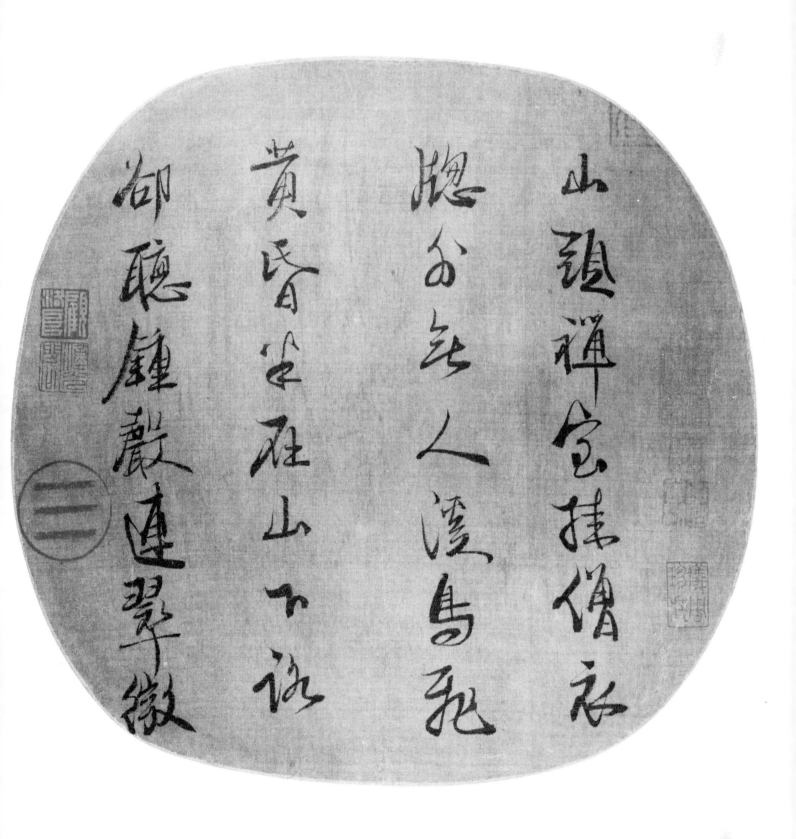

11 A Southern Sung Emperor (13th century),
 A Seven-word Poem by Meng Hao-jan.

宋理宗書扇 (孟浩然七言絕句)

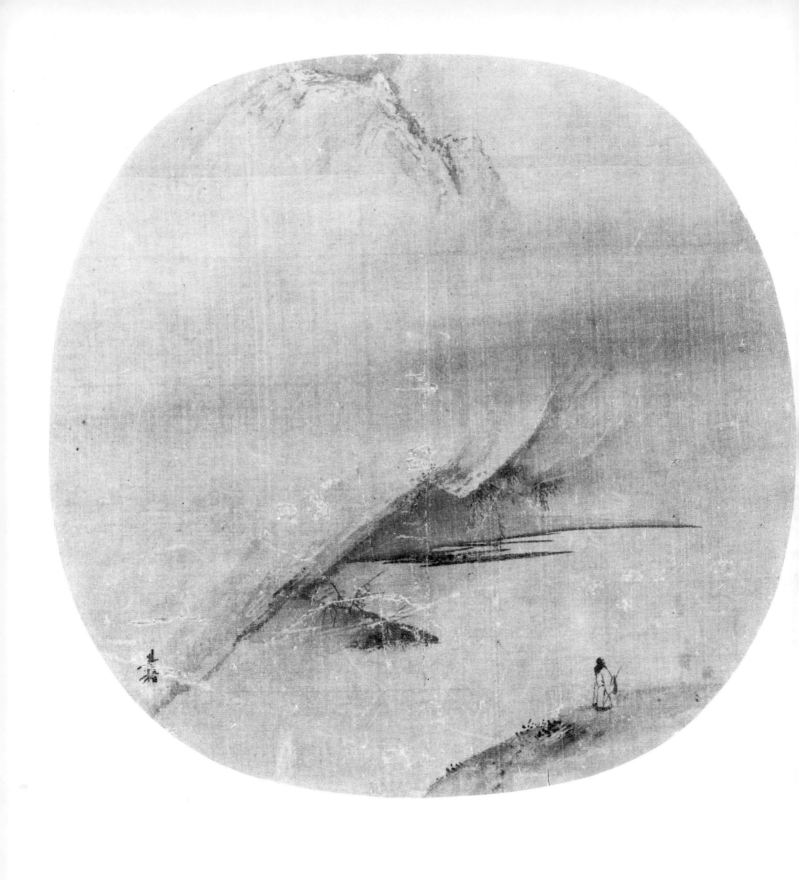

14 Liang K'ai (active early 13th century),
Strolling by a Marshy Bank.

梁楷澤畔行吟畫

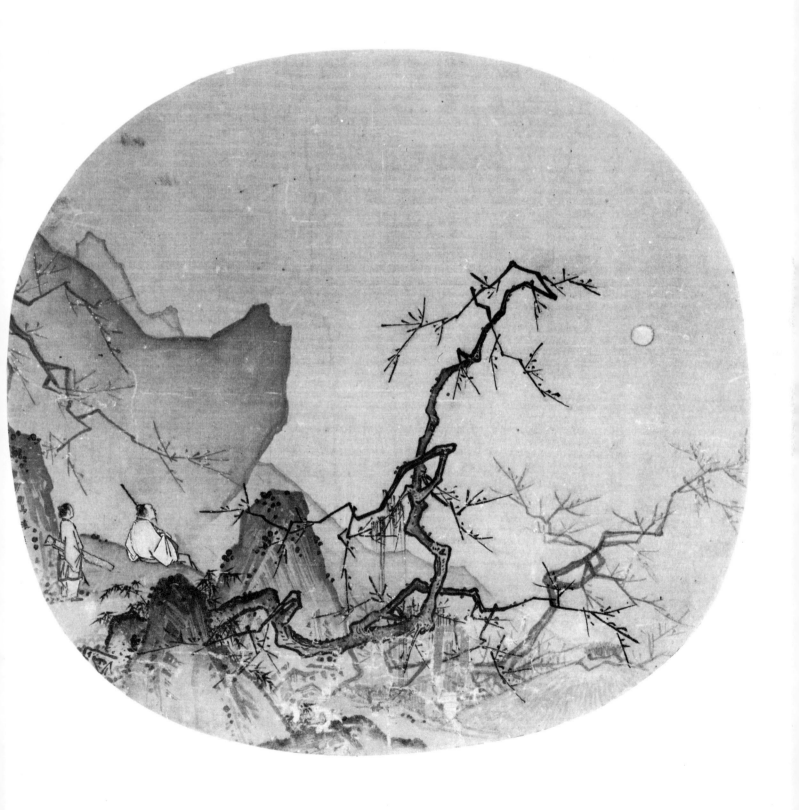

13 Ma Yüan (active 1180–1230),
 Plum Blossoms by Moonlight.　馬遠月夜賞梅畣

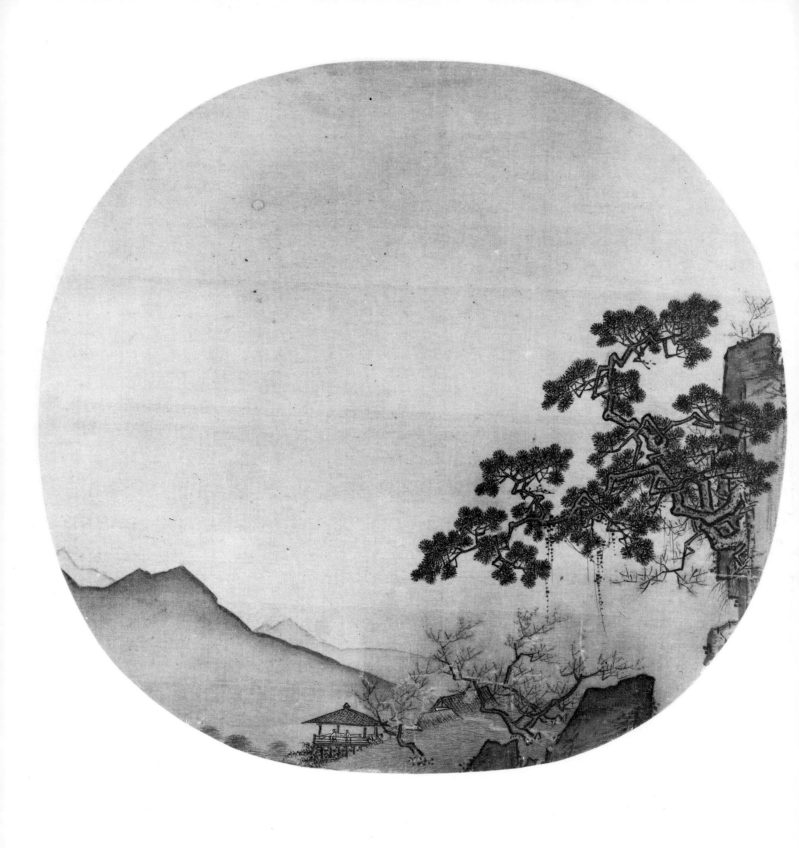

16 Anonymous (13th century), *Evening in the Spring Hills.* 南宋人春山仙隱畫

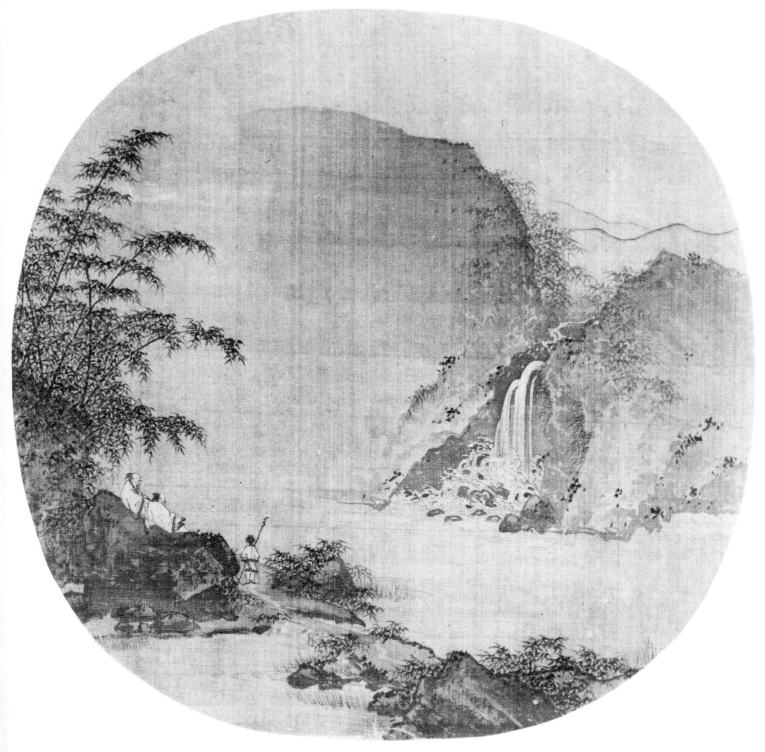

15 Anonymous (13th century),
 Gentlemen Gazing at a Waterfall. 南宋人觀瀑圖

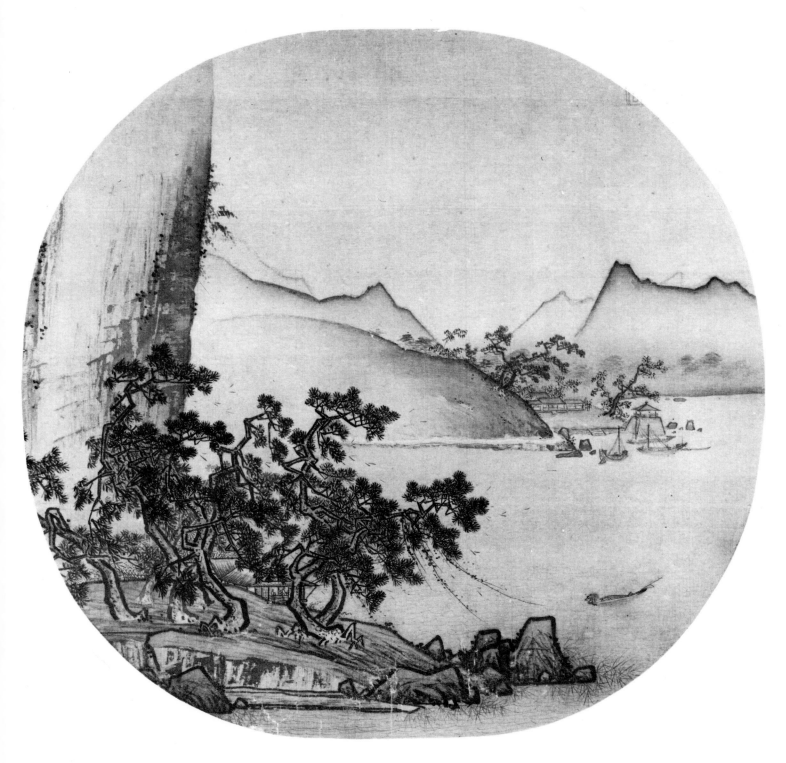

17 Anonymous (13th century),
Boats Moored in Wind and Rain. 南宋人風雨維舟畫

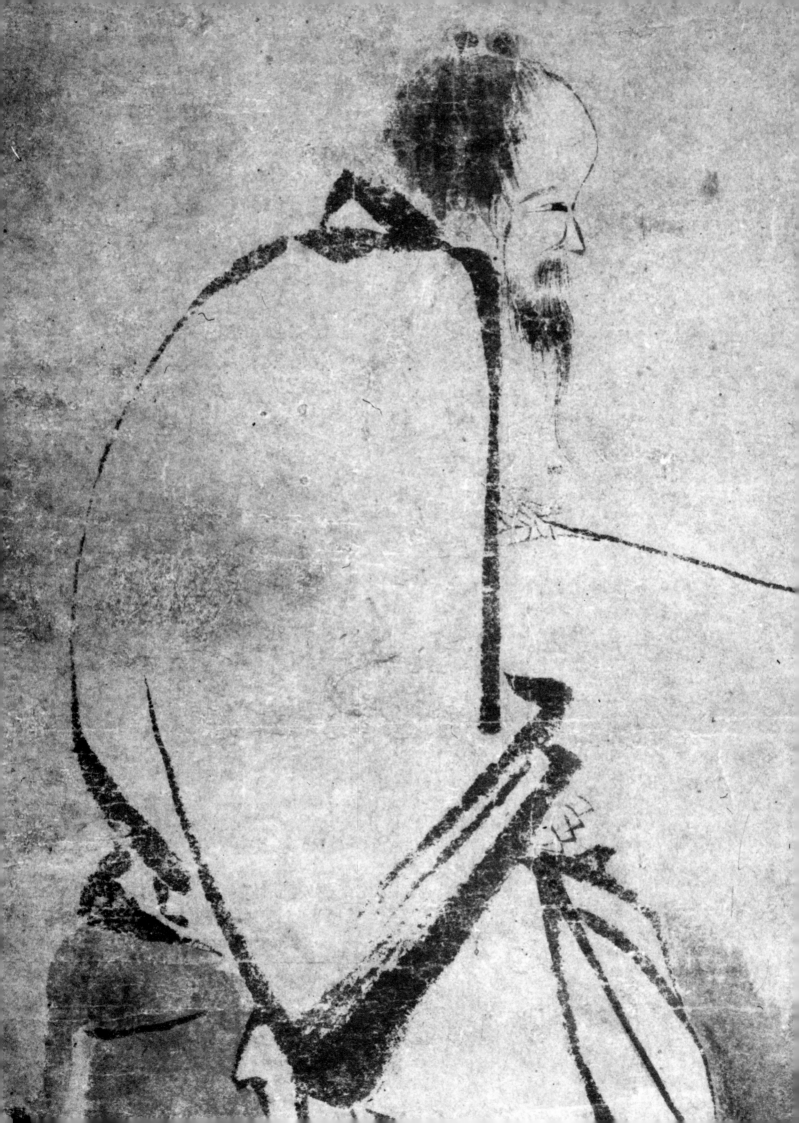

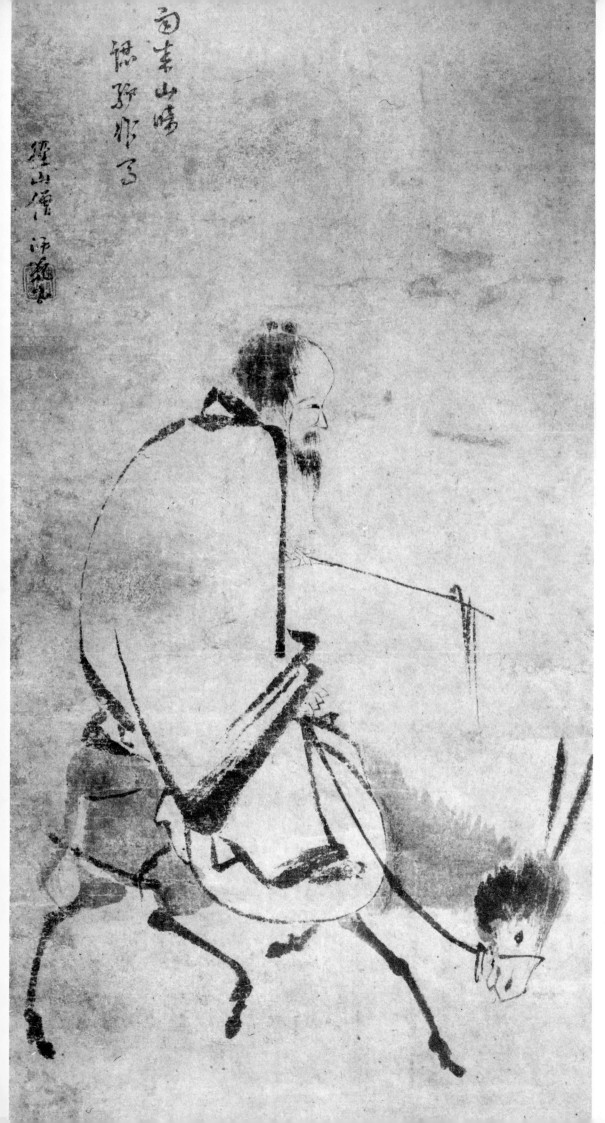

18 LEFT
Anonymous
(13th century),
*Monk Riding
a Mule.*
OPPOSITE: Detail
approx.
actual size.

無準題騎驢畫軸

19a & 19b
THE NEXT TWO
SPREADS
Anonymous
(13th century),
Odes of Pin.
Two sections
of a long
handscroll.

南宋人豳風畫卷（後二双頁）

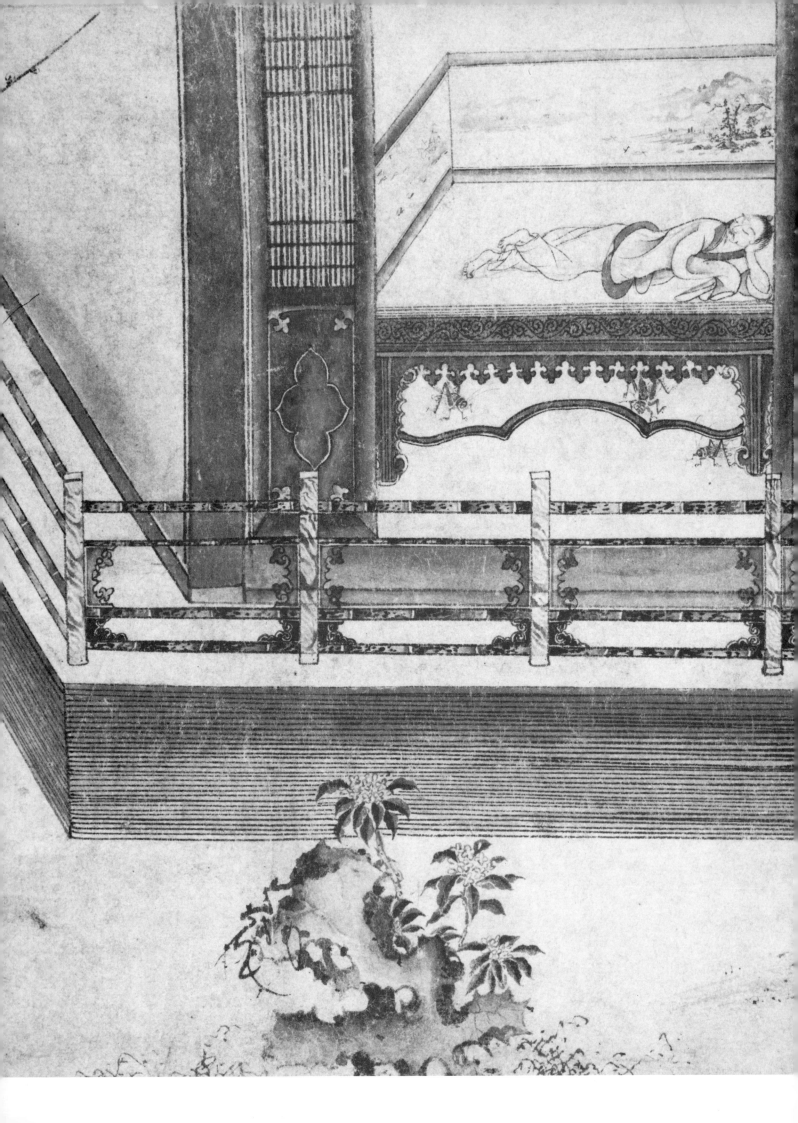

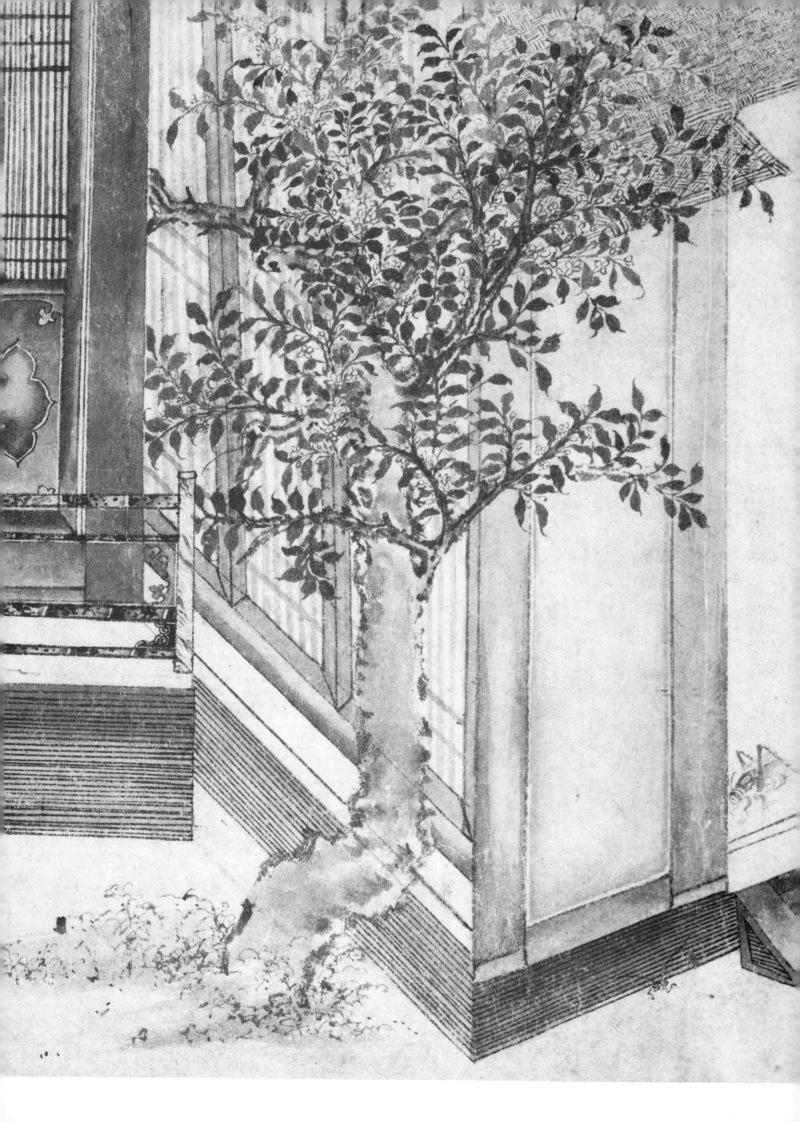

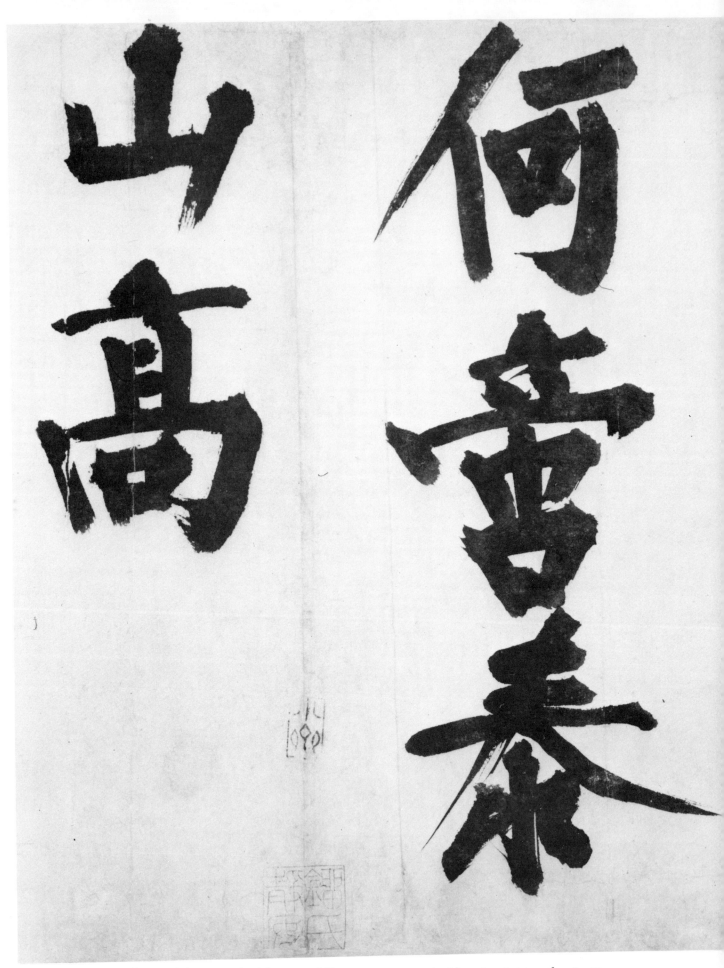

20 Yeh-lü Ch'u-ts'ai (1190–1244), *A Seven-word Poem.* Section of handscroll.

耶律楚材送劉滿詩卷

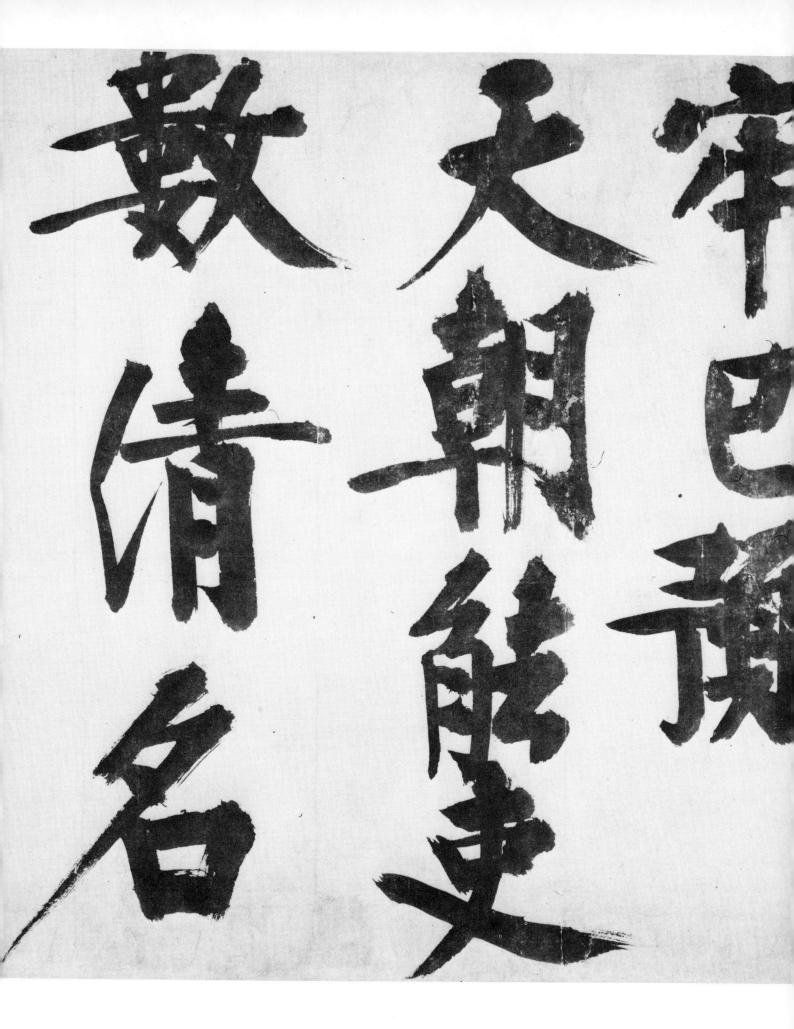

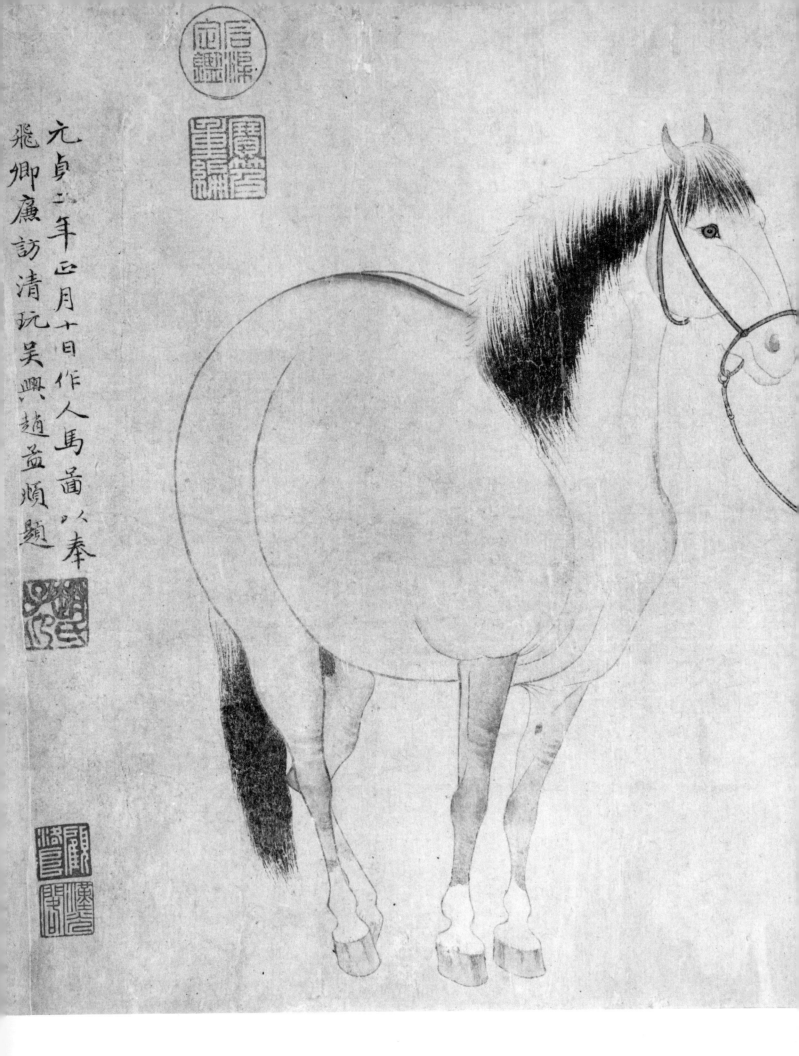

元貞二年正月十日作人馬畫以奉
飛卿廉訪清玩吳興趙孟頫題

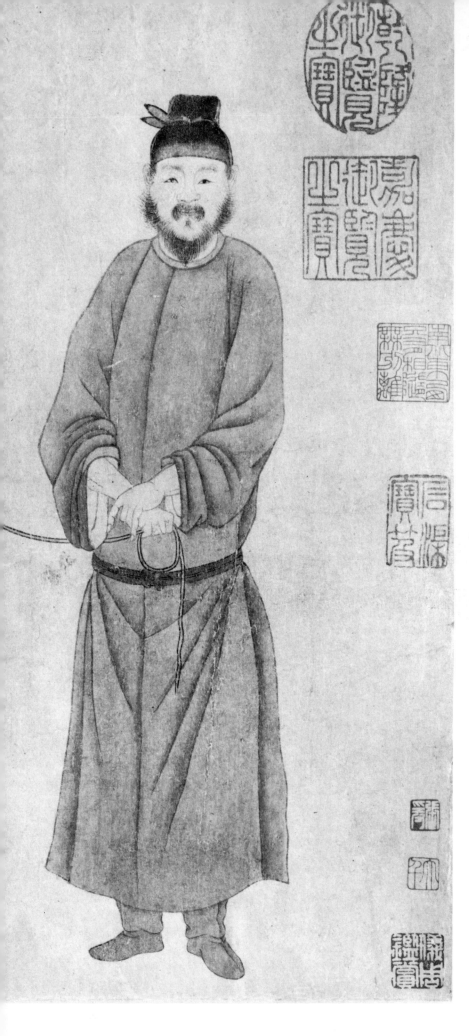

21 Chao Meng-fu (1254–1322),
Groom and Horse.

趙孟頫人馬畫

趙氏三世人馬畫卷之一

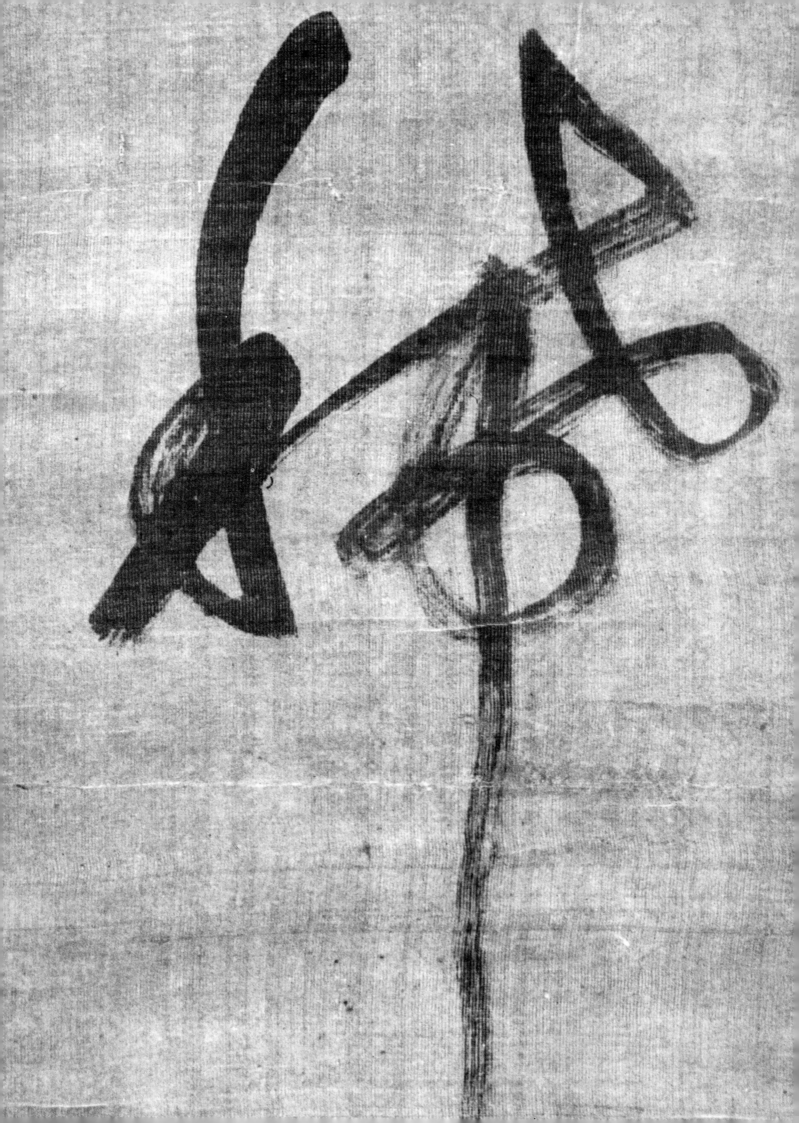

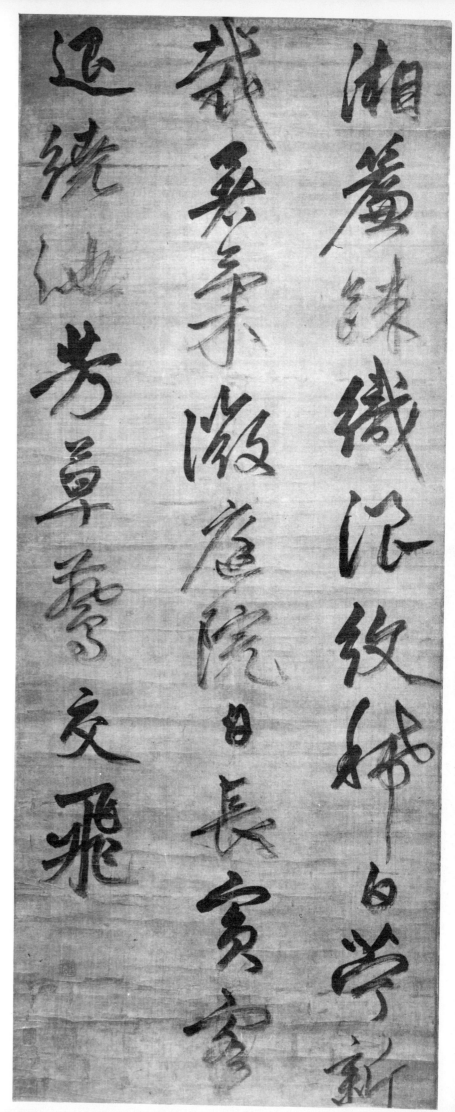

22 RIGHT
Chao Meng-fu (1254–1322),
A Summer Idyll (Quatrain).
OPPOSITE: Detail of one character,
approximately actual size.

趙孟頫草書七言絕句軸

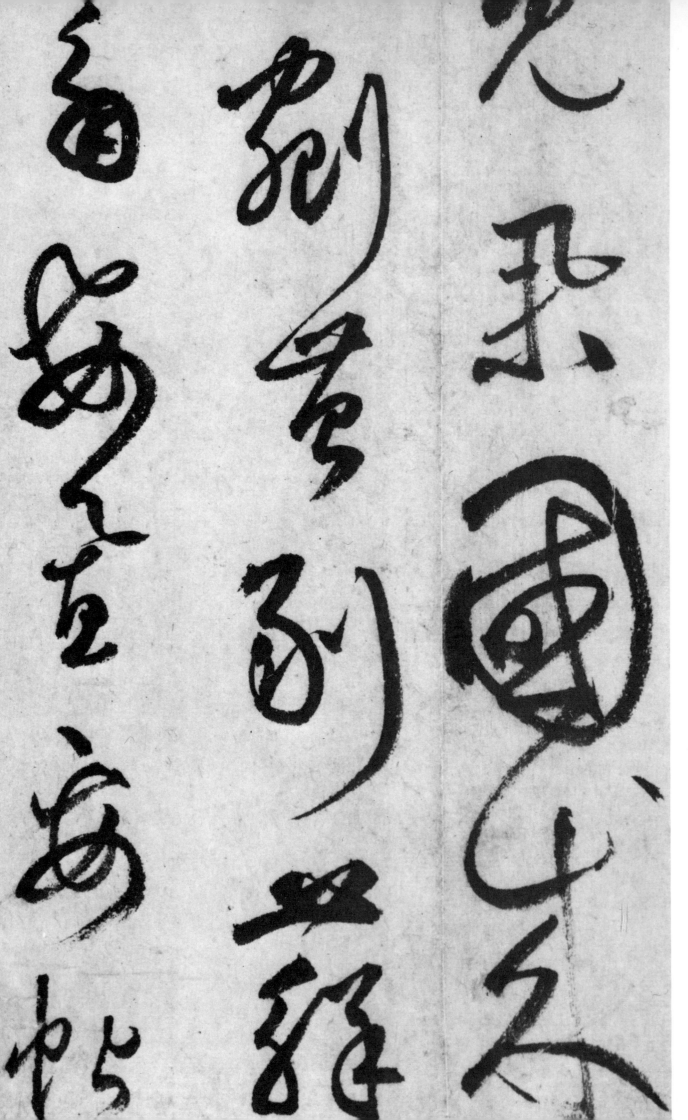

東坡夸夔

沸洞簇
游洽營

初蒙
情生
微之

如嫉稿
元和
夜人

罩王
去杏
捕子
家

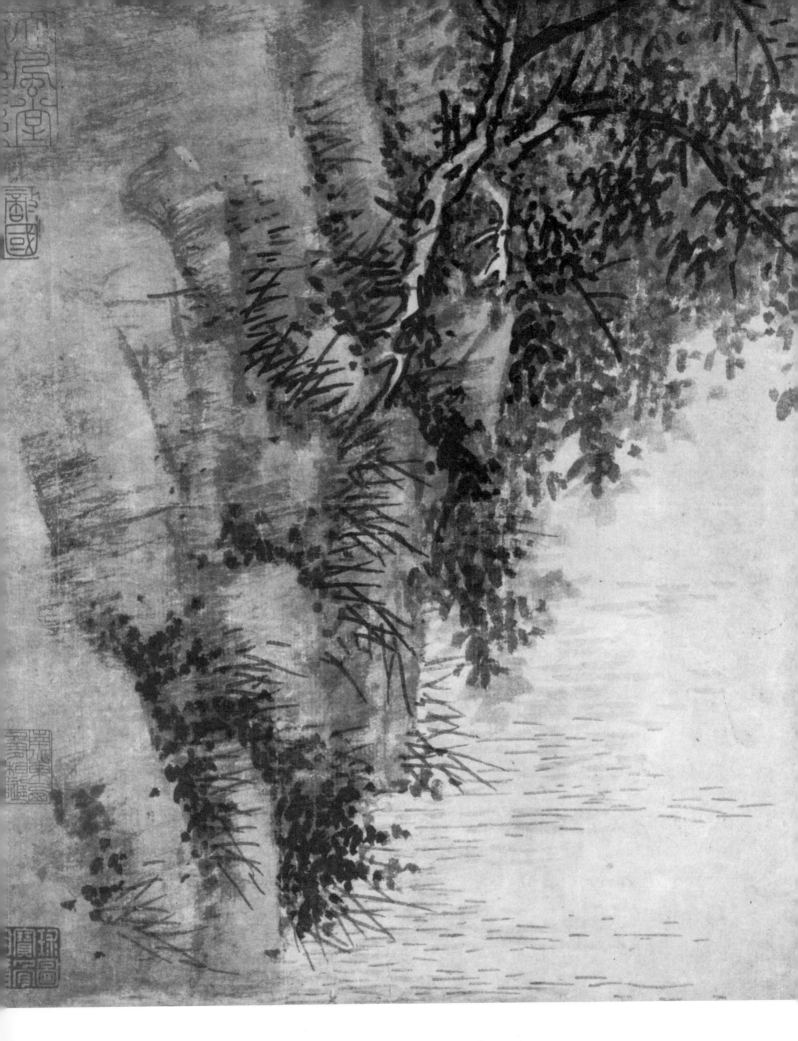

24 Wu Chen (1280–1354), 吳鎮漁舟畣卷
 Fisherman.

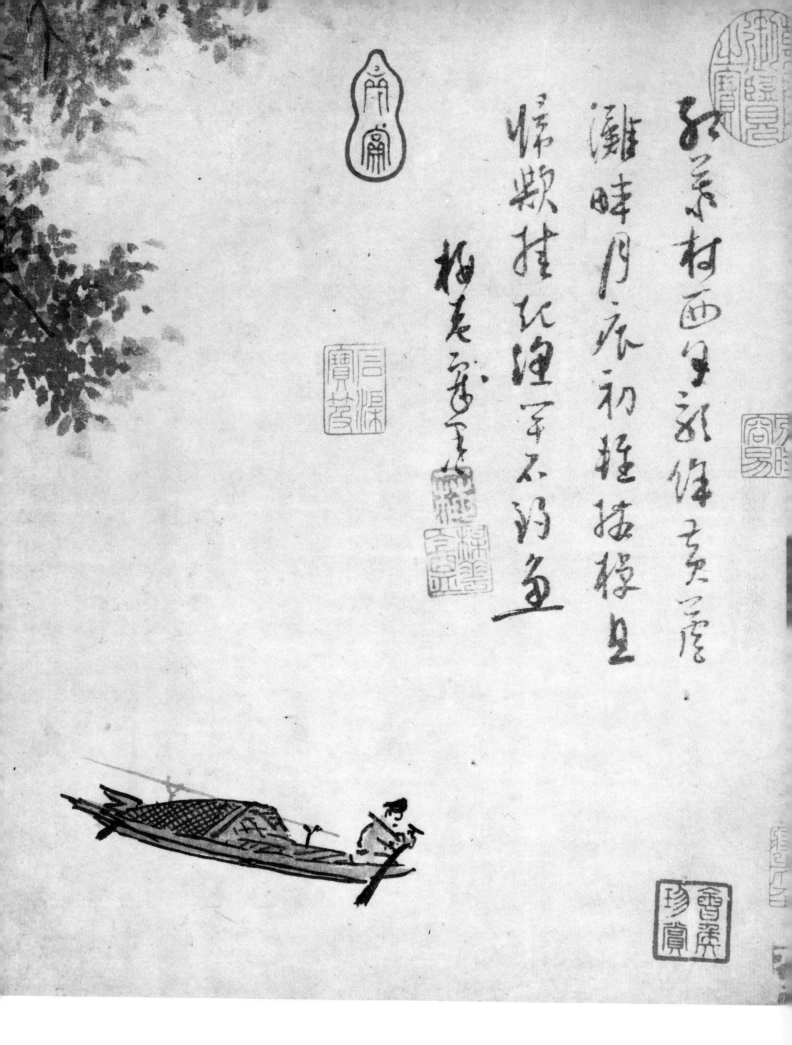

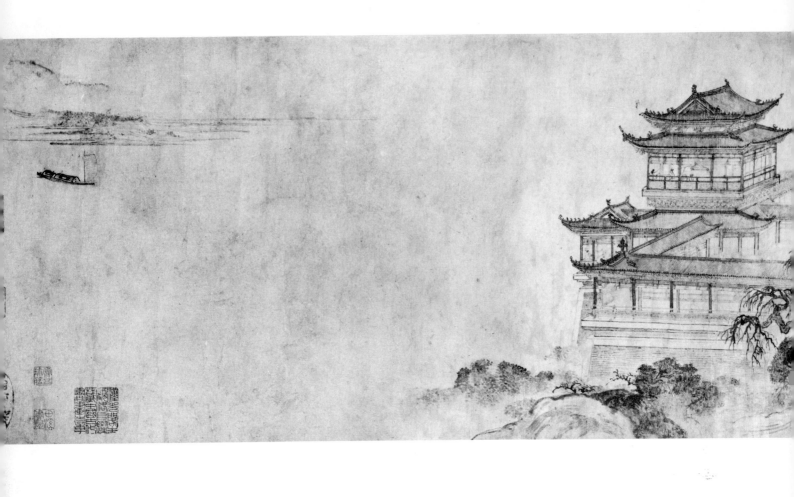

唐棣勝王閣畫卷

25 ABOVE
T'ang Ti (1296–ca. 1364),
The Pavilion of Prince T'eng.
OPPOSITE: Detail.

唐棣勝王閣畫卷

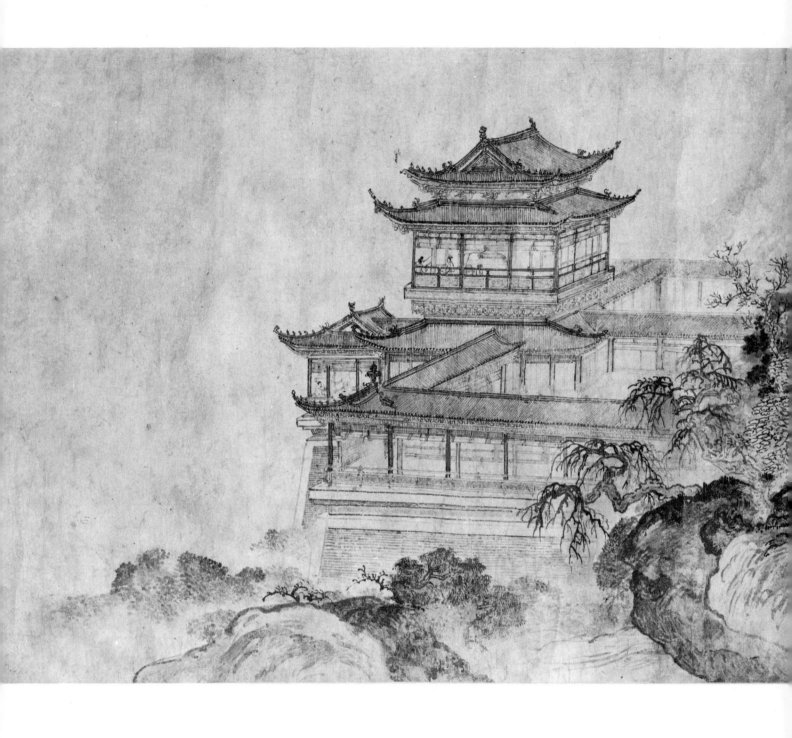

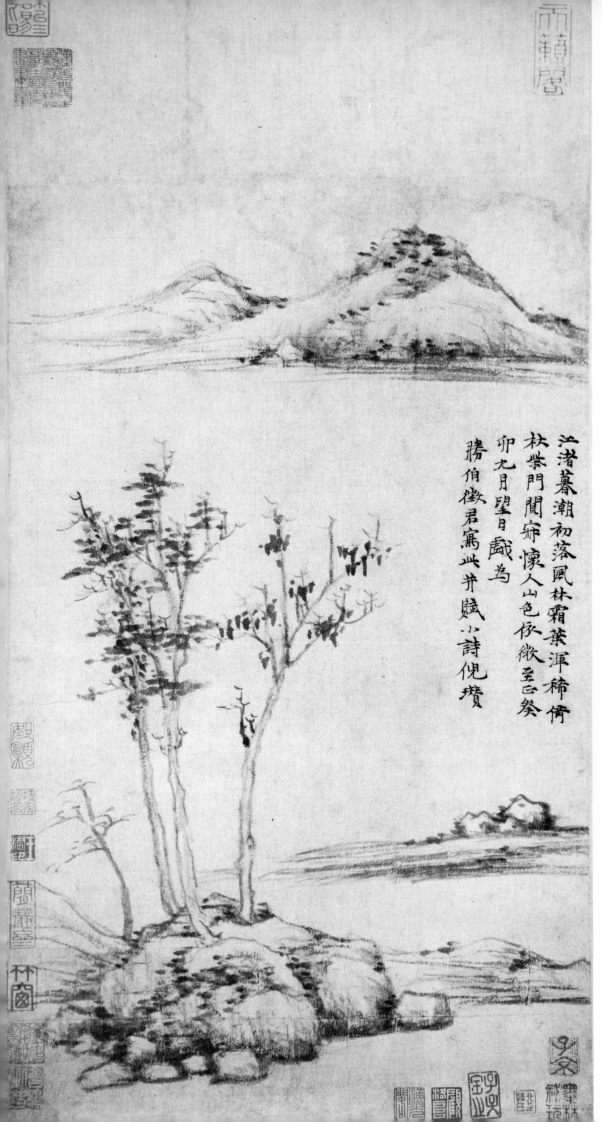

江渚暮潮初落風林霜葉渾稀倚
杖柴門聞帘懷人山色依微至巳癸
卯九月望日戲為
勝伯徵君寫此并賦小詩倪瓚

26 LEFT
Ni Tsan (1301–1374),
*Wind among the
Trees on the
Stream Bank.*
OPPOSITE: Detail
approx. actual size.

倪瓚江渚風林畫軸

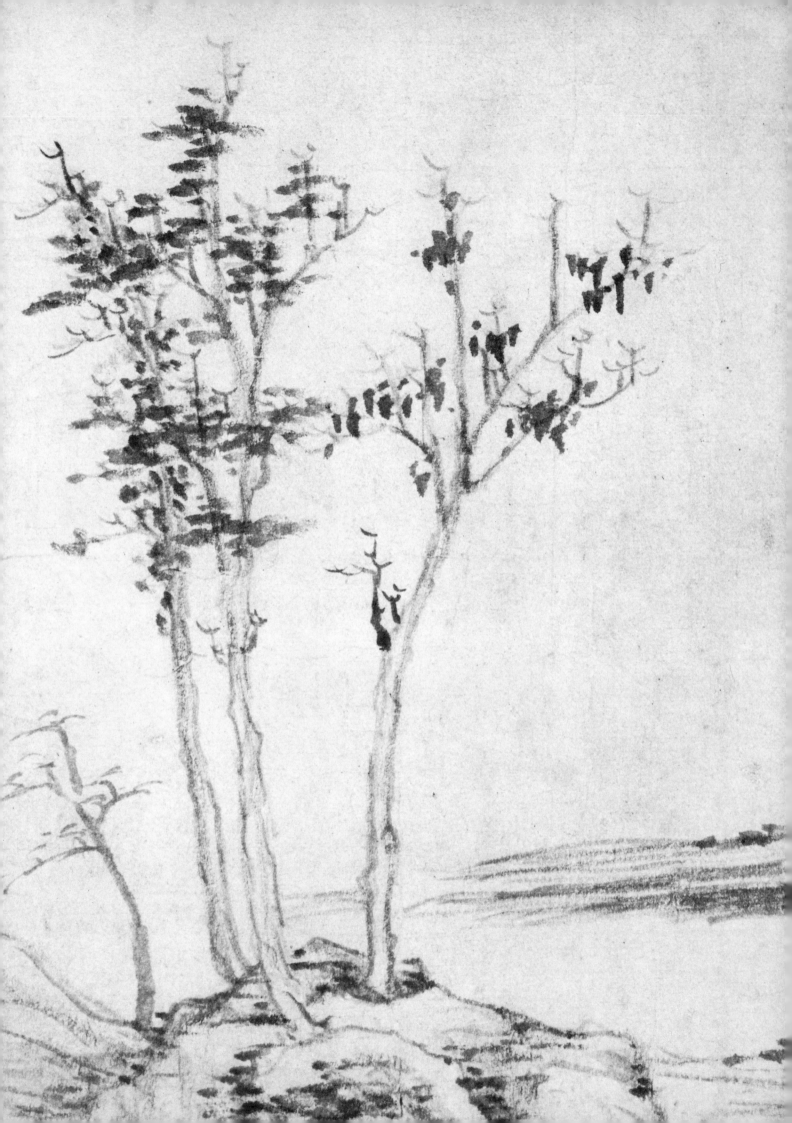

27　Sung K'o (1327–1387),
A Seven-word Poem.
First section of handscroll,
approx. actual size.

宋克章書七言律詩卷

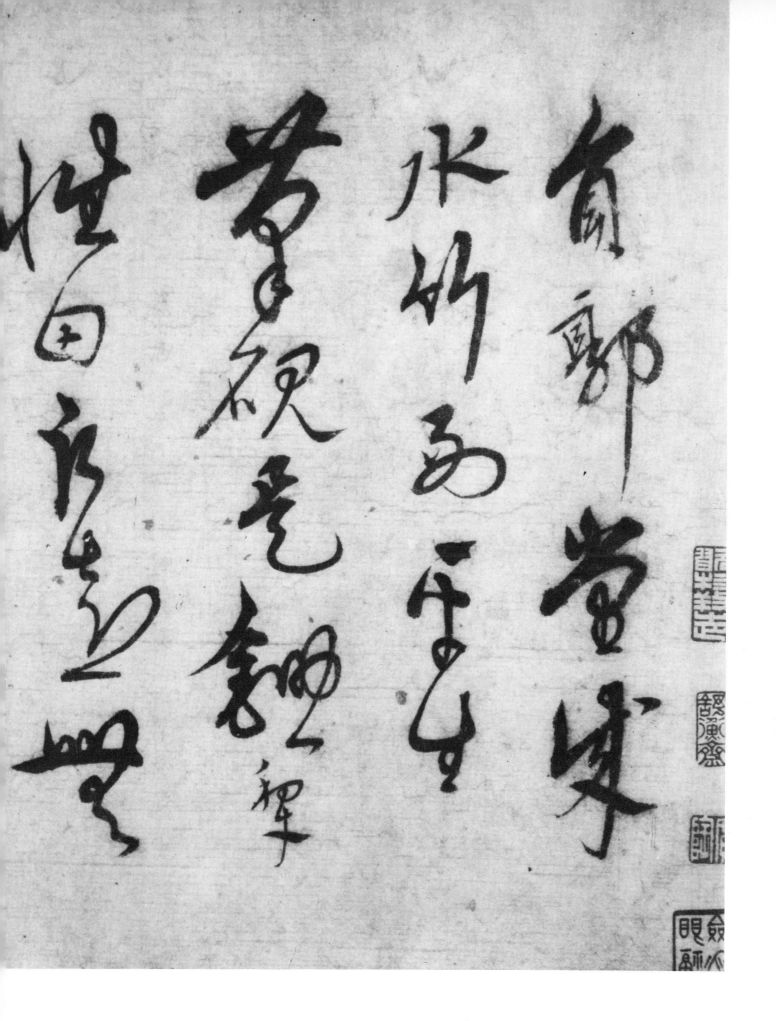

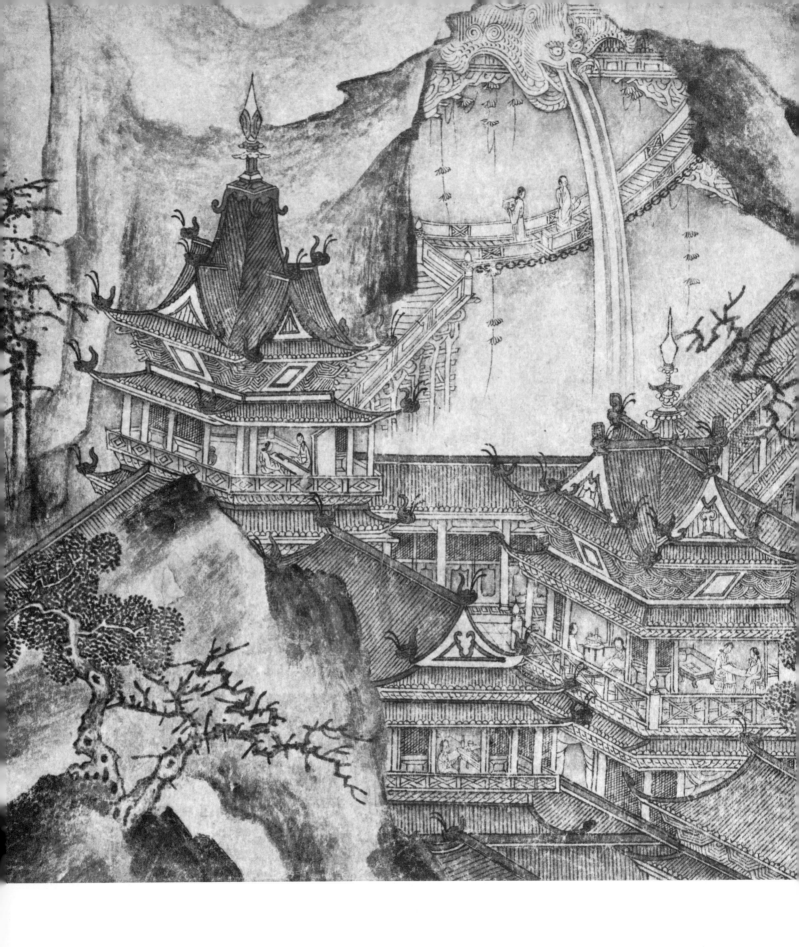

28 Anonymous (14th century?),
The Ta-ming Palace.
Section of a long handscroll.

元人大明宮畫卷

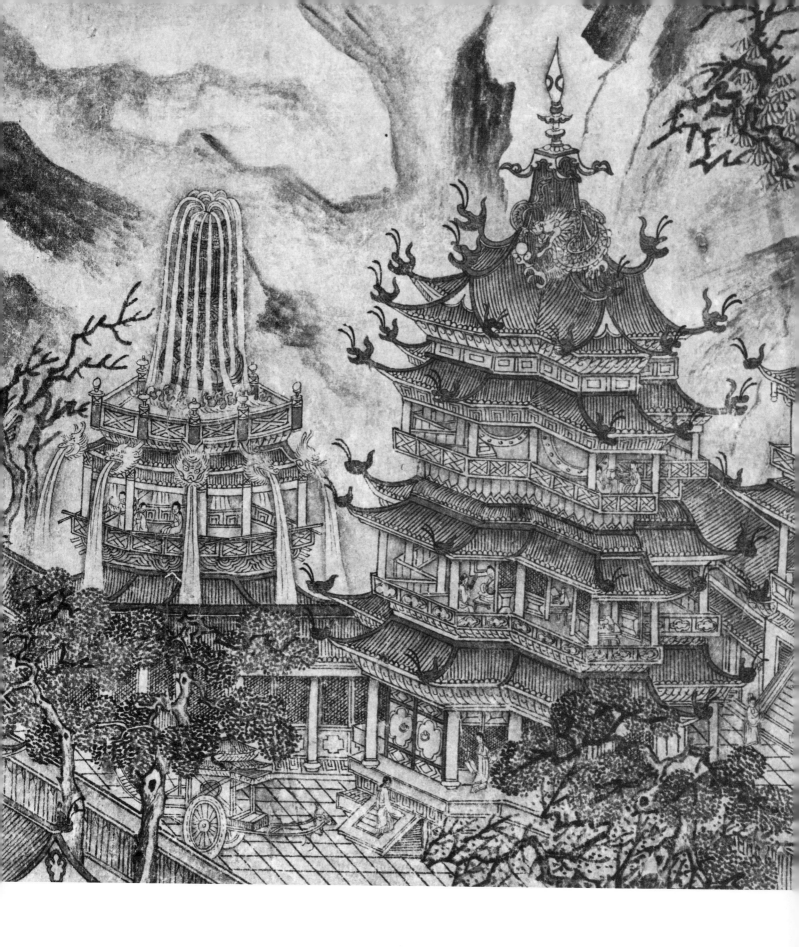

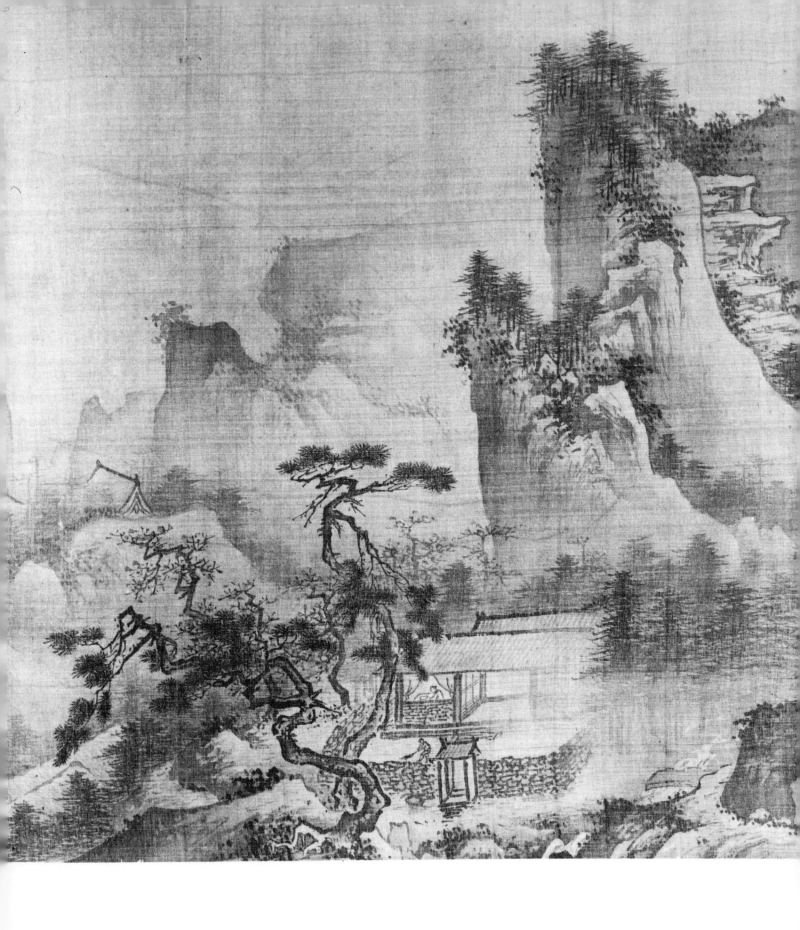

29a Anonymous (early 15th century),
Mountain Landscape—the Four Seasons.
Section of handscroll.

明人四時山水畫卷

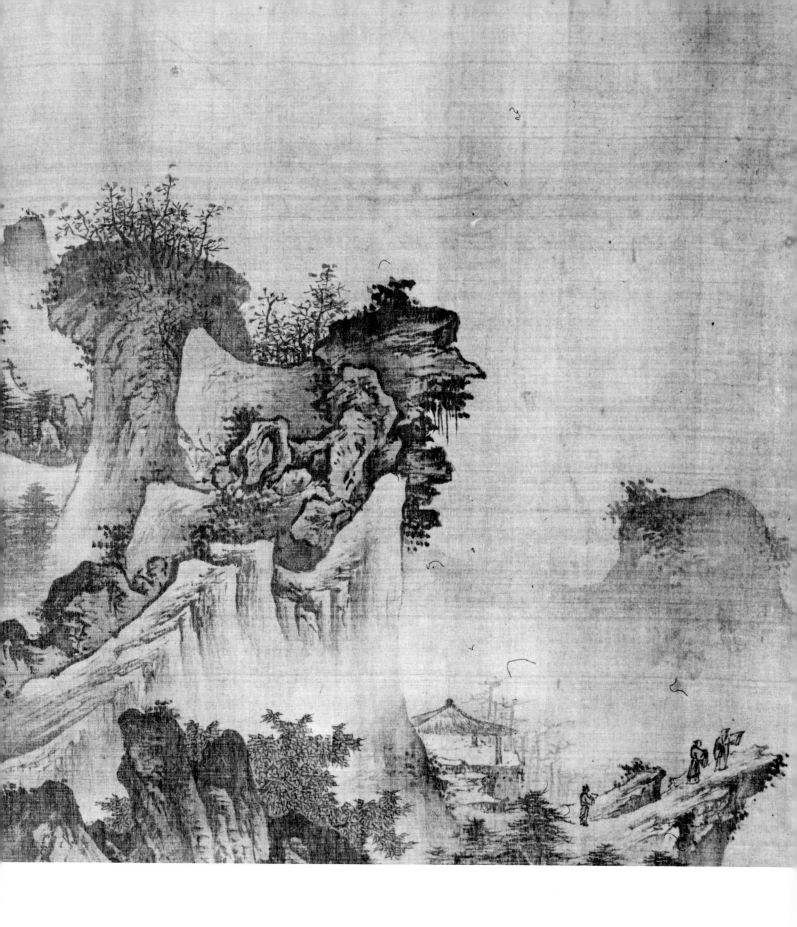

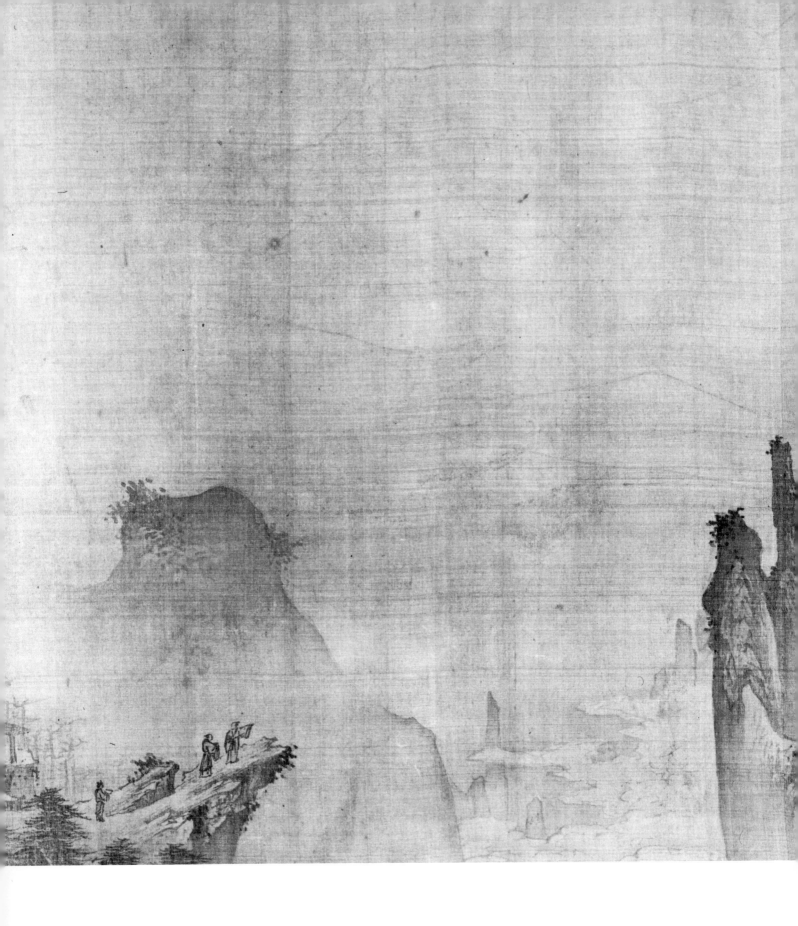

29b Anonymous (early 15th century),
Mountain Landscape—the Four Seasons.
Section of handscroll, contiguous to 29a. In viewing,
this section precedes 29a, since the scroll opens from right to left.

明人四時山水畫卷

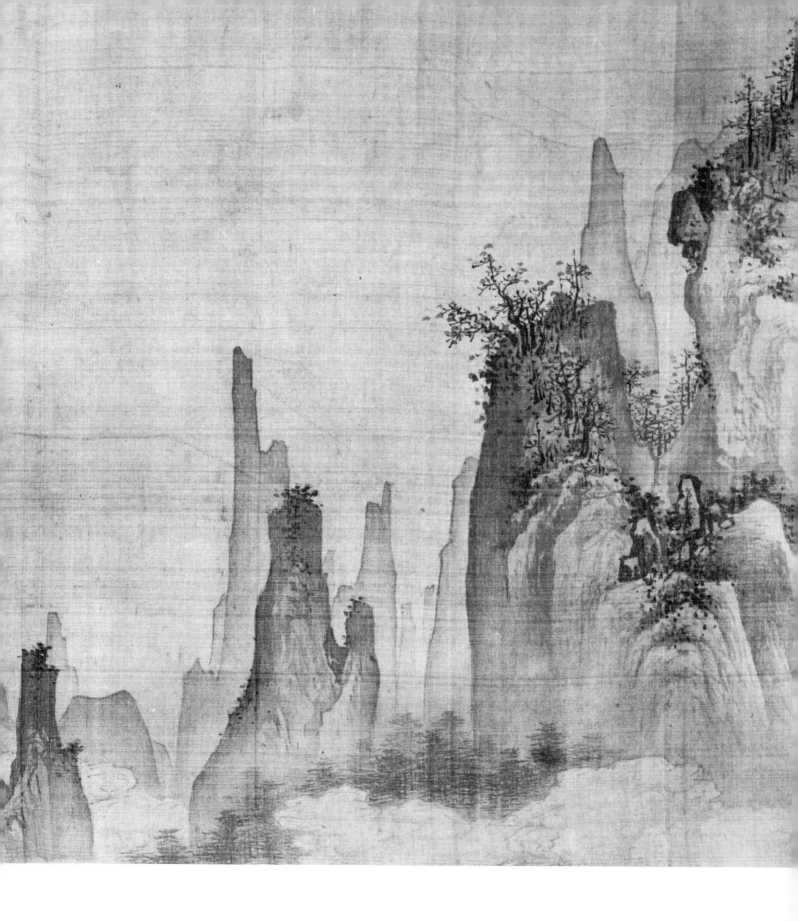

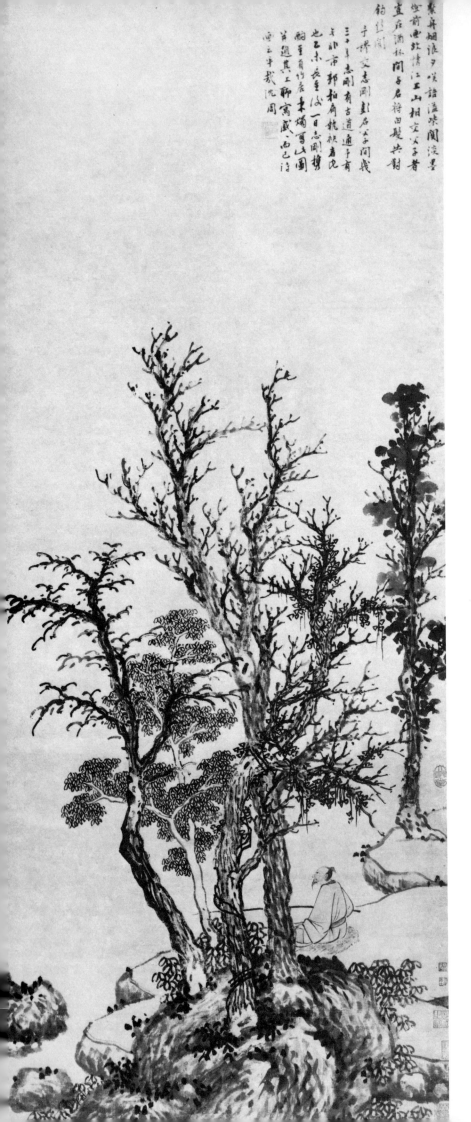

高青遣見工師窩處。戊申己酒遙至有作居朱燭寫此圖物至有作居朱燭寫此圖也己末長沙一日志剛持平邦市郭柏庸能狀居況三十年志剛有古道通子有于塏文志剛鄭石父子閉戲釣絲閣宣在酒林間各名將田髮共對坐前垂紅清江玉山相交父子者紫舟煙浪了味語溢嘆闐淺墨

30 LEFT
Shen Chou (1427–1509),
*Silent Angler
in an Autumn Wood.*
OPPOSITE: Detail.

沈
周
秋
林
靜
釣
畫
軸

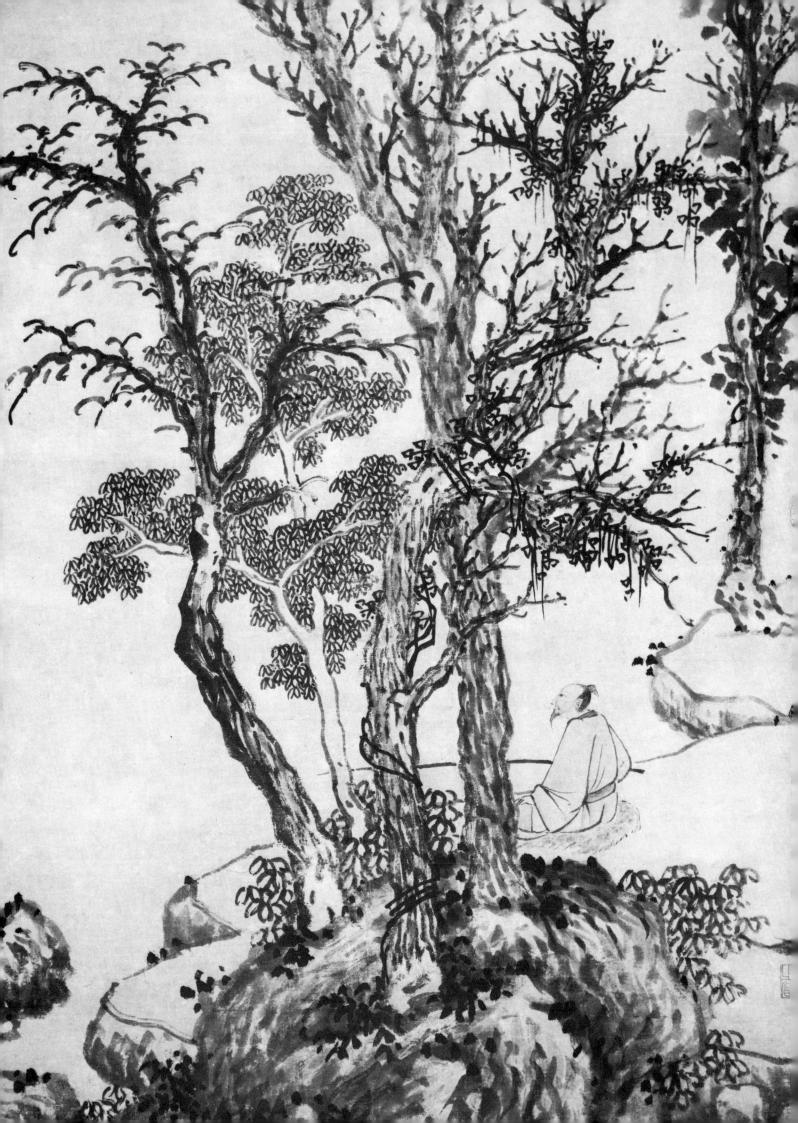

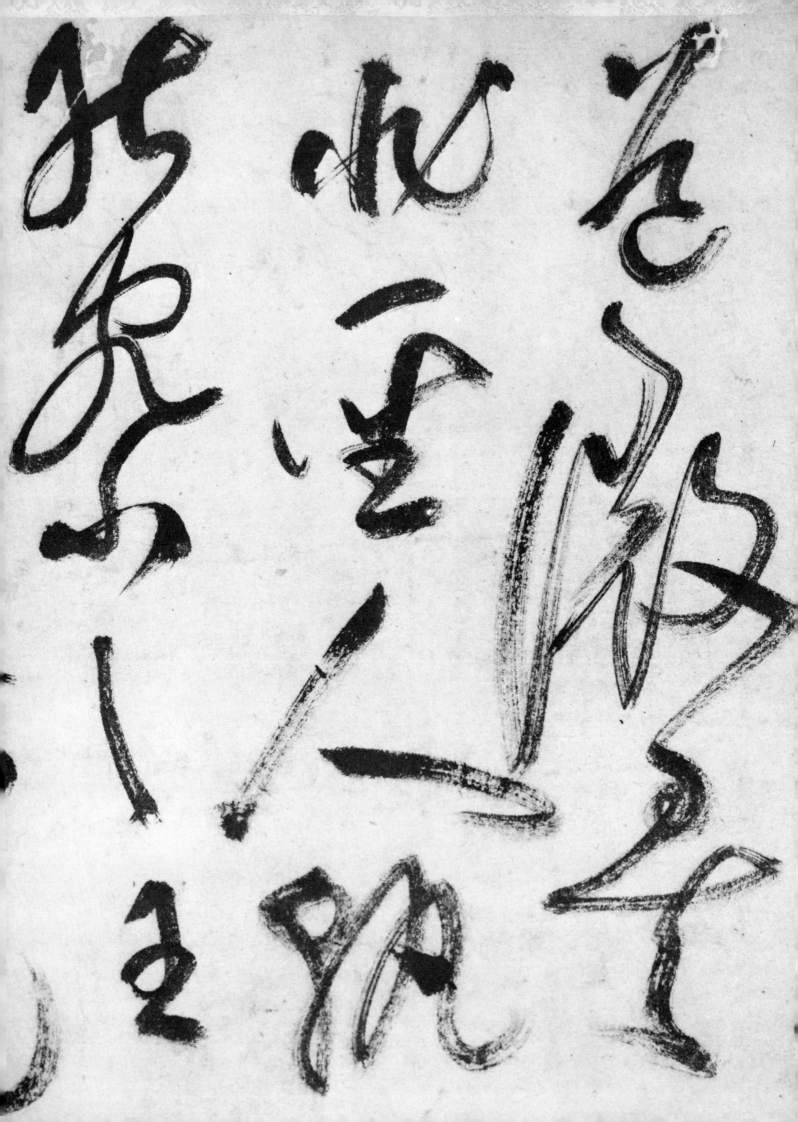

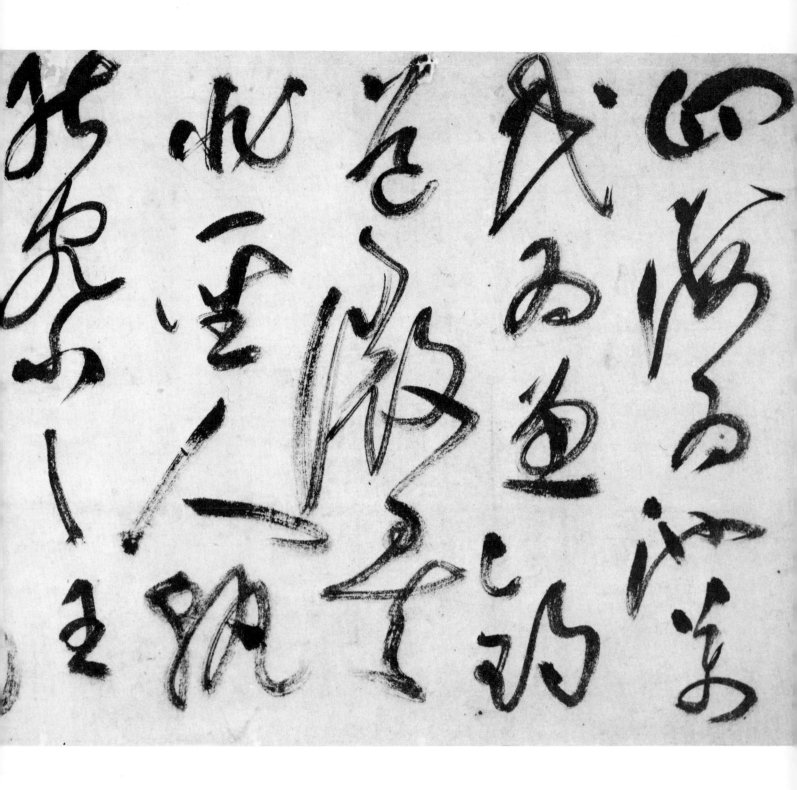

31 ABOVE
Chu Yün-ming (1461–1527),
Prose Poem on Fishing.
Section of handscroll.
OPPOSITE: Detail approx. actual size.

祝允明草書宋玉釣賦卷

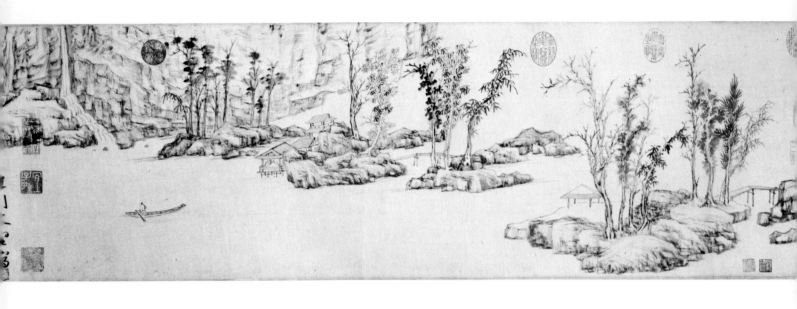

32 ABOVE
Wen Cheng-ming (1470–1559),
Summer Retreat in the Eastern Grove.
OPPOSITE: Detail.

文徵明東林避暑畫卷

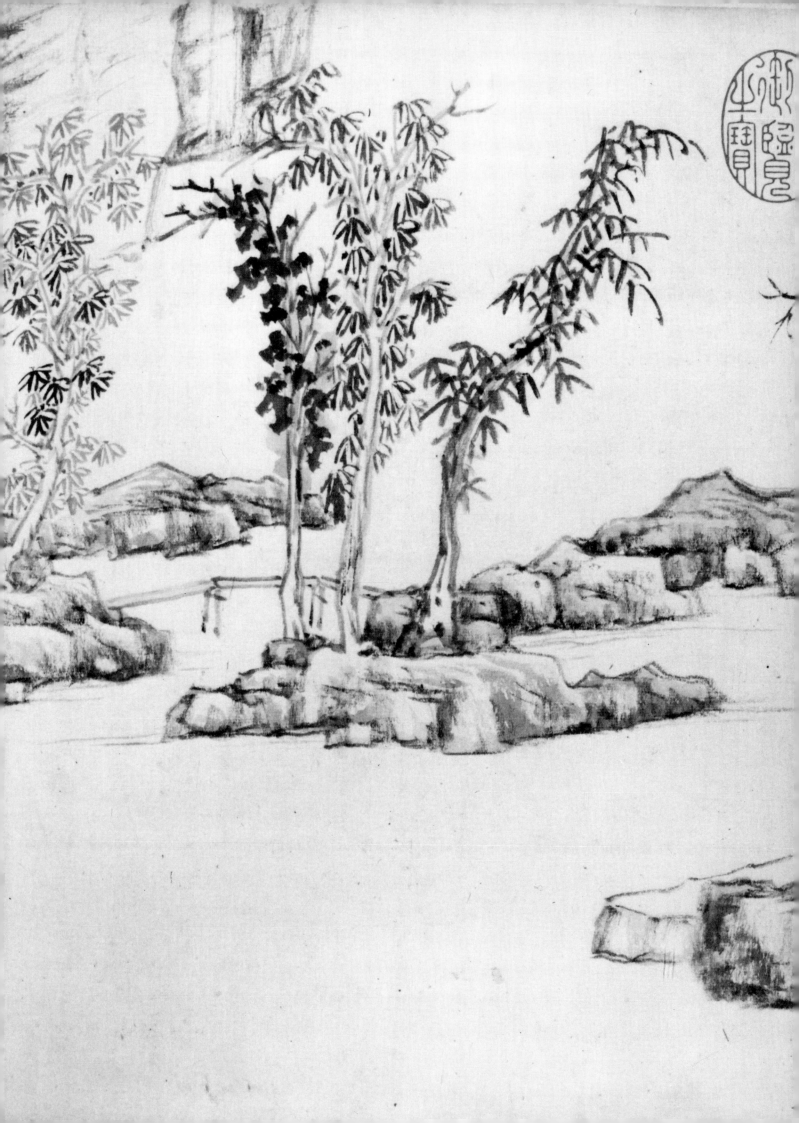

之有蓋同臺篇之閫窮與天地乎並育雖絲謂於此世嘆

不盈於手搦患摯瓶以屢空病昌言之難屬故躓躅於短

於叩缶顧取笑乎鳴玉若夫應感之會通塞之紀來不可

韻放庸音以足曲恒遺恨以終篇豈懷盈而自足懼蒙塵

過去不可止藏若景滅行猶響起方天機之駿利夫何紛

而不理患風發於曾臆言泉流於唇齒紛紜葳蕤以馺遝惟

毫素之所擬文徵而溢目音泠泠而盈耳及其六情底

滯志往神留元若枯木窈若迴流覽螢魂以探賾頓精爽

而自求理翳翳而逾伏思軋軋其若抽是故或竭情而多

悔或率意而寡尤錐茲物之在我非余力之所勠故時撫

空懷而自惋吾未識夫開塞之所由也伊茲文之為用固

眾理之所因恢萬里使無閡通億載而為津俯貽則於來

葉仰觀象于古文武濟文於將墜宣風聲於不泯塗無遠

而不彌理無微而不綸配霑潤於雲雨象變化乎鬼神被

金石而德廣流管絃而日新

嘉靖甲辰三月過 補菴先生綠筠窩出楮索書此賦書三日未及半而歸至

是再過為補書之巳三易寒暑矣日就昏耄指弱不工不足觀也二月 徵明識

余每觀才士之作竊有以得其心夫其放言遣辭良多變
美妍蚩好惡可得而言每自屬文尤見其情恒患意不稱
物文不逮意蓋非知之難能之難也故作文賦以述先士
之盛藻因論作文之利害所由他日殆可謂曲盡其妙至
於操斧伐柯雖取則不遠若夫隨手之變良難以辭逐蓋
昕能言具於此云爾

佇中區以玄覽頤情志於典墳遵四時以歎逝瞻萬物而思
紛悲落葉於勁秋喜柔條於芳春心懍懍以懷霜志眇
眇而臨雲詠世德之俊烈誦先人之清芬遊文章之林府
嘉藻麗之彬彬慨投篇而援筆聊宣之乎斯文其始也皆
收視反聽耽思傍訊精鶩八極心遊萬仞其致也情曈曨而
彌鮮物昭晰而互進傾羣言之瀝液漱六藝之芳潤浮
天淵以安流濯下泉而潛浸於是沈辭怫悅若遊魚銜鈎
而出重淵之深浮藻聯翩若翰鳥嬰繳而墜曾雲之峻收
百代之闕文採千載之遺韻謝朝華於已披啟夕秀於未
振觀古今於須臾撫四海於一瞬然後選義按部考辭就班
抱景者咸叩懷響者必彈或因枝以振葉或沿波而討
源或本隱以末顯或求易而得難或虎變而獸擾或龍見

文賦

33　ABOVE
Wen Cheng-ming (1470–1559),
The Art of Letters.
First section of handscroll.
OPPOSITE: Last section.

文徵明小楷陸機文賦卷

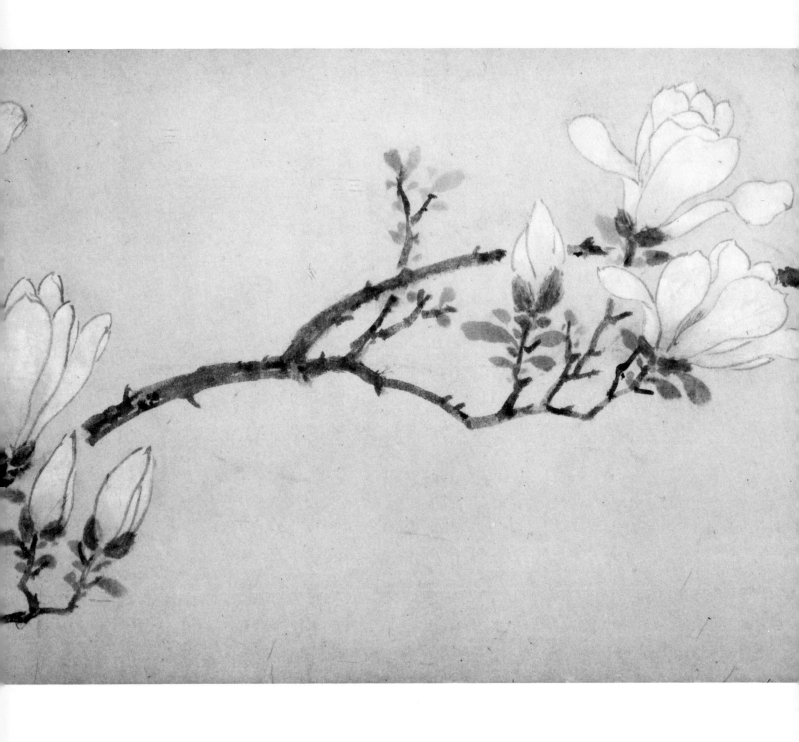

34 Wen Cheng-ming (1470–1559),
Magnolia.
First section of handscroll.

文徵明玉蘭畫卷

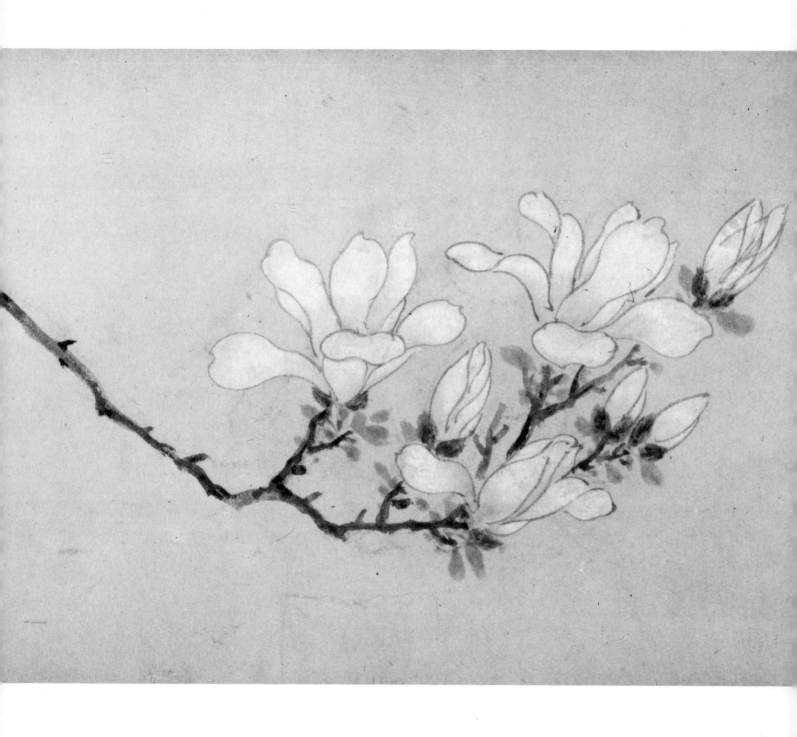

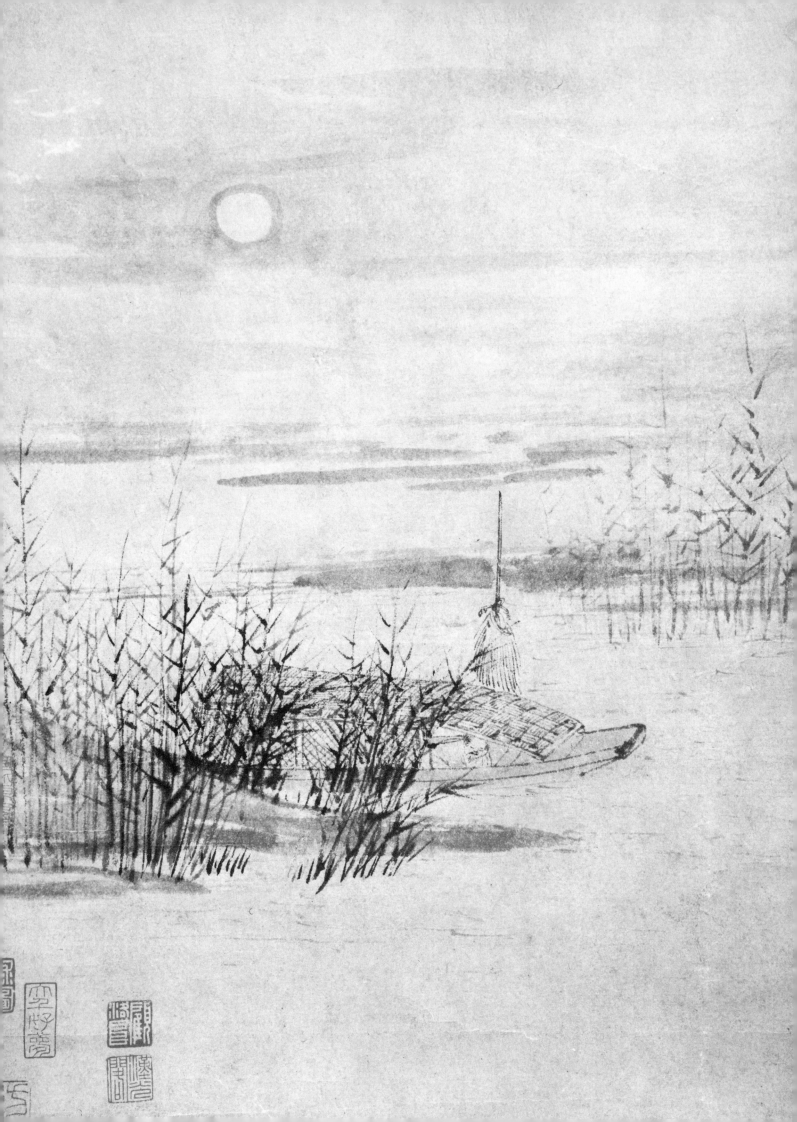

插篙蕭渚繫釣艖
三更月上當篙頂老
漁爛醉喚不醒起來
霜印蓑衣影　唐寅畫

35　RIGHT
T'ang Yin
(1470–1523),
*Drunken Fisherman
by a Reed Bank.*
OPPOSITE: Detail.

唐寅葦渚醉漁畫軸

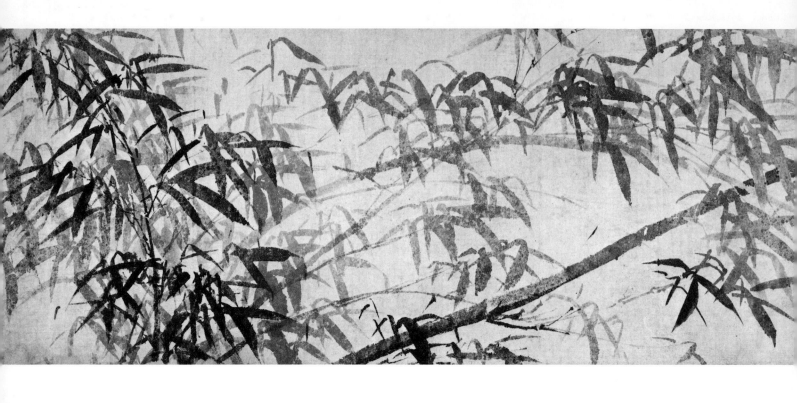

36a ABOVE
T'ang Yin (1470–1523),
Ink-bamboo.
Complete handscroll.
OPPOSITE RIGHT: Detail of the poem inscribed by the artist.

唐寅墨竹畫卷

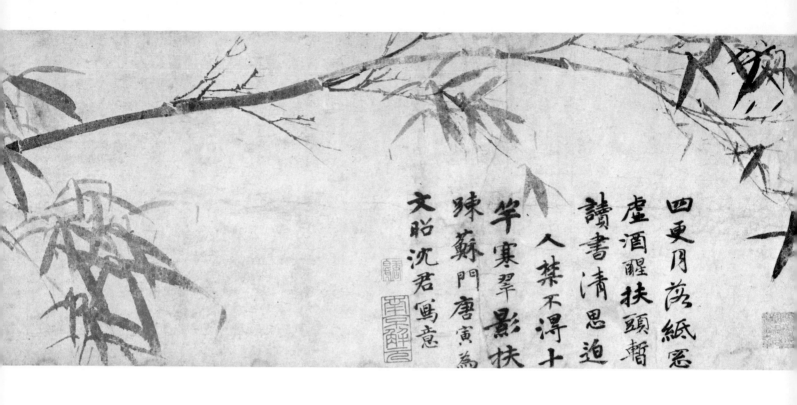

四更月落紙窓寒
虚酒醒扶頭暫
讀書清思迥
人葉不得十
竽寒翠影扶
辣蘇門唐寅為
文昭沈君寫意

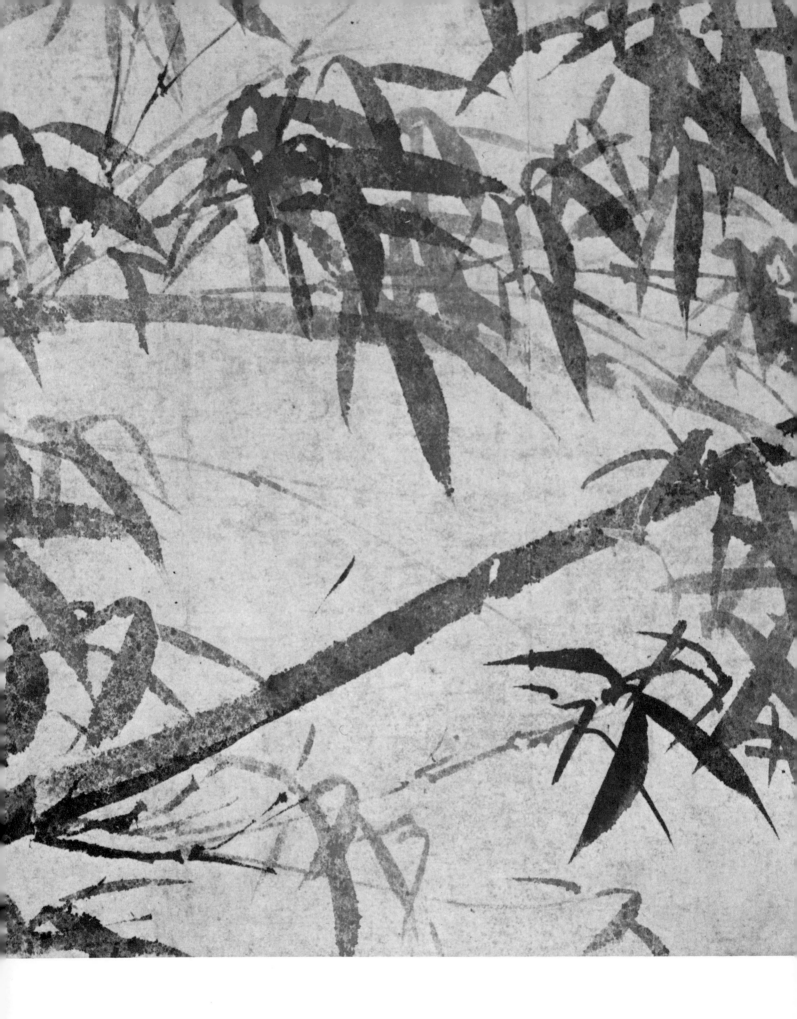

36b T'ang Yin (1470–1523),
Ink-bamboo.
Detail of handscroll.

唐寅墨竹畫卷

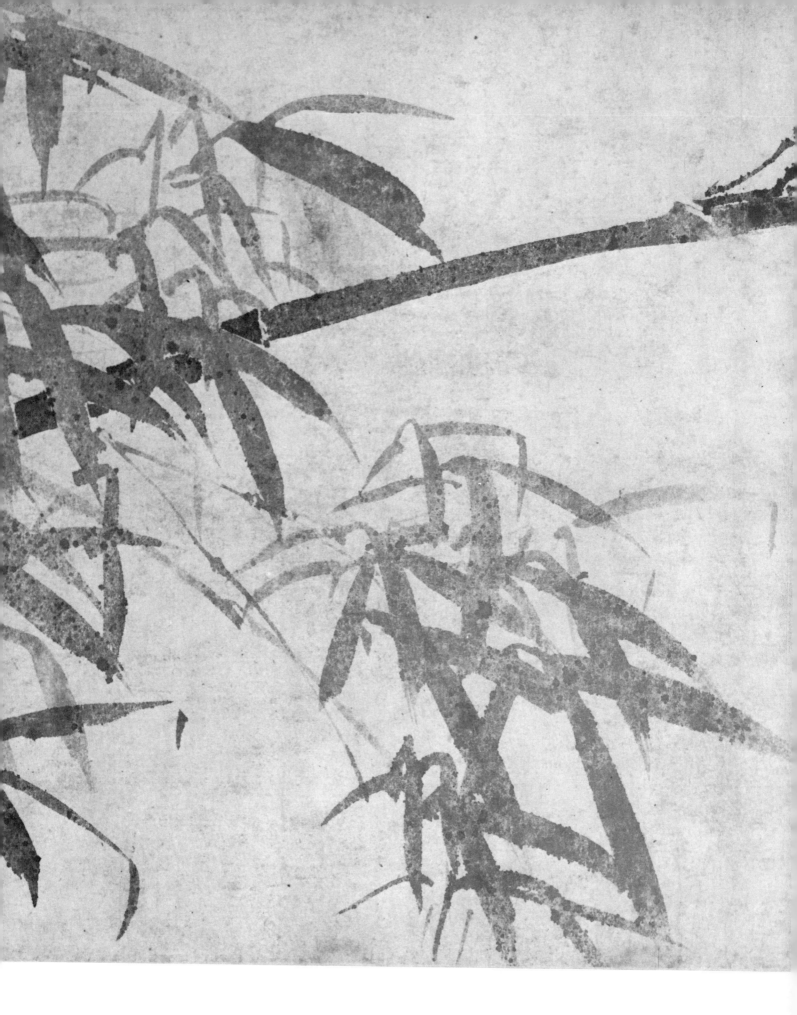

37 FOLLOWING SPREAD
Wu I (1472–1519),
Enjoying the Pines.
"Enjoying" on the right and "the Pines" on the left.

吳奕篆書怡松（後双頁）

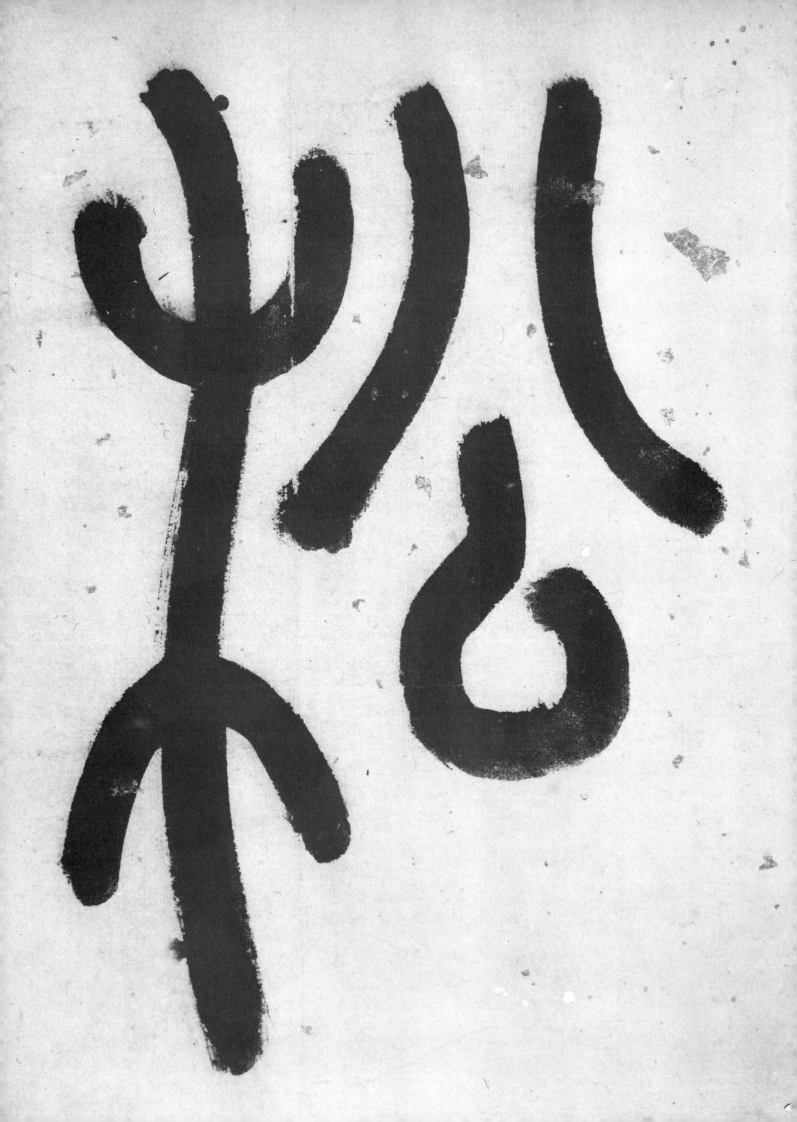

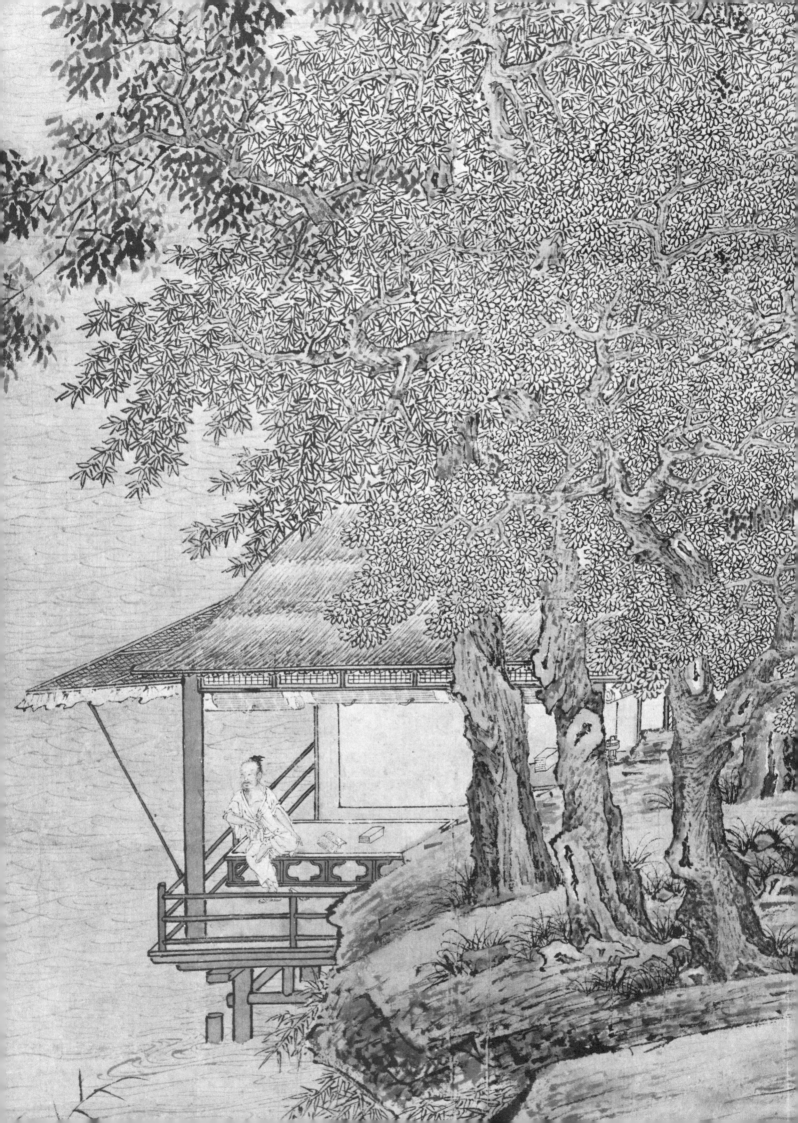

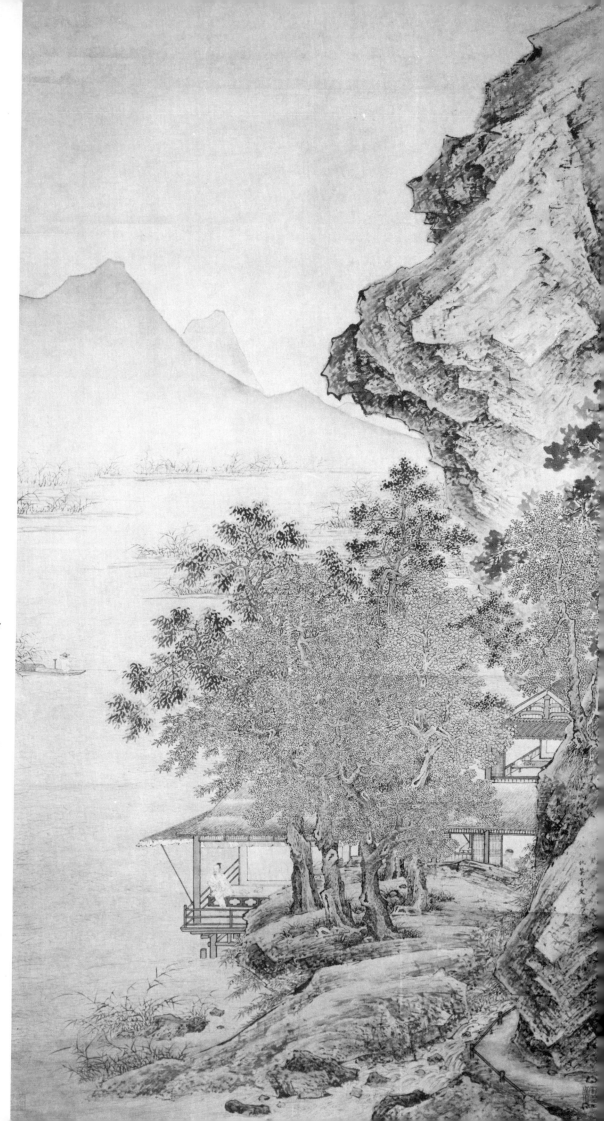

38 RIGHT
Ch'iu Ying
(probably
1494/5–1552),
*Fisherman's Flute
Heard over
the Lake.*
OPPOSITE: Detail.

仇英滄浪漁笛畫軸

39 Wang Ch'ung (1494–1533),
Letter to Nan-ts'un.
Approx. actual size.

王寵致南村高士書

散庄菜峯事鄰
盛東王先生極力周旋甚
感更望
南村為我多致意必得
其餘雜需來氏以一兩為□

40 Lu Chih (1496–1576),
Brocaded Sea of Peach-blossom Waves.

陸治桃花錦浪畫扇

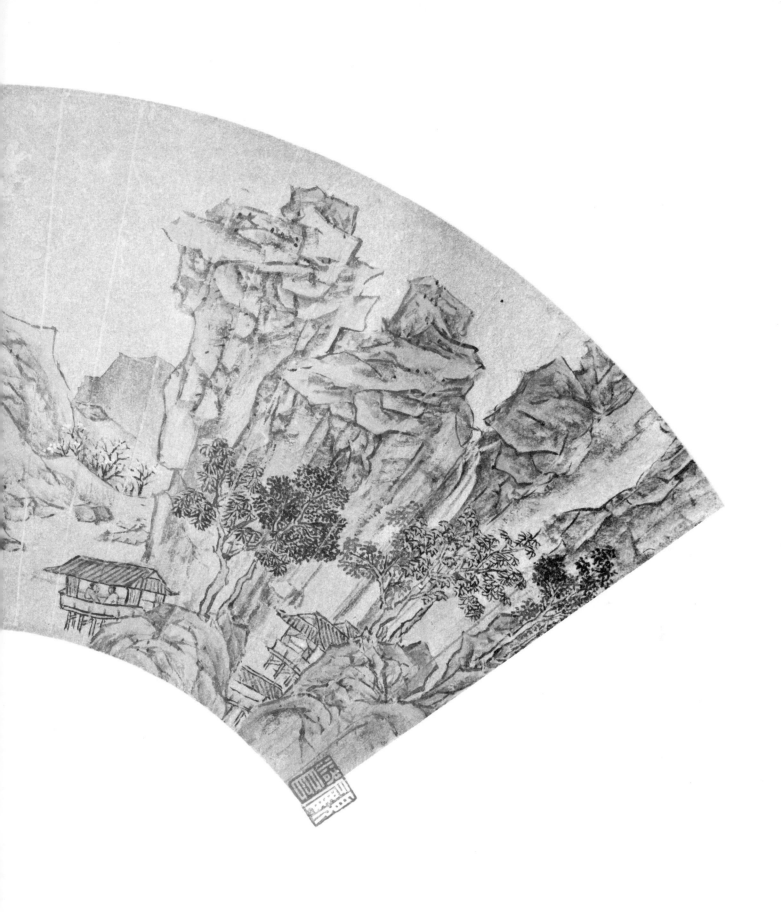

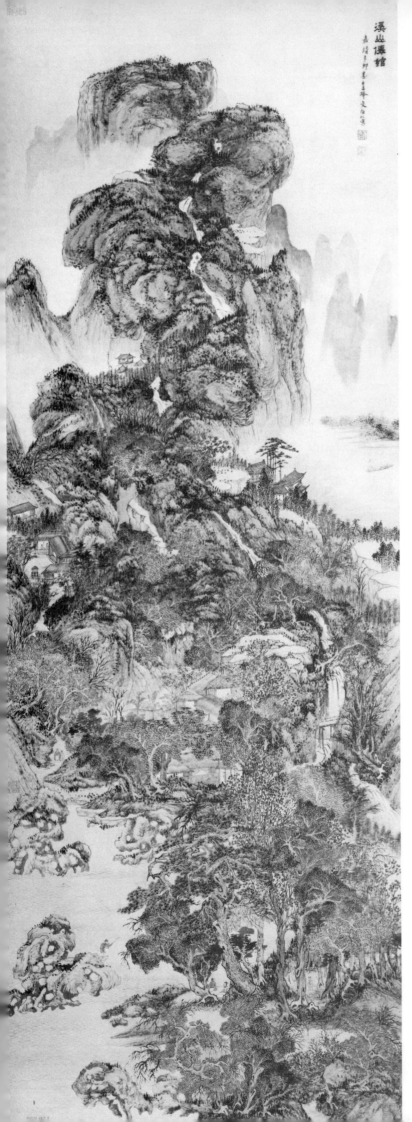

溪山傳館

文伯仁溪山仙館畫軸

41 LEFT
Wen Po-jen (1502–1575),
*Dwellings of the Immortals
amid Streams and Mountains.*
OPPOSITE & FOLLOWING
SPREAD: Details.

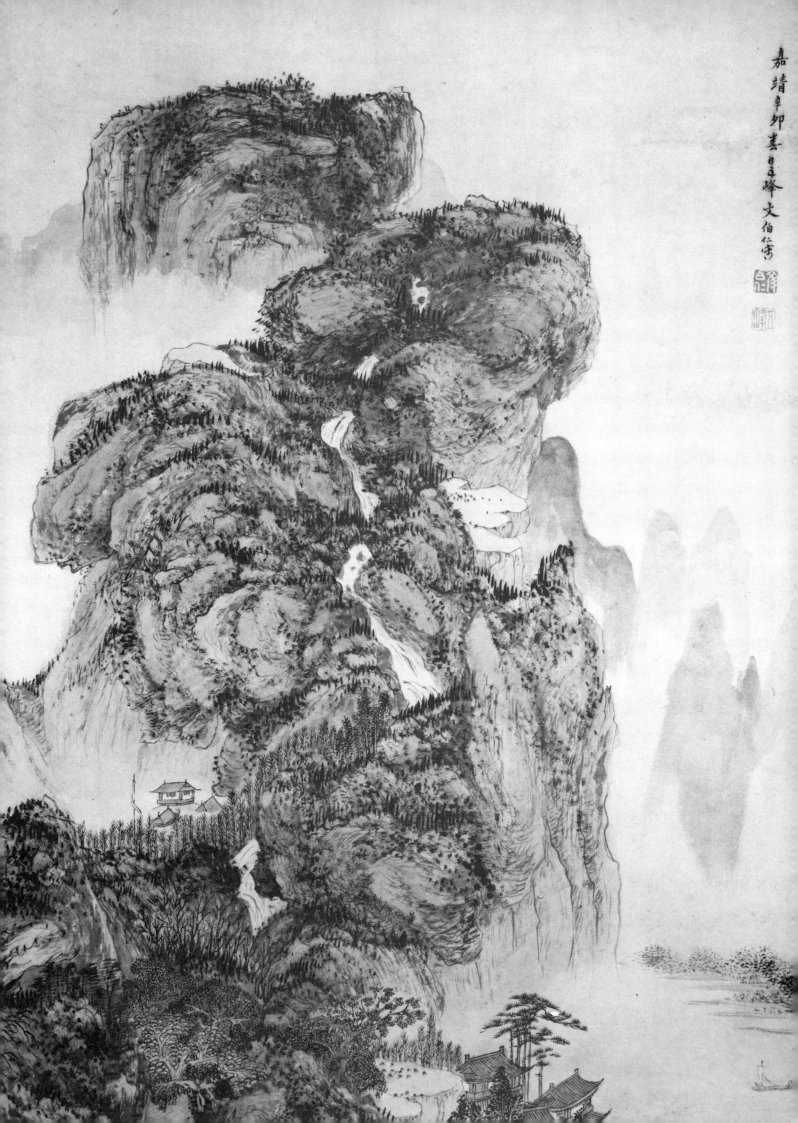

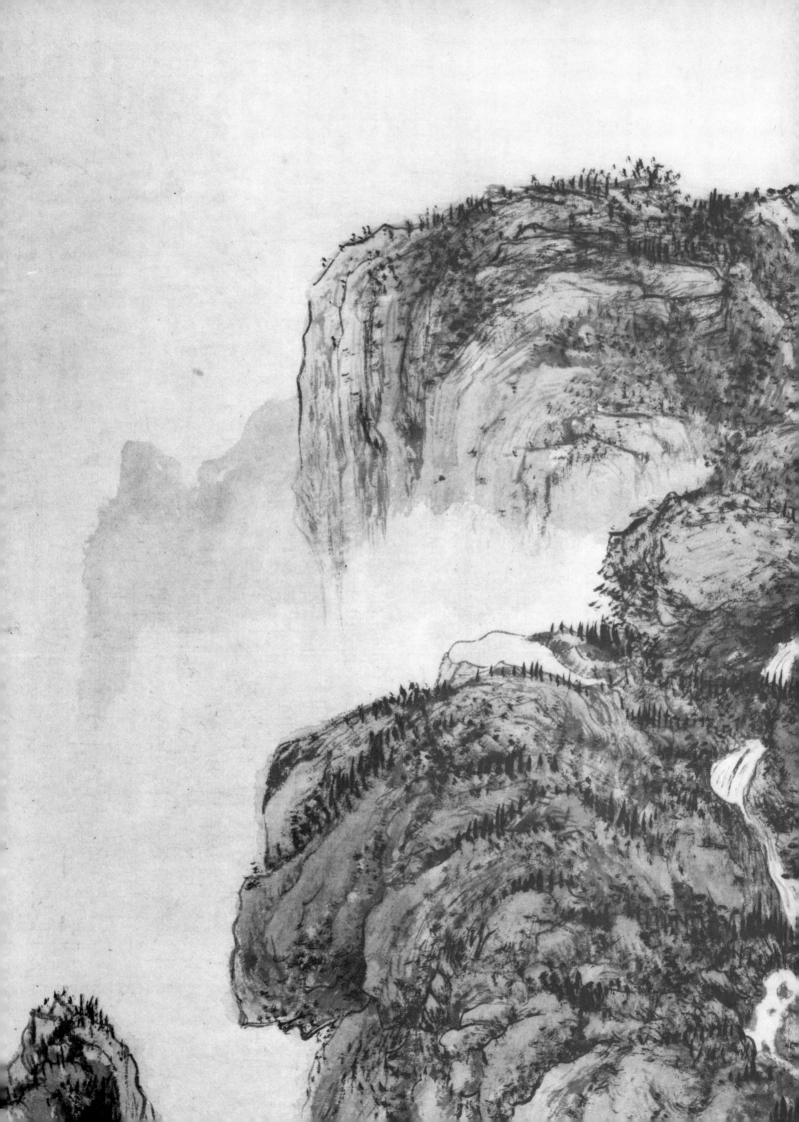

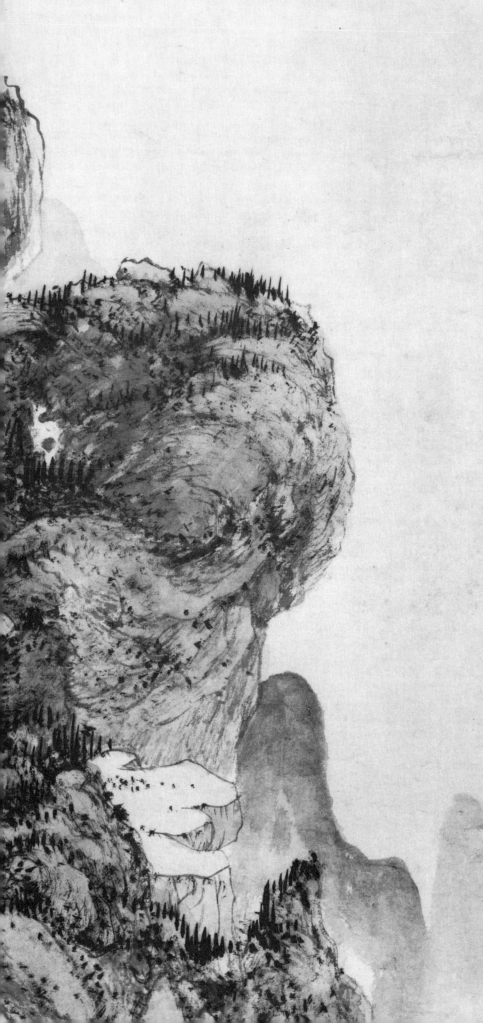

溪山謀館

嘉靖辛卯春日五峰文伯仁寫

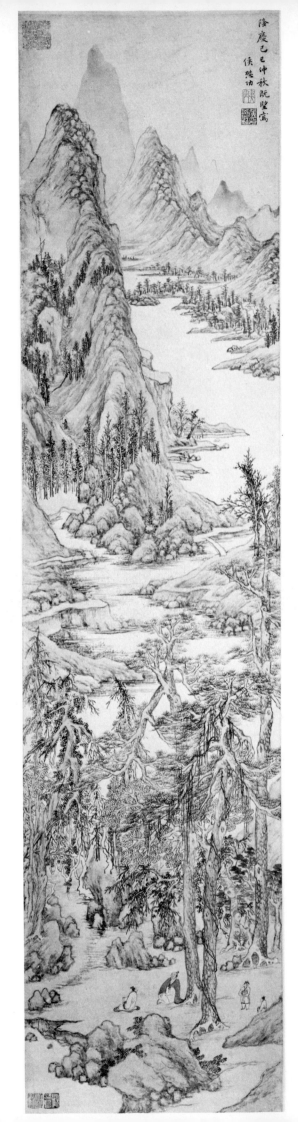

42 **LEFT**
Hou Mou-kung (fl. ca. 1540–1580),
High Mountains.
OPPOSITE: Detail.

侯懋功山水軸

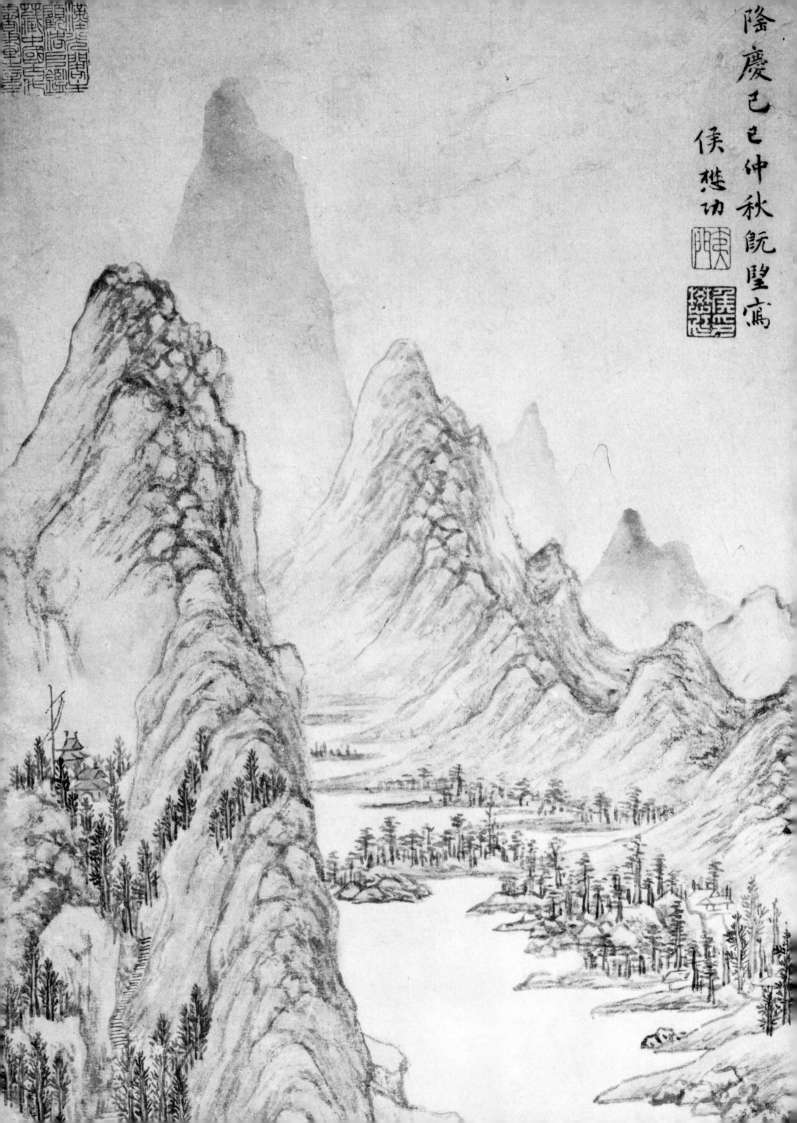

隆慶己巳仲秋阮聖寓
侯懋功

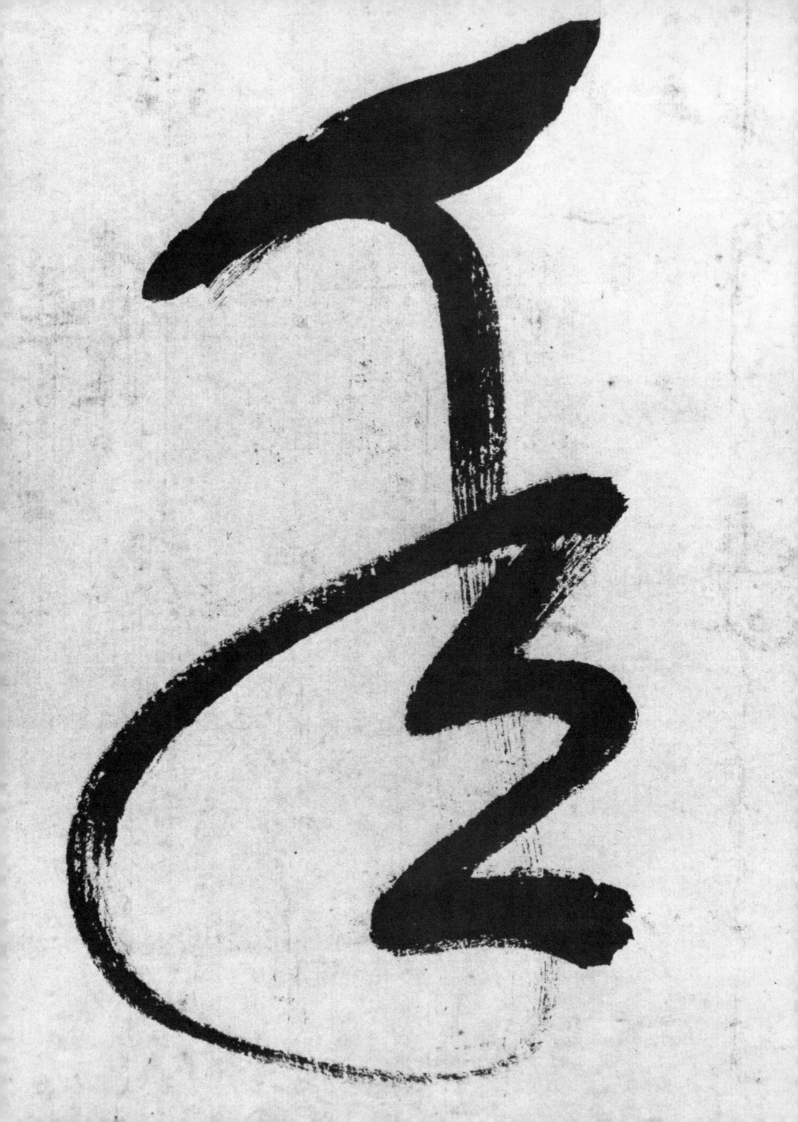

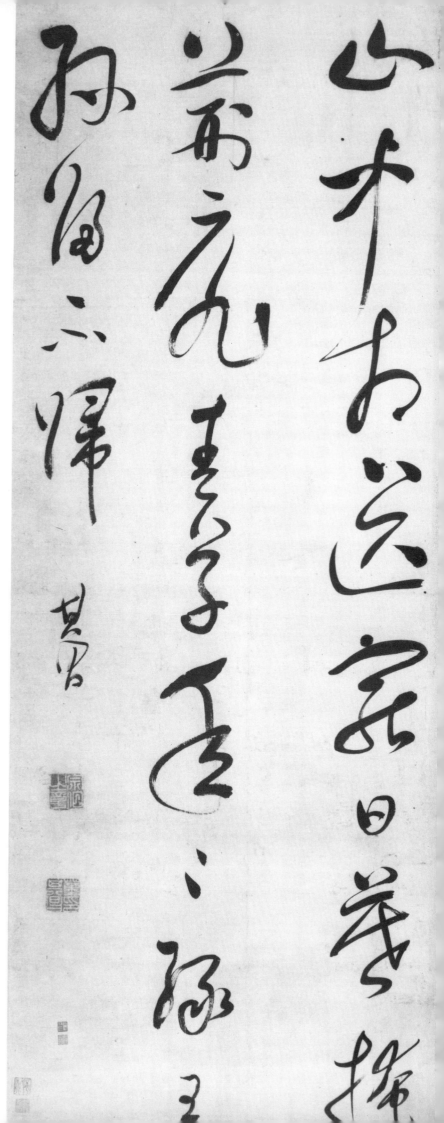

43 RIGHT
Tung Ch'i-ch'ang (1555–1636),
Poem by Wang Wei.
OPPOSITE: Detail, a single character.

董其昌草書王維五言絕句軸

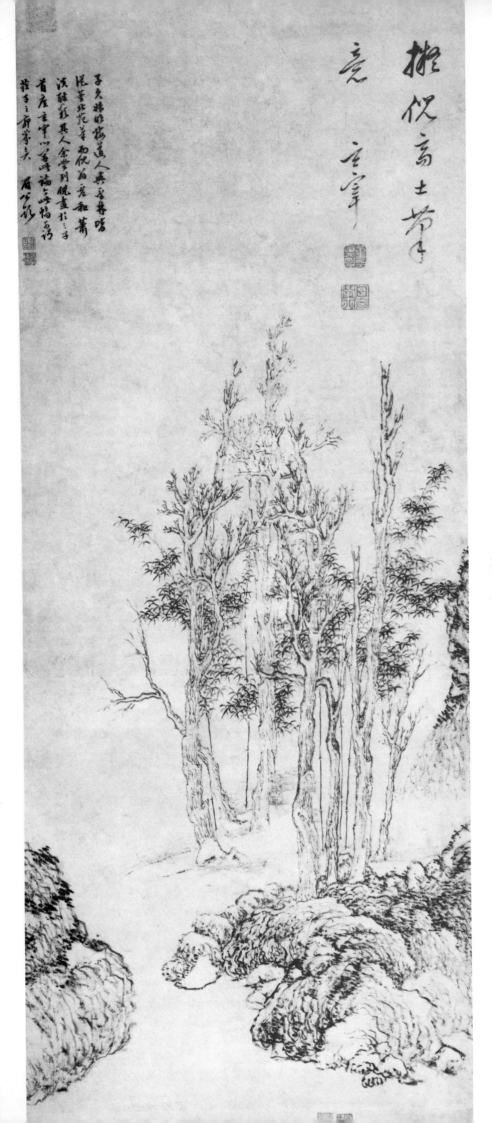

44 **LEFT**
Tung Ch'i-ch'ang (1555–1636),
Landscape with Trees,
after Ni Tsan.
OPPOSITE: Detail.

董其昌仿倪瓚筆意軸

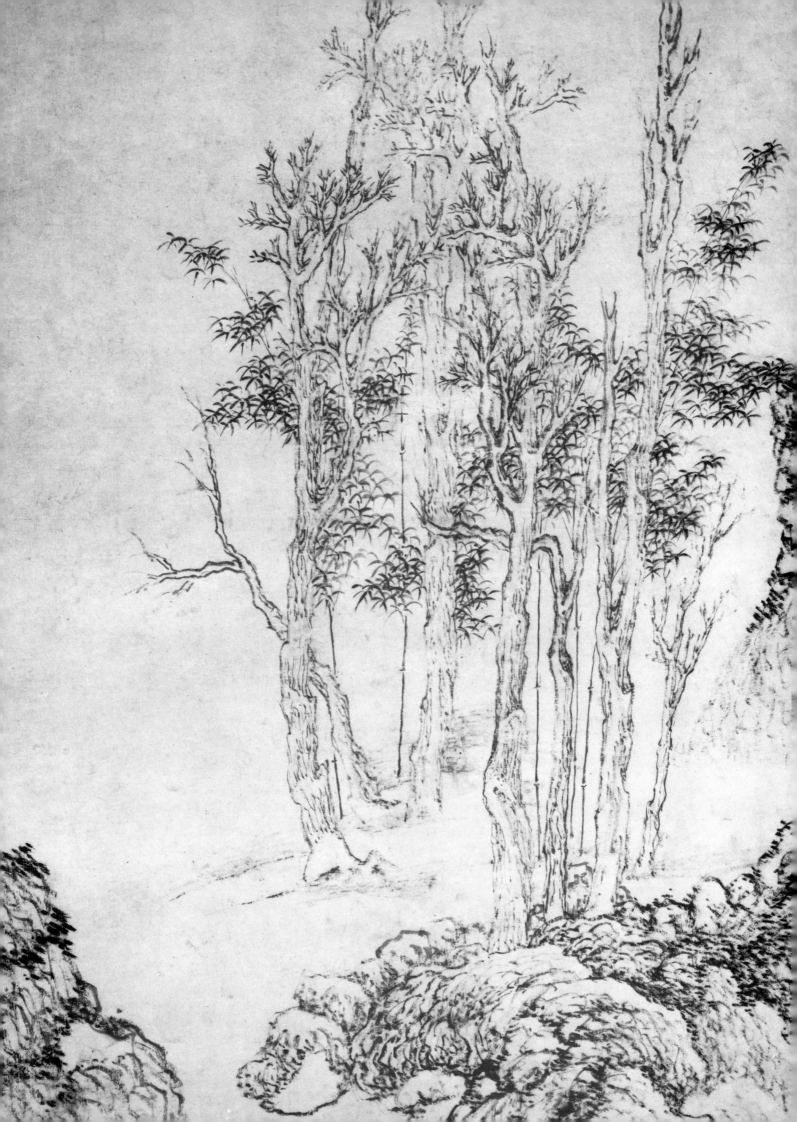

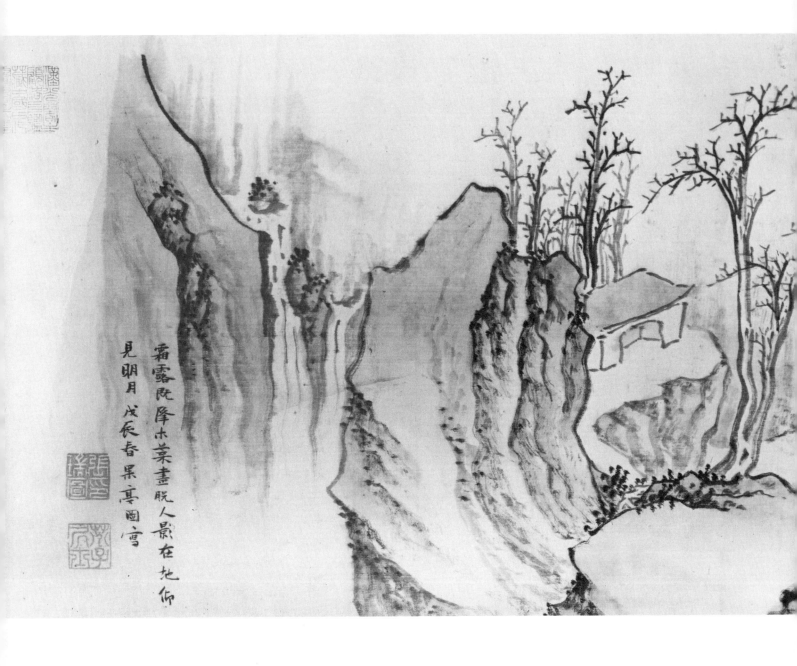

霜露既降木葉盡脫人影在地仰
見明月戊辰春果亭畫雪

45 Chang Jui-t'u (1570–1641),
Ode on the Red Cliff, Part II.
Last section of handscroll.

張瑞畫後赤壁賦畫卷

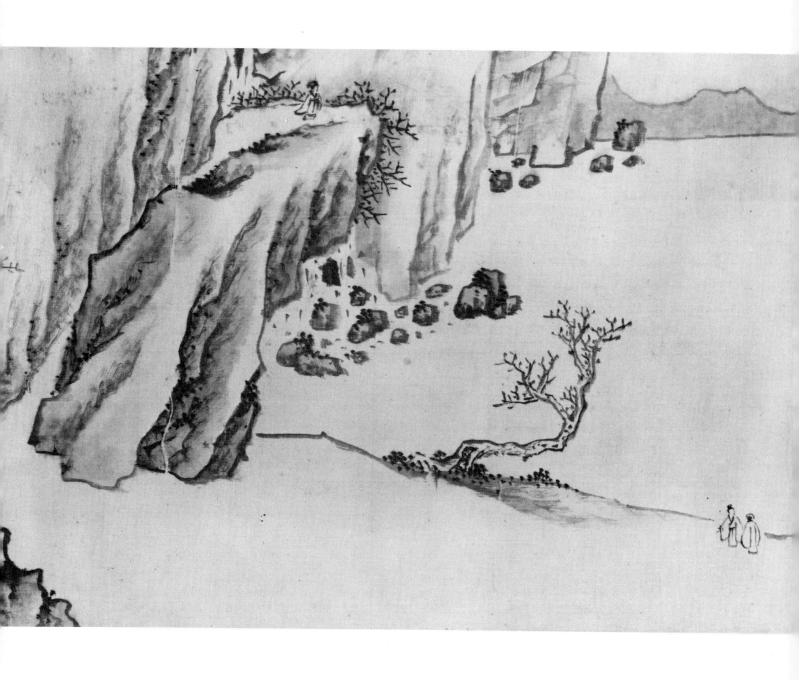

46 RIGHT
Chang Jui-t'u
(1570–1641),
Couplet.
OPPOSITE: Detail
of two characters
from the second
(left) scroll
of the pair.

張瑞畚行書聯

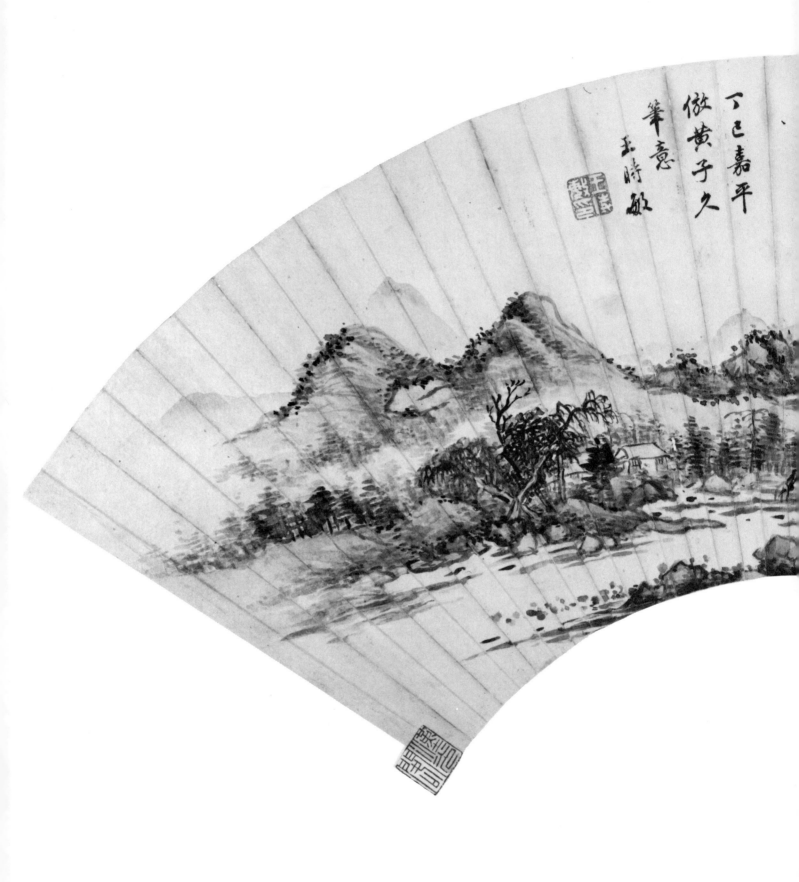

丁已嘉平
倣黃子久
筆意
王時敏

47　Wang Shih-min (1592–1680),
Landscape after Huang Kung-wang.

王時敏仿黃公望筆意画扇

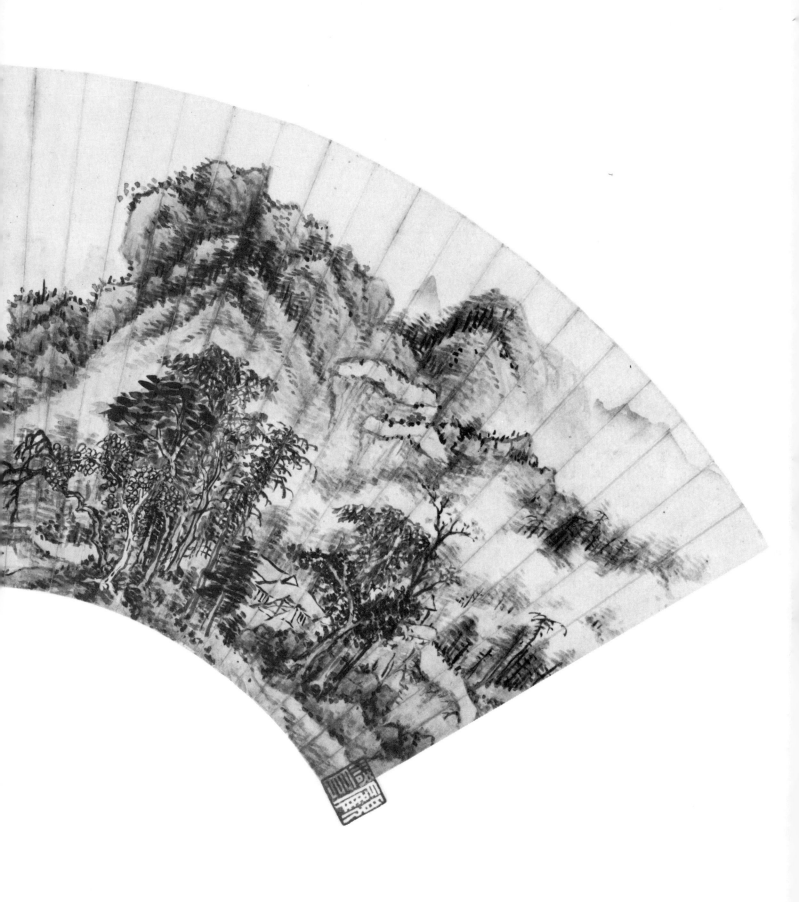

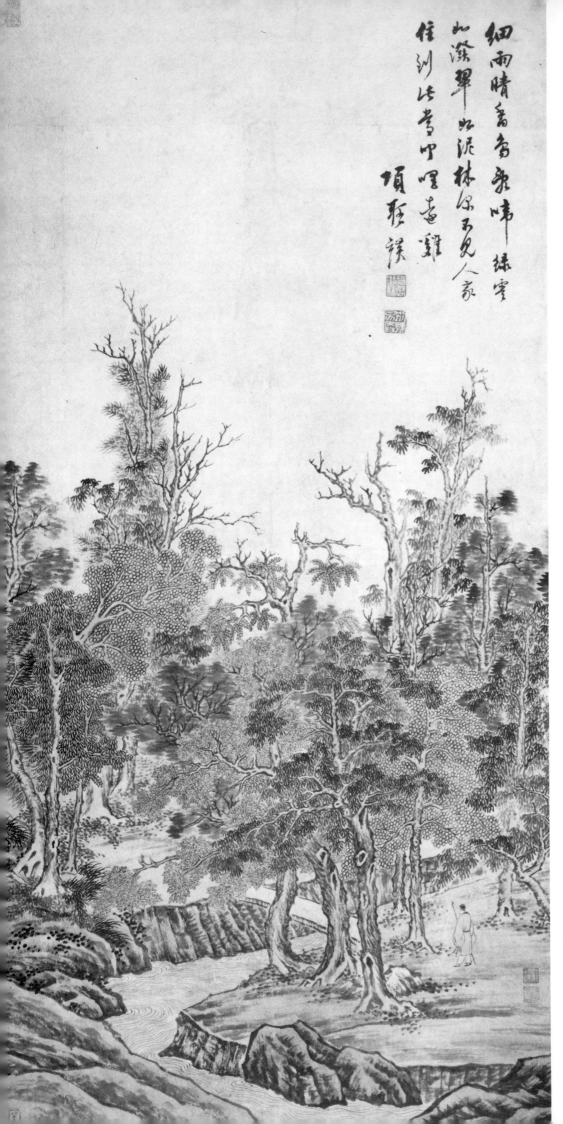

細雨晴香鳥亂啼 綠雲
如潑翠如泥 林深不見人家
住剝啄誰叩呷哩竟難
項聖謨

48 LEFT
Hsiang Sheng-mo
(1597–1658),
Scholar in the Woods.
OPPOSITE: Detail.

項聖謨細雨晴香詩意軸

49 FOLLOWING SPREAD
Fa Jo-chen (1613–1696),
Discourse on Painting.
Section of handscroll.

法若真行草書畫說卷（後雙頁）

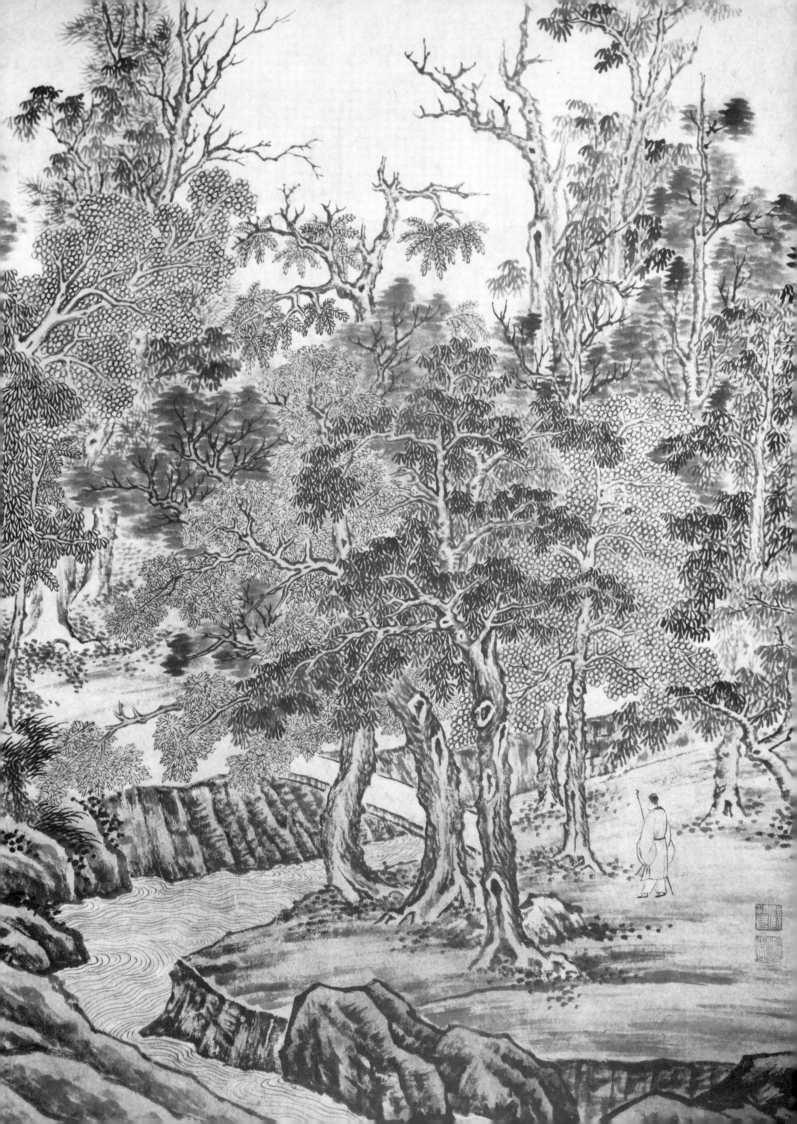

其無乃頁其

畫見山先生邪聖

者太傑先生孫

也書甲天下亡

浪浪王

可以書畫精之而天下之人至
寶而玩遺者此縑天下独
人自其藏其身於翰墨之工
術者也畫者乃以買後
目舄不五其亢於禹錄于

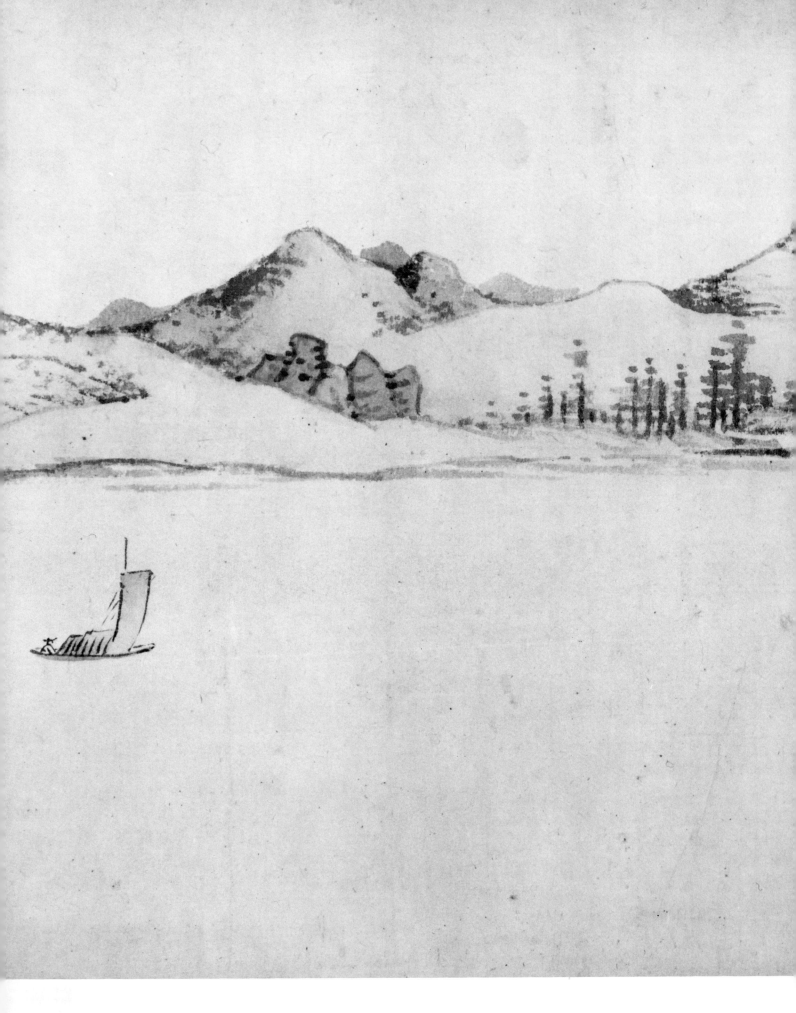

50a Hung-jen (d. 1663),
River Scene in Winter.
Section of handscroll.

弘仁寺橋山色畫卷

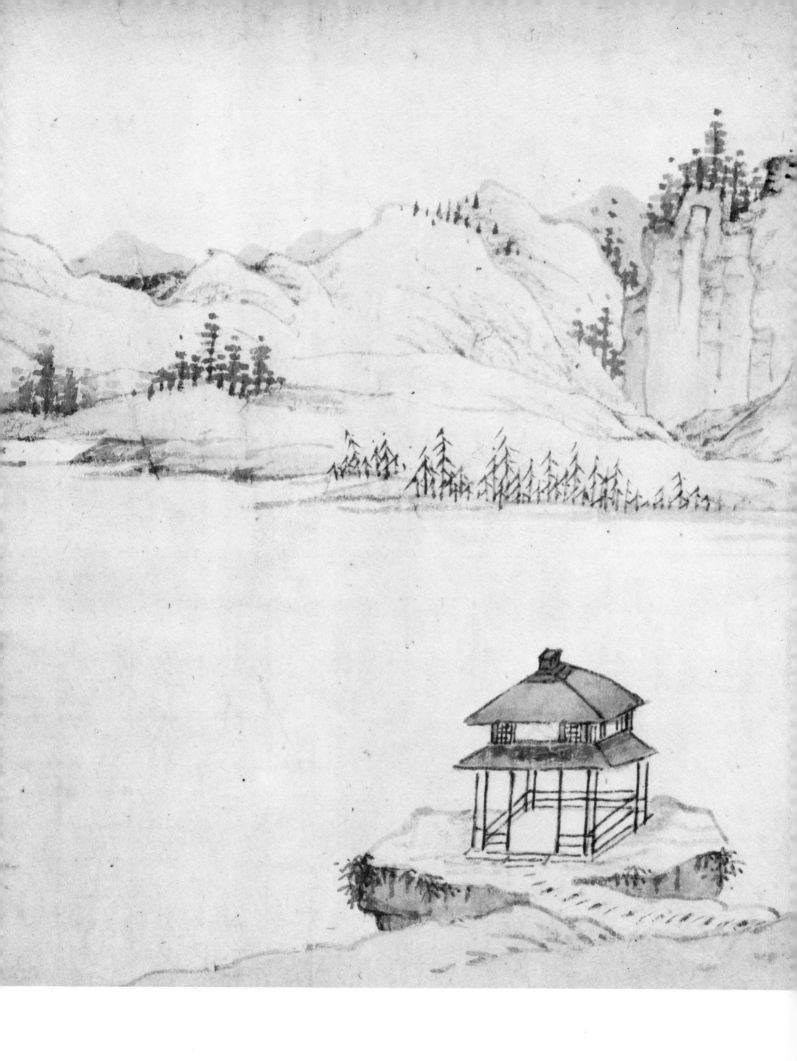

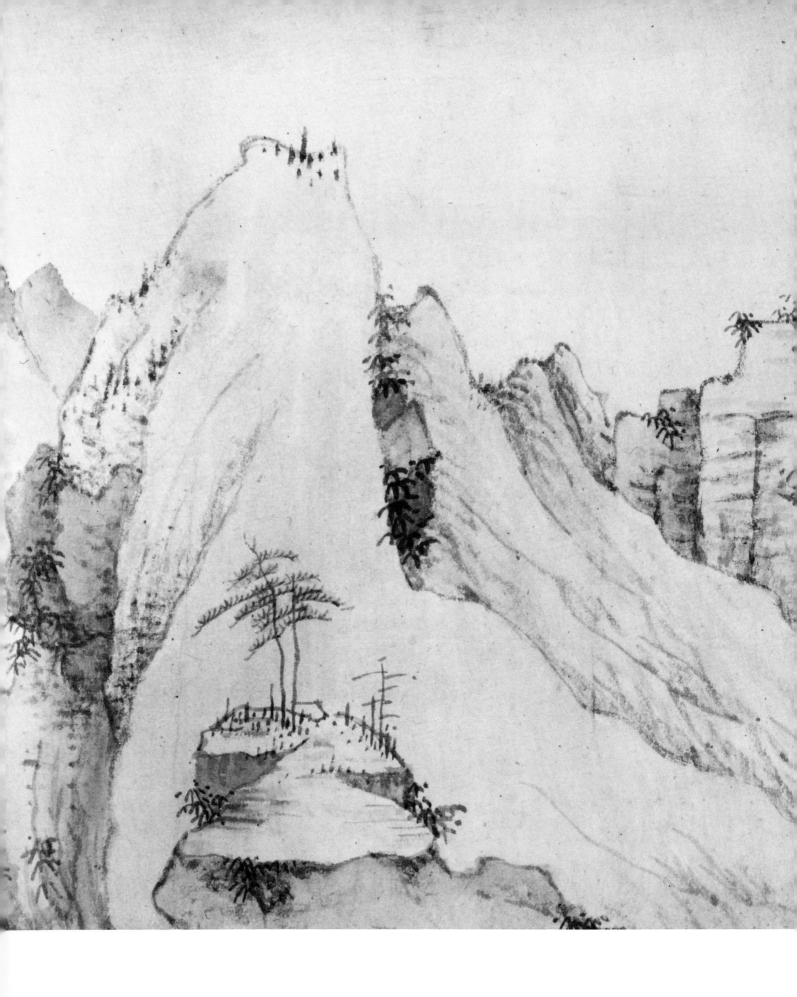

50b Hung-jen (d. 1663),
River Scene in Winter.
Section of handscroll.

弘仁寺橋山色畫卷

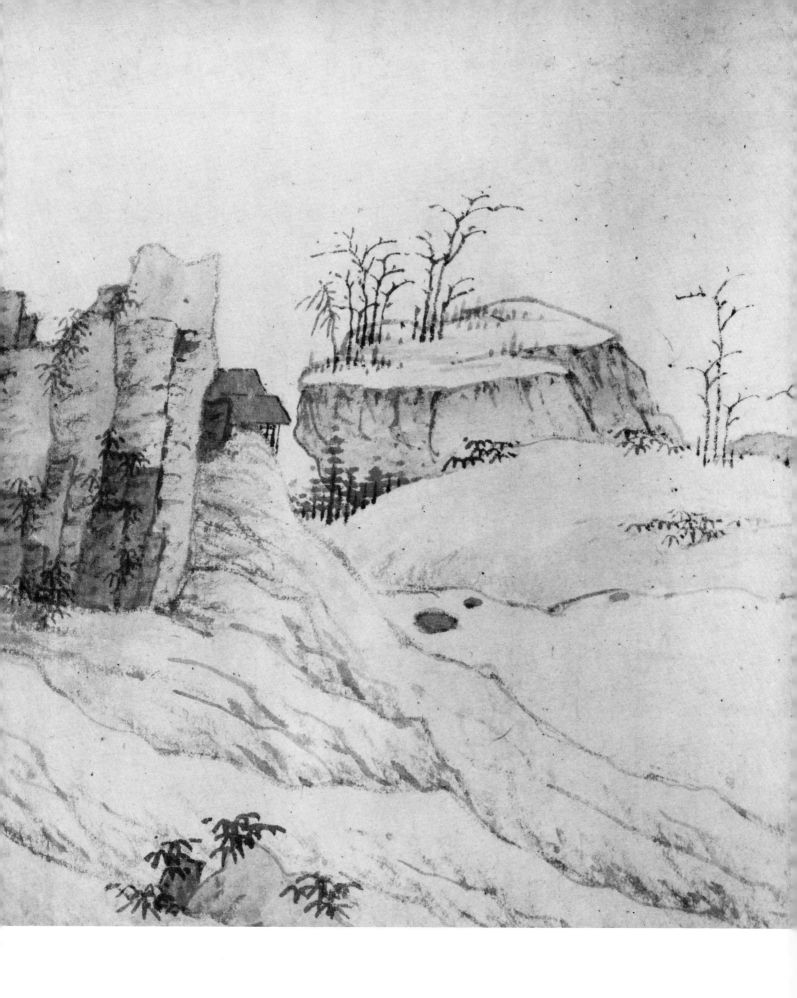

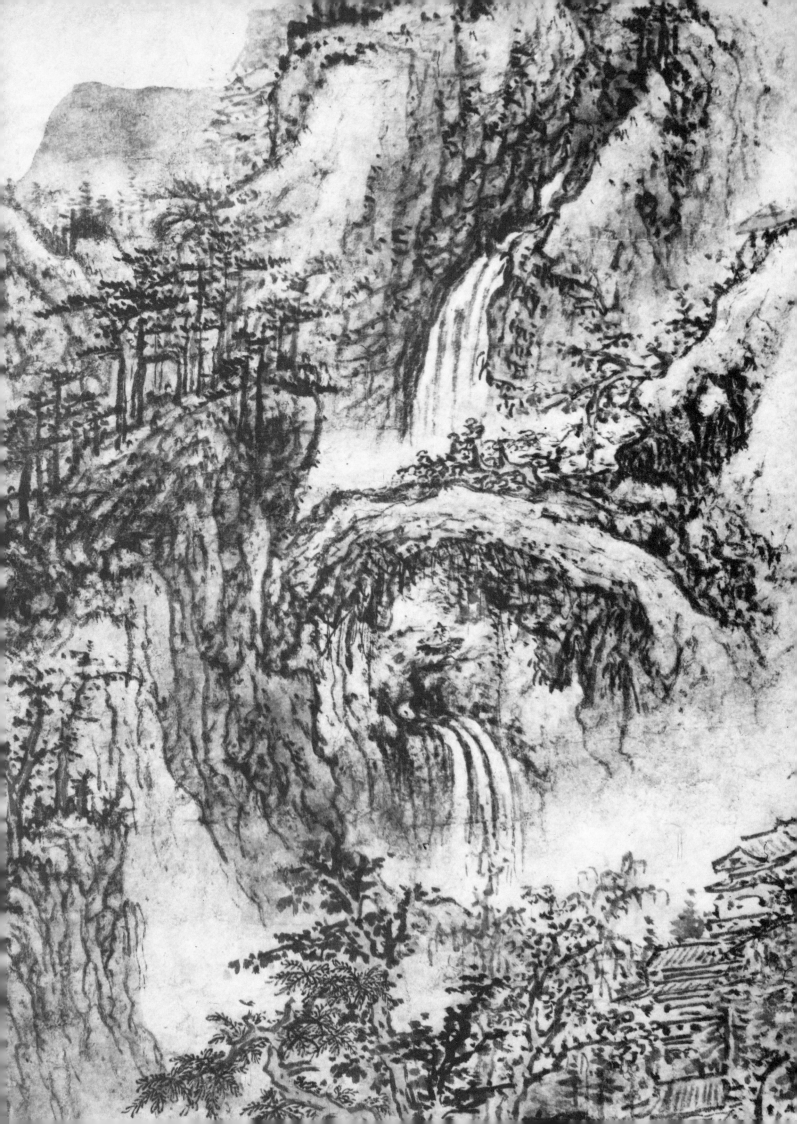

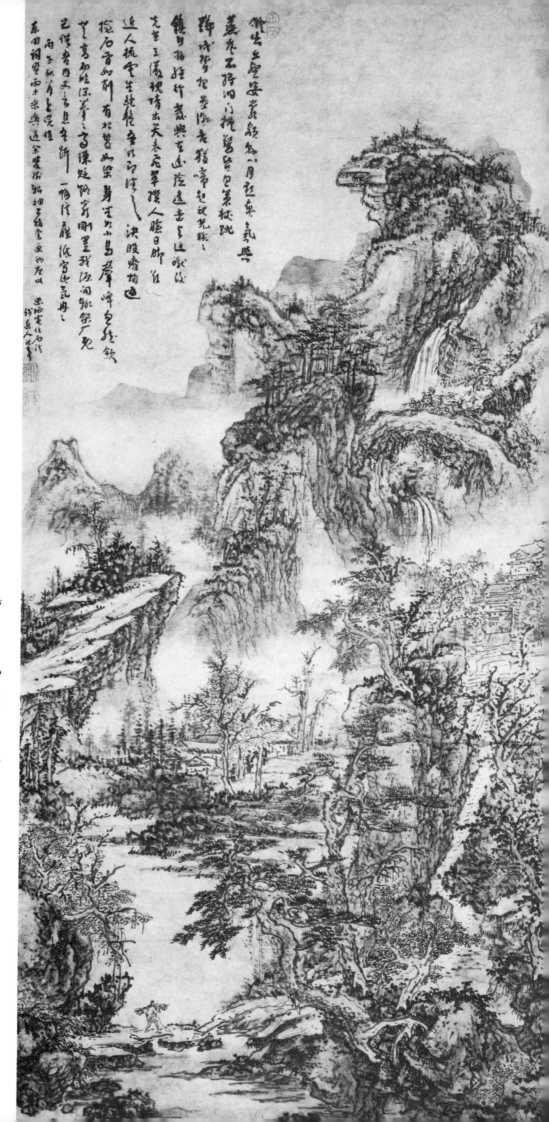

51 RIGHT
K'un-ts'an
(active 1655–1686),
*Wooded Mountains
at Dusk.*
OPPOSITE: Detail.

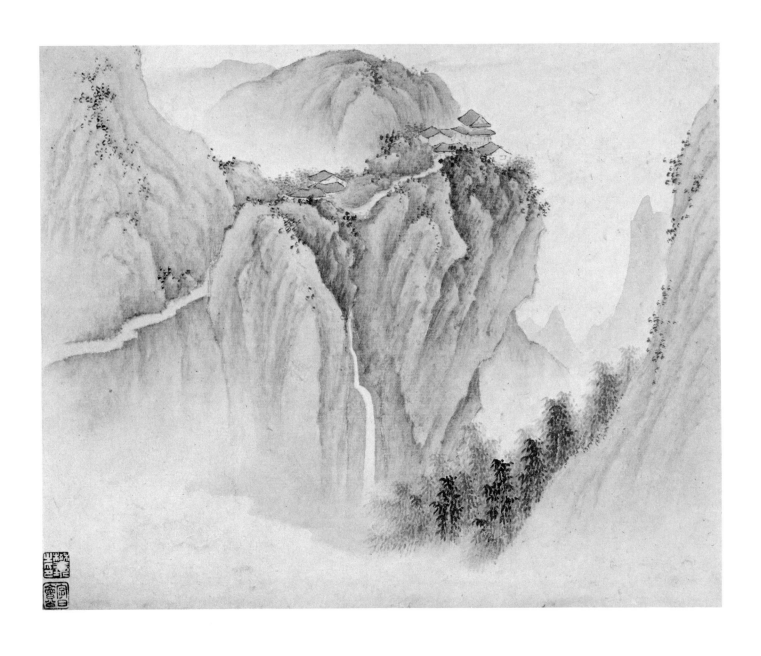

52a Fan Ch'i (b. 1616, still living 1692),
Landscape.
No. 4 of an album of eight leaves.
Actual size.

樊圻山水冊(八葉之四)

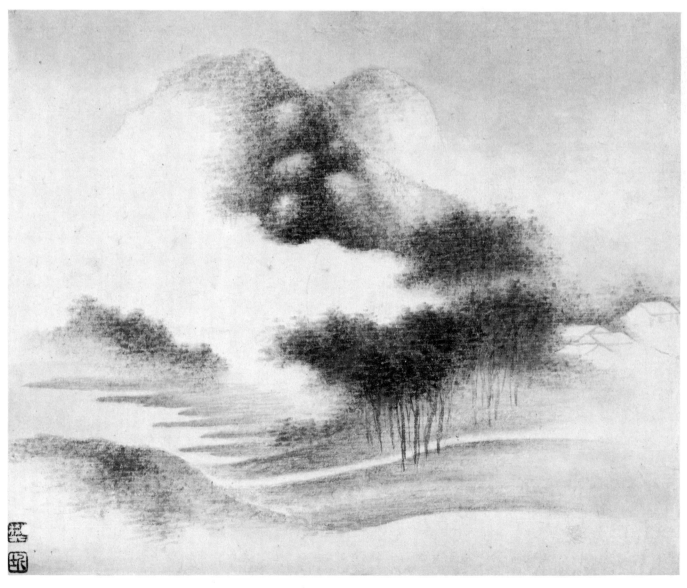

樊圻山水册（八葉之五）

52b Fan Ch'i (b. 1616, still living 1692),
Landscape.
No. 5 of an album of eight leaves.
Actual size.

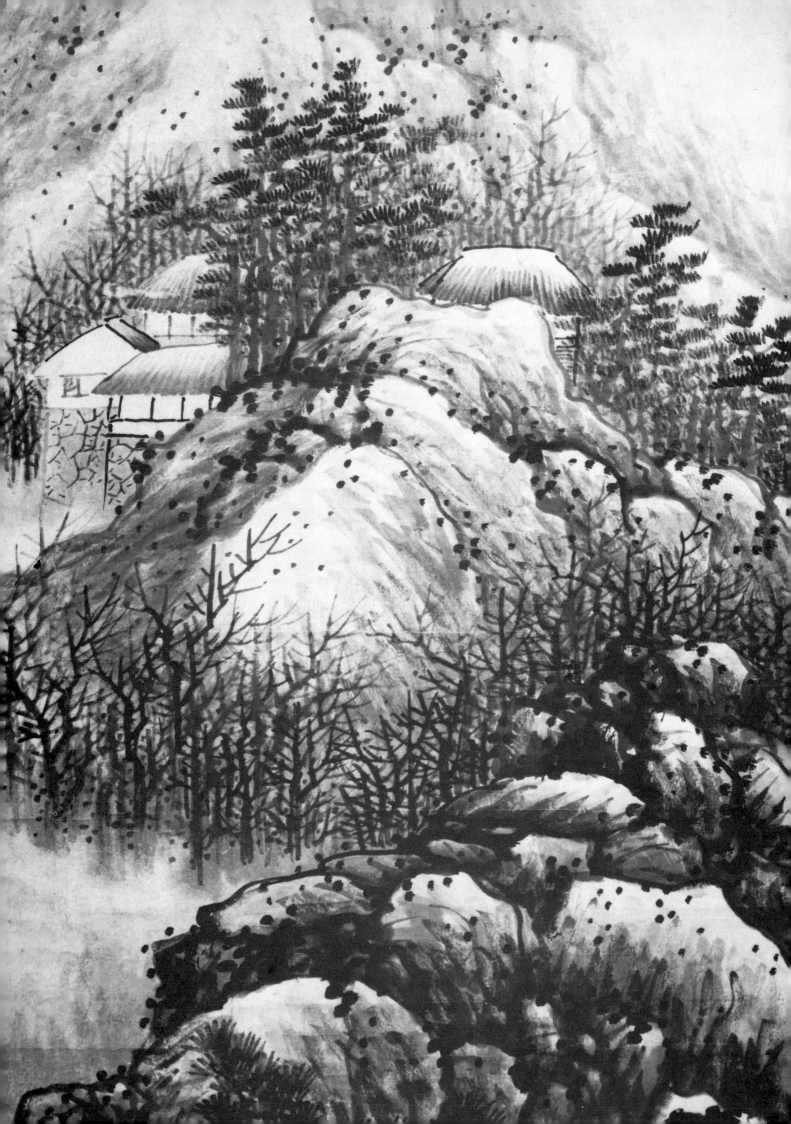

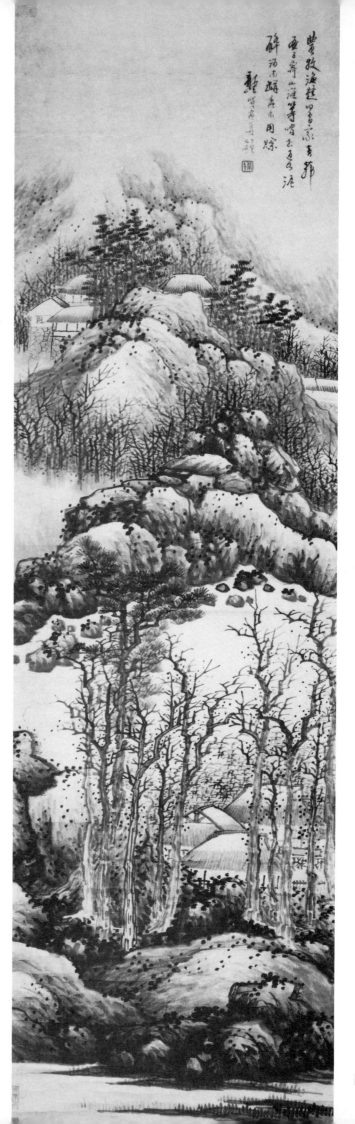

53　RIGHT
Kung Hsien　(ca. 1620–1689),
Wintry Mountains.
OPPOSITE: Detail.

龔賢冬景山水軸

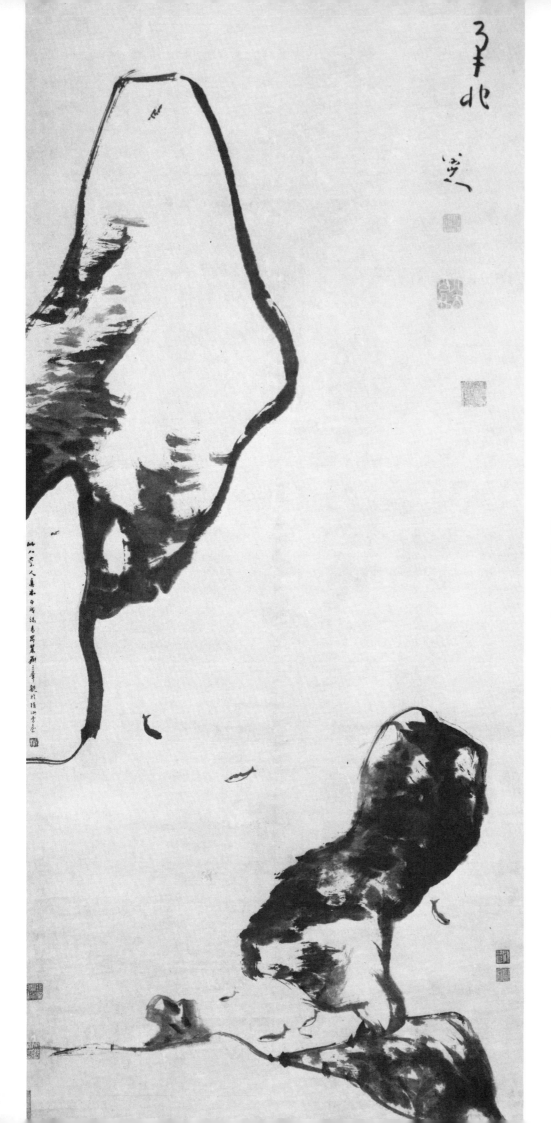

54 **LEFT**
Chu Ta
(1626–1705),
Fish and Rocks.
OPPOSITE: Detail.

朱耷魚樂畫軸

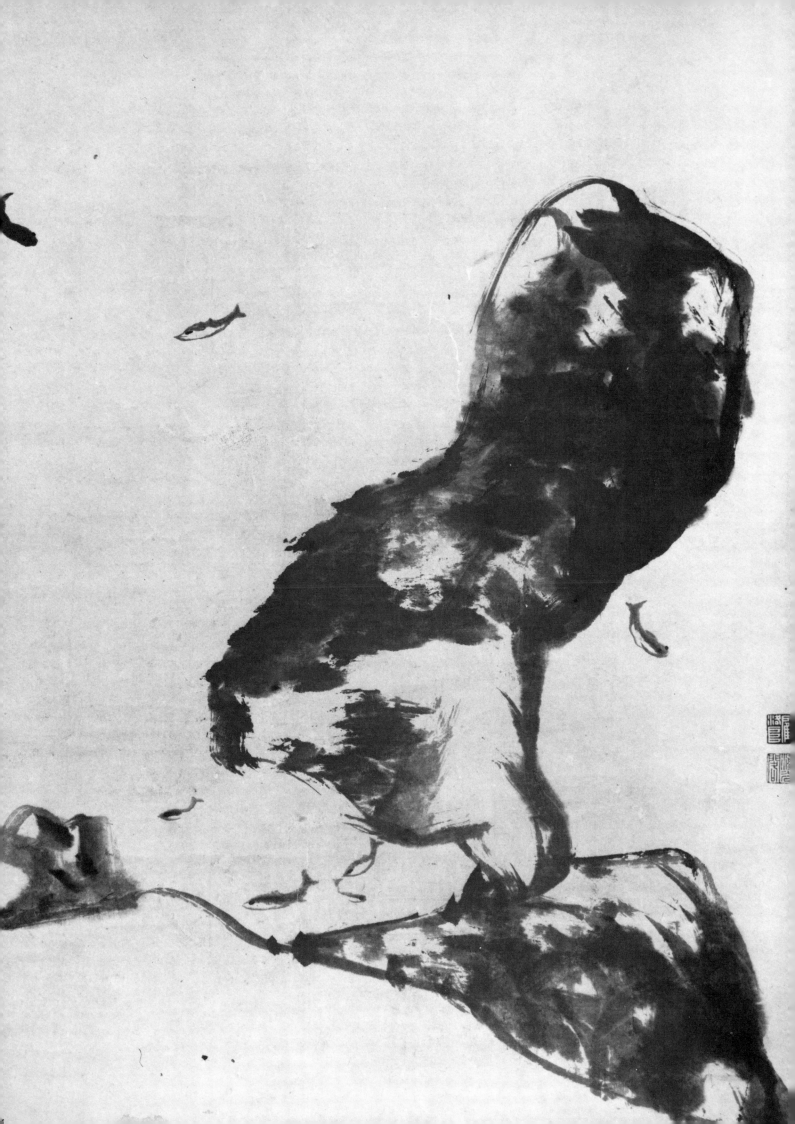

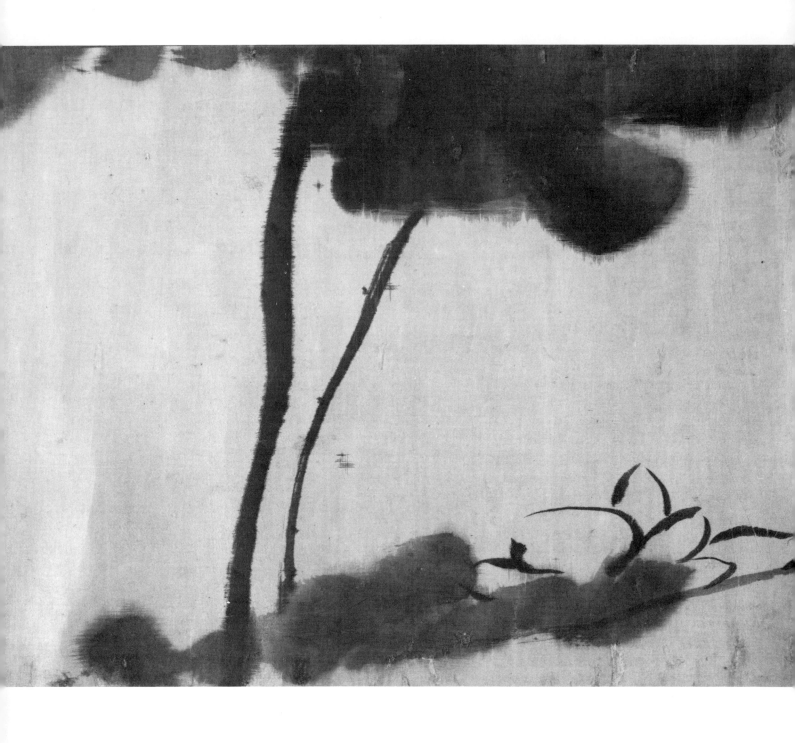

朱耷蓮塘戲禽畫卷

55a Chu Ta (1626–1705),
Birds in a Lotus Pond.
Section of handscroll.

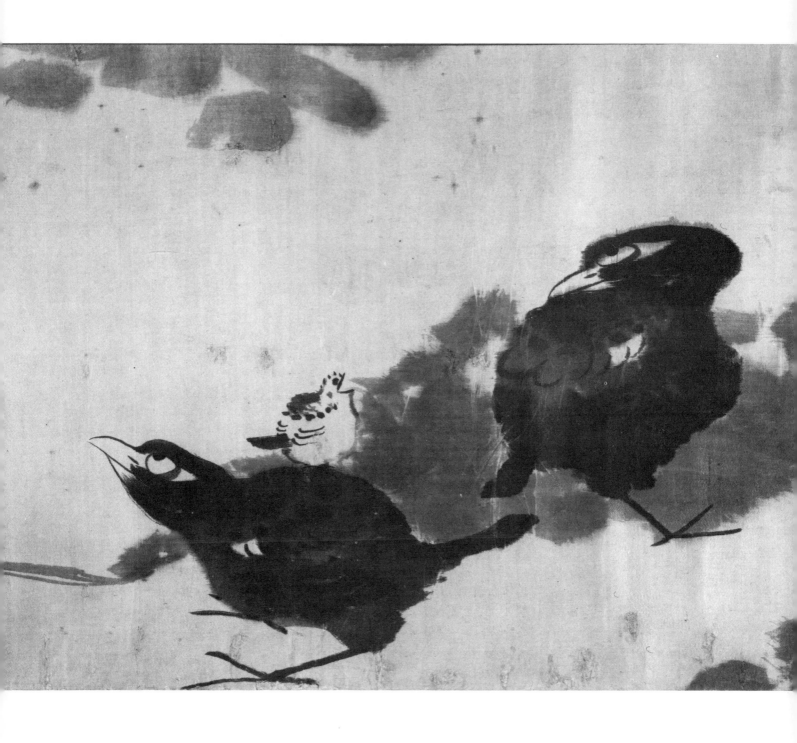

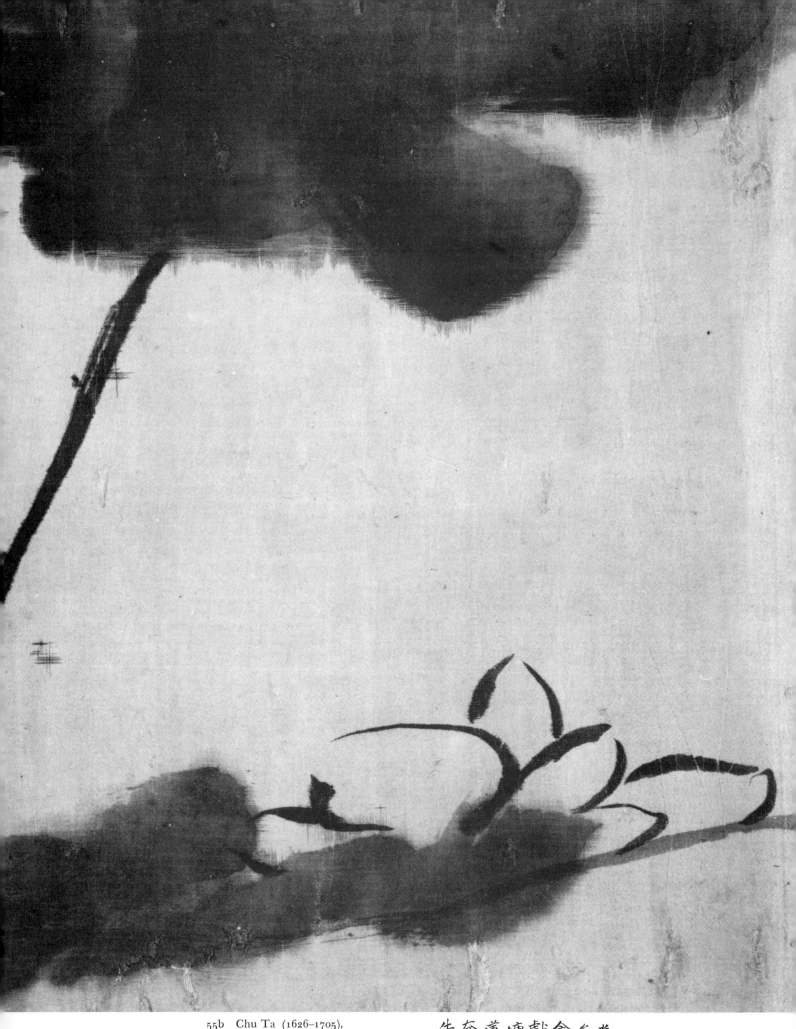

55b Chu Ta (1626–1705),
Birds in a Lotus Pond.
Detail of section of handscroll.

朱耷蓮塘戲禽畫卷

雖無絲竹管弦之盛一觴一詠亦足以暢叙

幽情是日也天朗氣清惠風和暢仰觀

宇宙之大俯察品類之盛遊目騁懷信

可樂也

公之書

臨蘭亭序

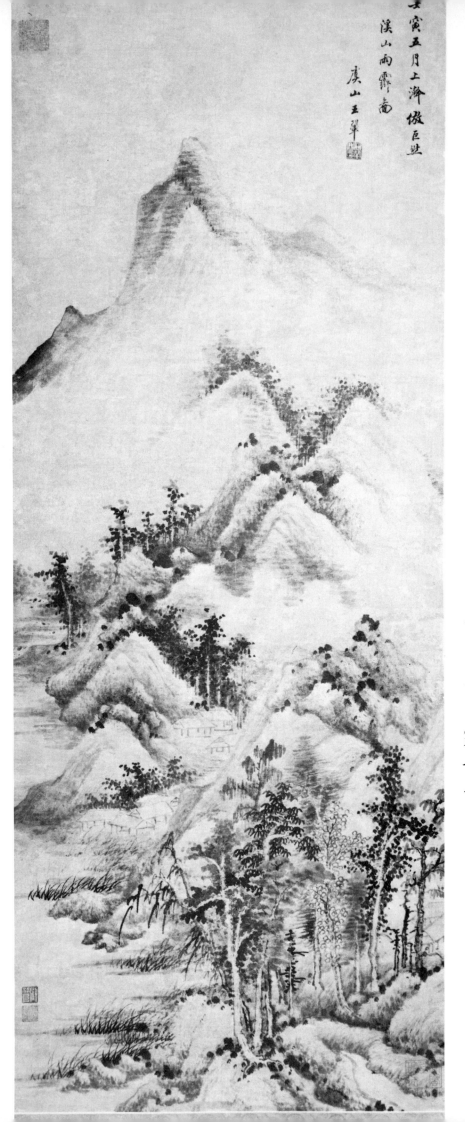

57　LEFT
Wang Hui
(1632–1717),
*Clearing
after Rain
over Streams
and Hills.*
OPPOSITE: Detail.

壬寅五月上澣倣巨然
溪山雨霽圖
虞山王翬

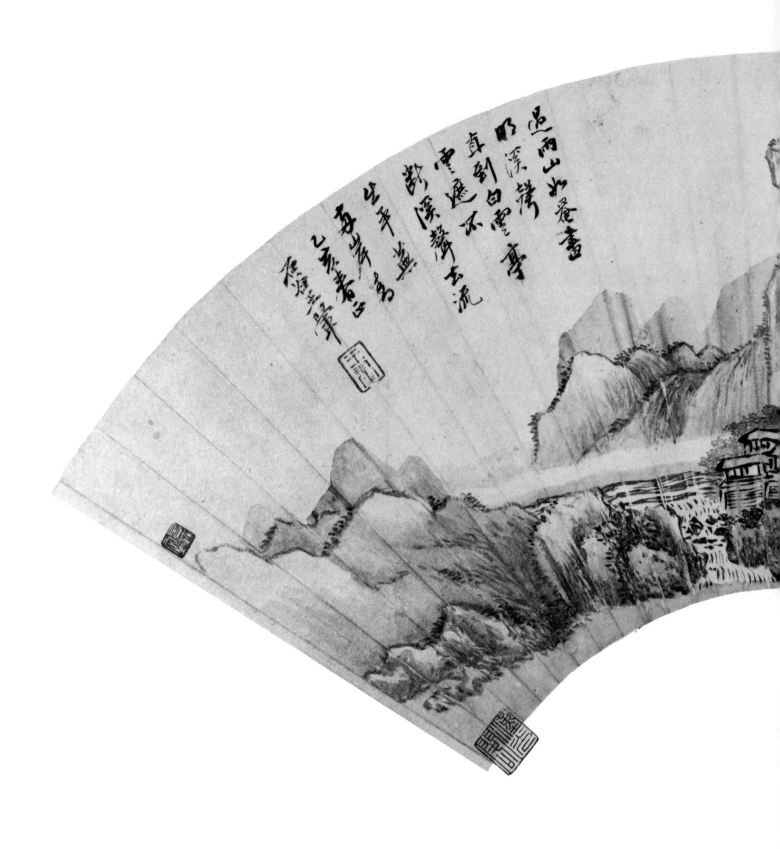

58 Wang Hui (1632–1717),
Mountain after Rain Passes.

王翬過雨山面扇

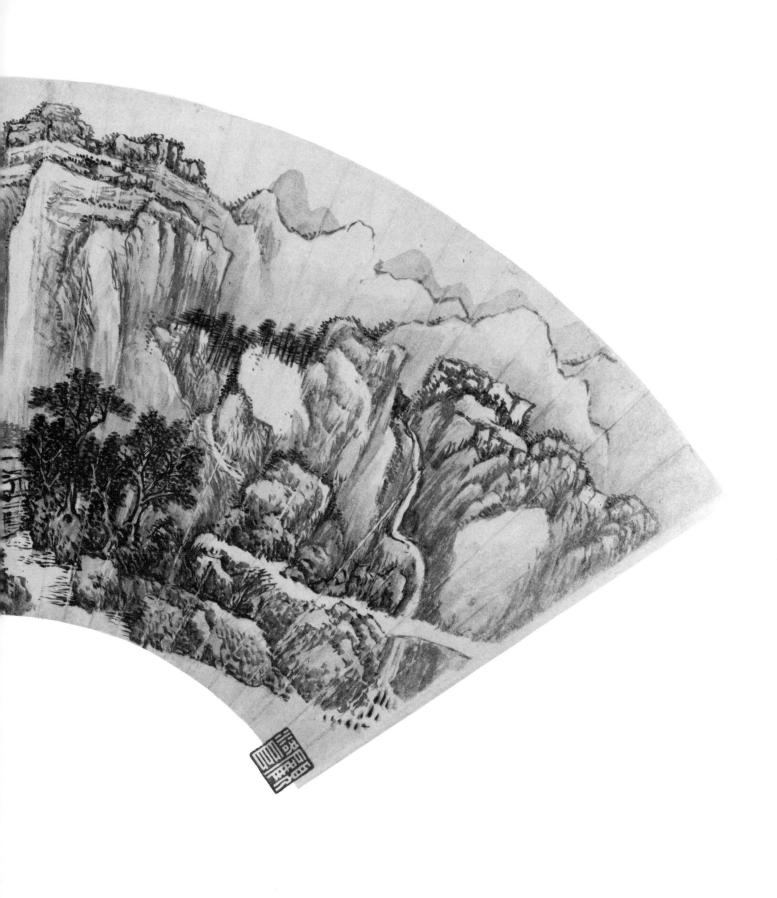

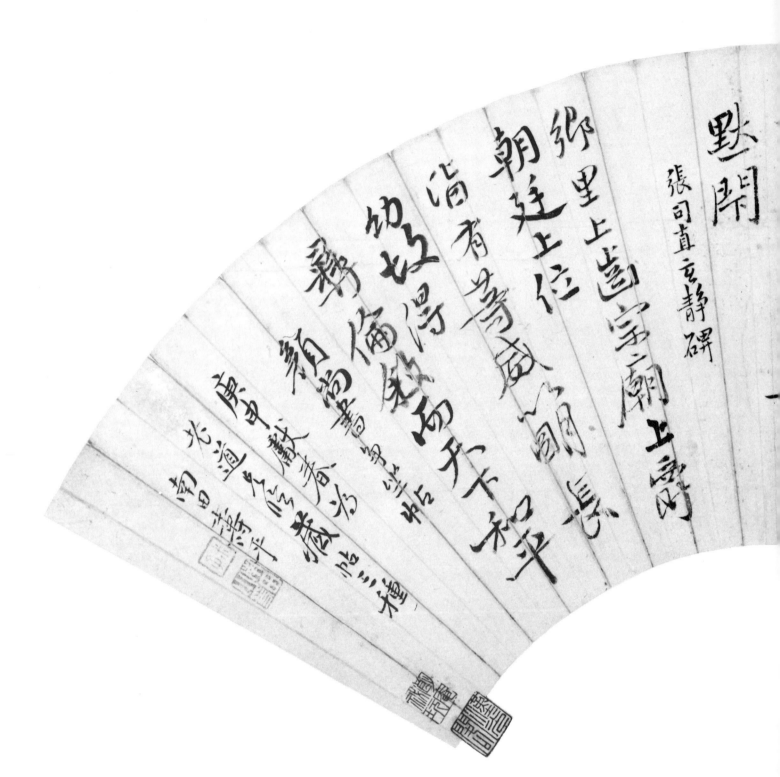

59 Yün Shou-p'ing (1633–1690),
After Three Rubbings.

惲壽平書扇

泥丸九真皆有房 方圓一寸處此中 同服紫衣飛羅裳 但思一部壽無窮 非各別住俱腦中 列位次坐向外方 所存在心自相當

黄庭内景經

元氣不散瑤圖 虛映 達靈己久晦曜 為常 動作非用用爭

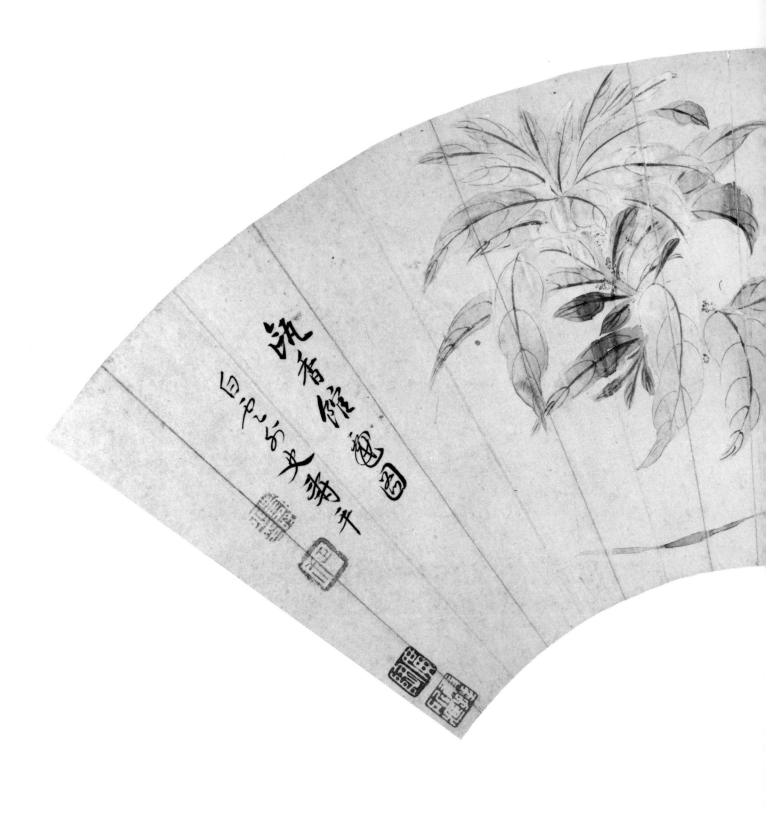

60 Yün Shou-p'ing (1633–1690),
Two Garden Plants.

惲壽平花卉扇

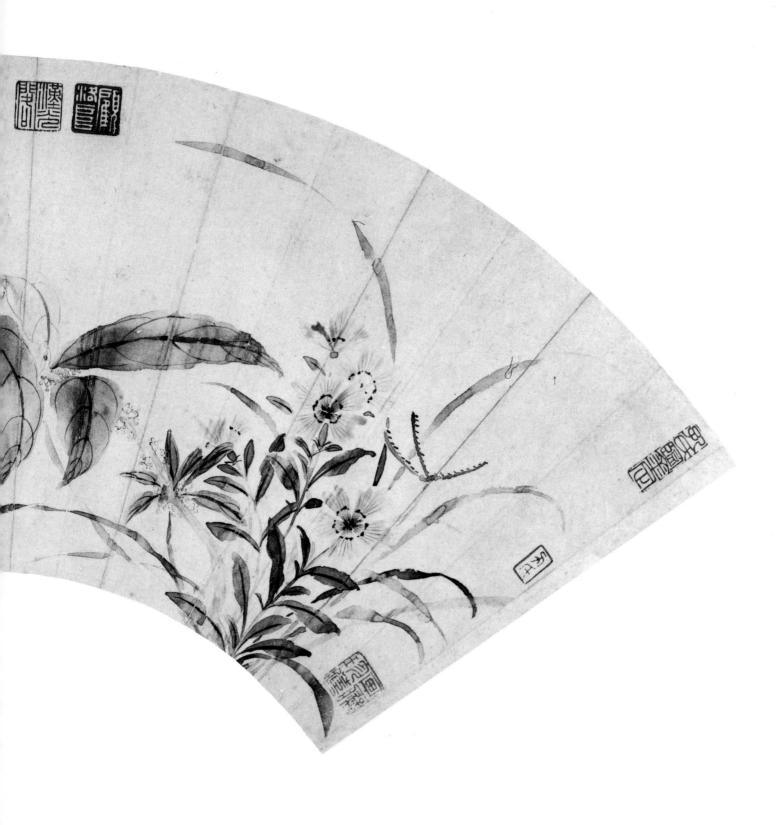

61 Tao-chi (1641–ca. 1717),
Five Poems.

道濟書舊作五首扇

野樵痕空堂夜巳明如
湖雁字破山作畫裁詩
煨窮養拙根蹟地有粒無柴
燒畫過冬火歷蓬門無隣
籬雪猖掩萬許硯鳴馬奔
堆事拙得一笑空上旬
風解頓會忘俸春擔信嚴然世何
不復好詳新許擅俗飲餘
畫魂斷梅花冷落村
絕粒

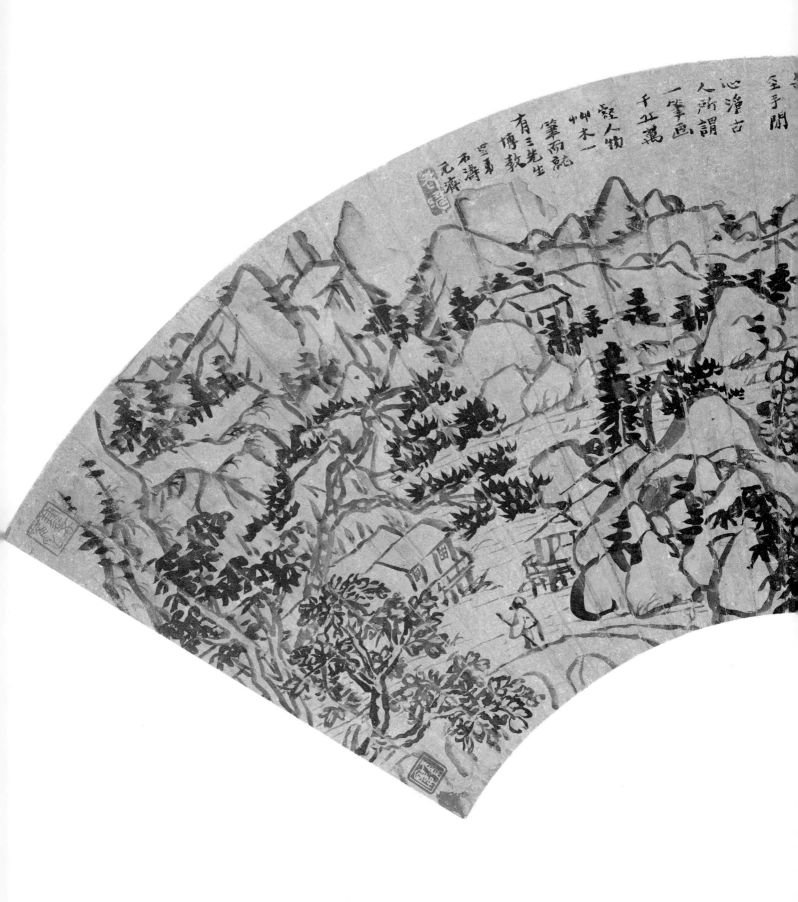

62　Tao-chi (1641–ca. 1717),
Landscape on a Gold-paper Fan.

道濟山水扇

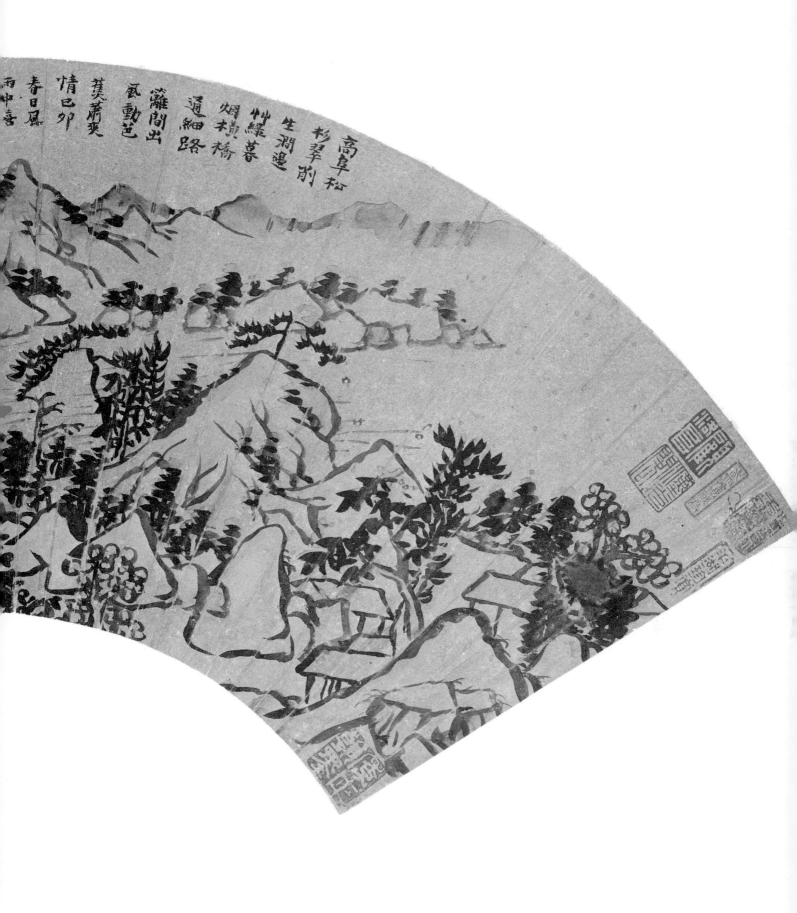

高阜松杉翠削前
生澗邊
怪蝶暮
烟木橋
道細路
灘間出
風動苣
蔞蕭爽
情巳卯
春日屠
兩中壽

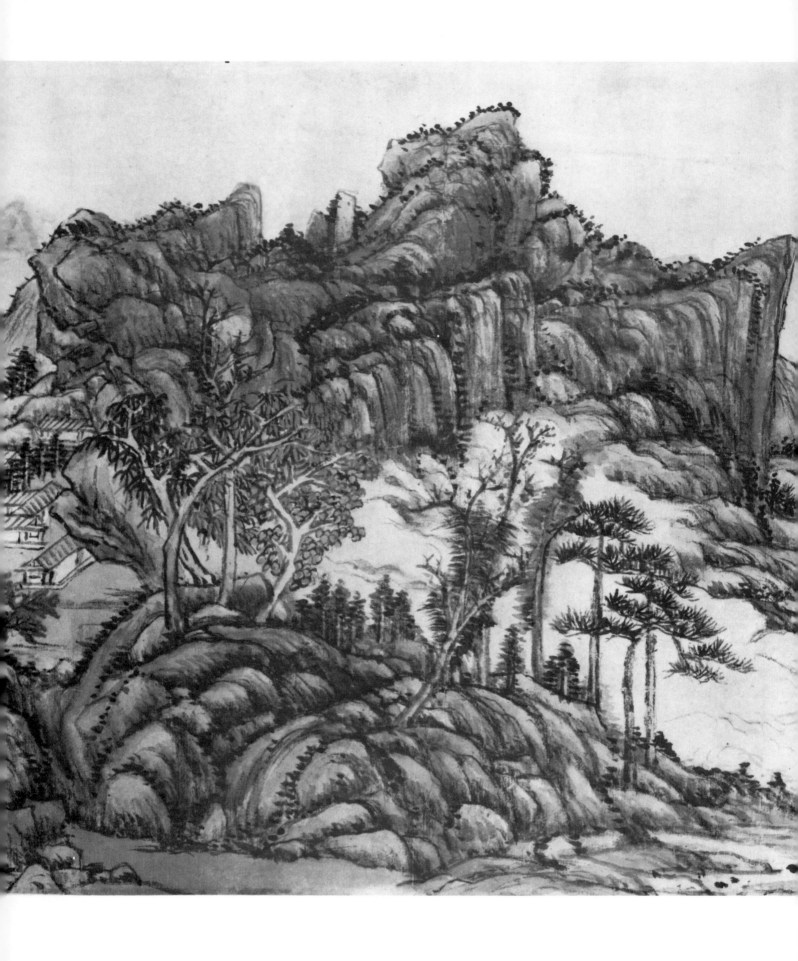

63 Wang Yüan-ch'i (1642–1715),
Fishing in a River in Blossoming Time.
Section of handscroll.

王原祁江國垂綸畫卷

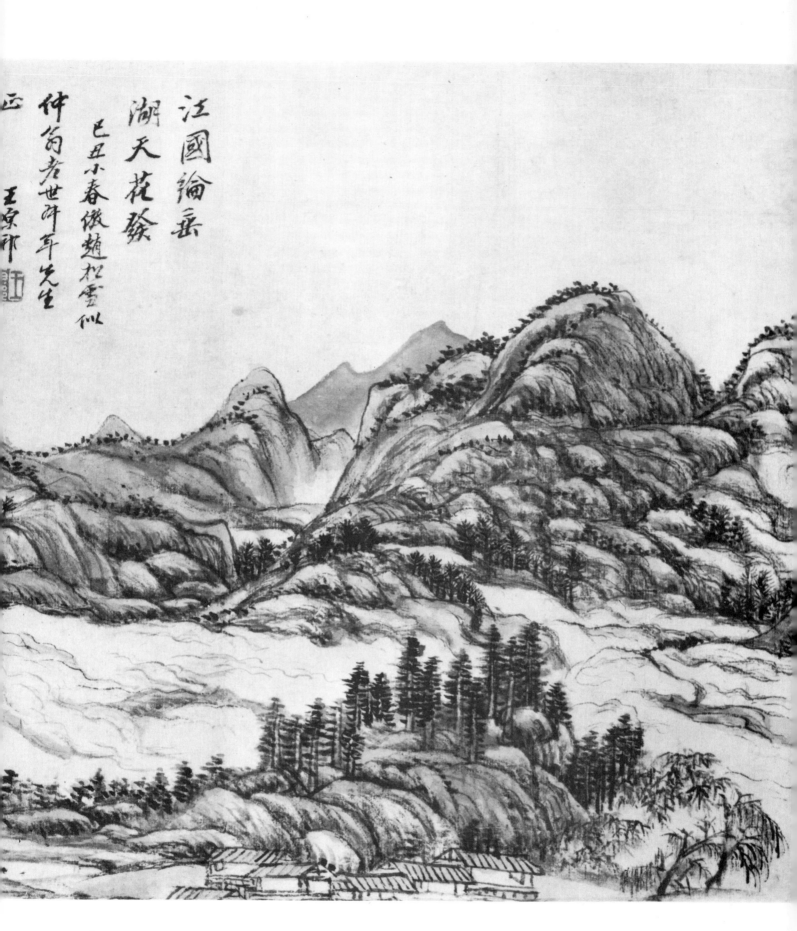

江國輪嵐
湖天花發
巳丑小春倣趙松雲似
仲句老世仲年先生
正
王原祁

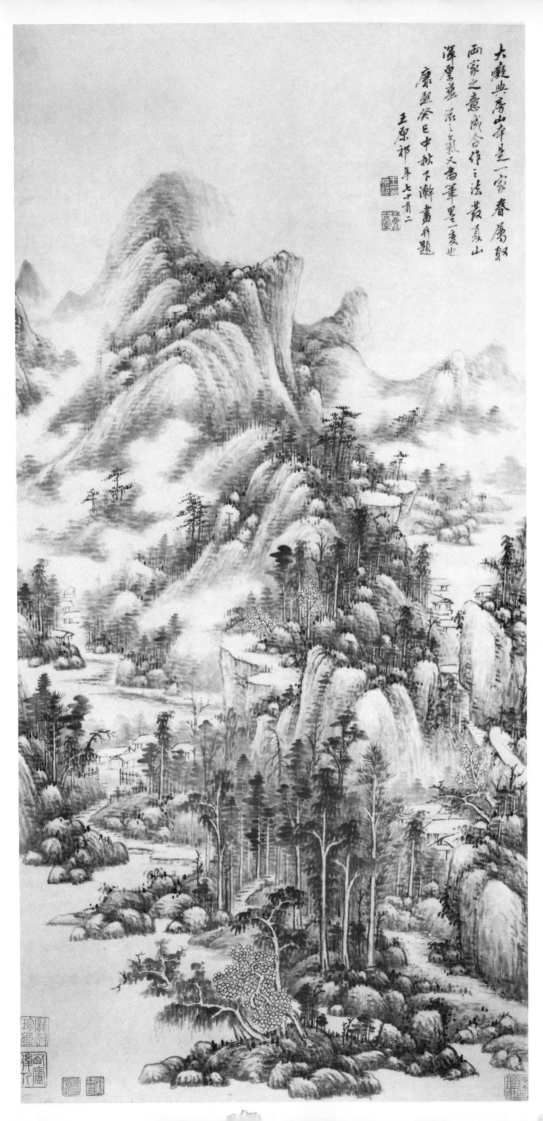

大癡與房山本是一家春屬臨
兩家之意或成合作之法茲夏山
渾厚華滋之氣又當筆墨一變也
康熙癸巳中秋下澣畫并題
王原祁年七十有二

64 LEFT
Wang Yüan-ch'i
(1642–1715),
Summer Mountains.
OPPOSITE: Detail.

王原祁夏山畫軸

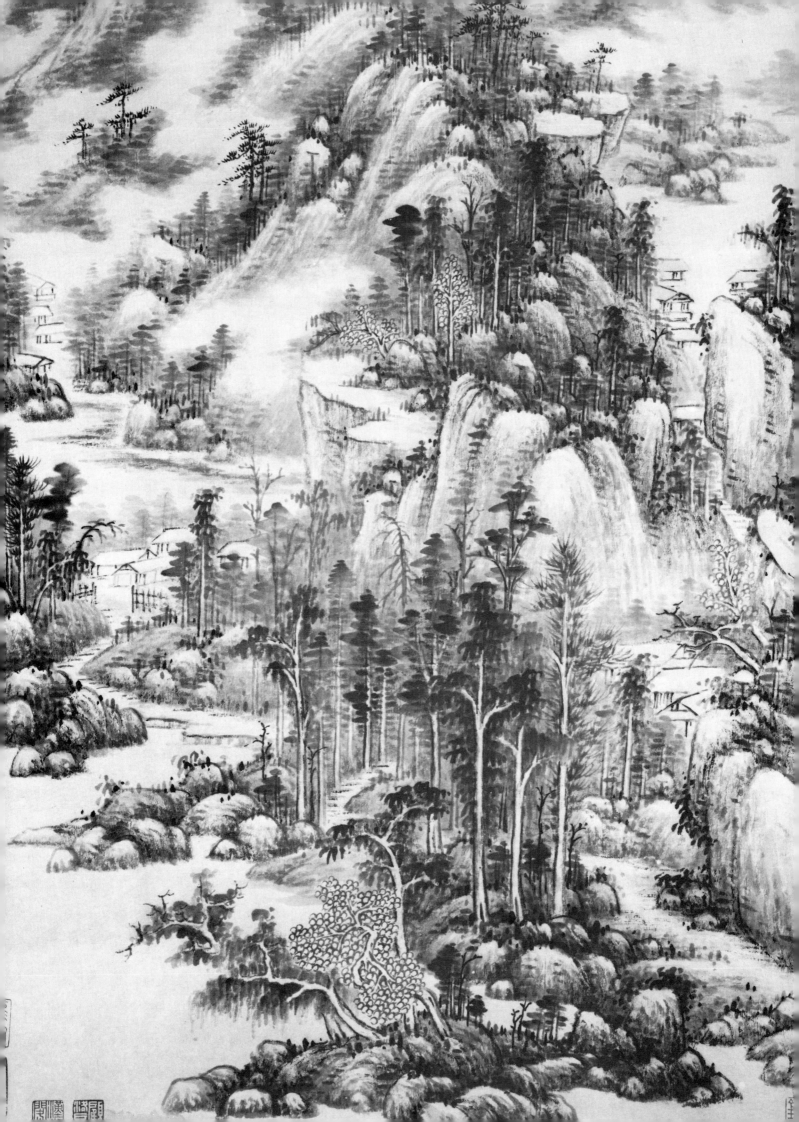

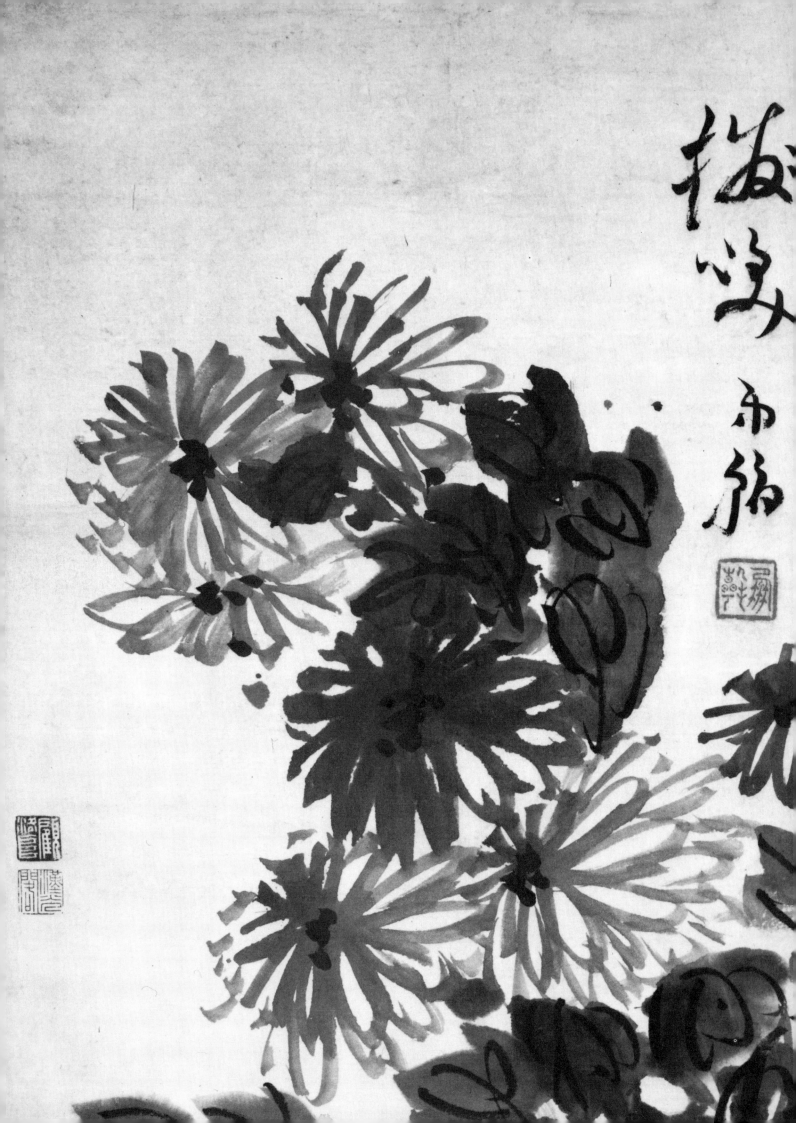

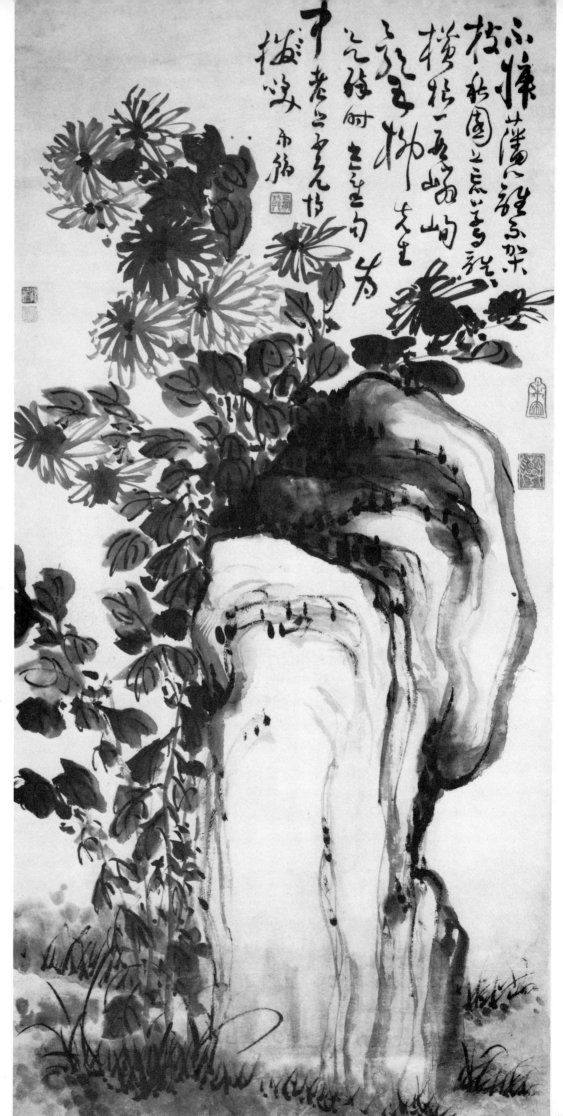

65 RIGHT
Kao Feng-han
(1683–1748),
*Chrysanthemums
by the Rock.*
OPPOSITE: Detail.

高鳳翰菊石畫軸

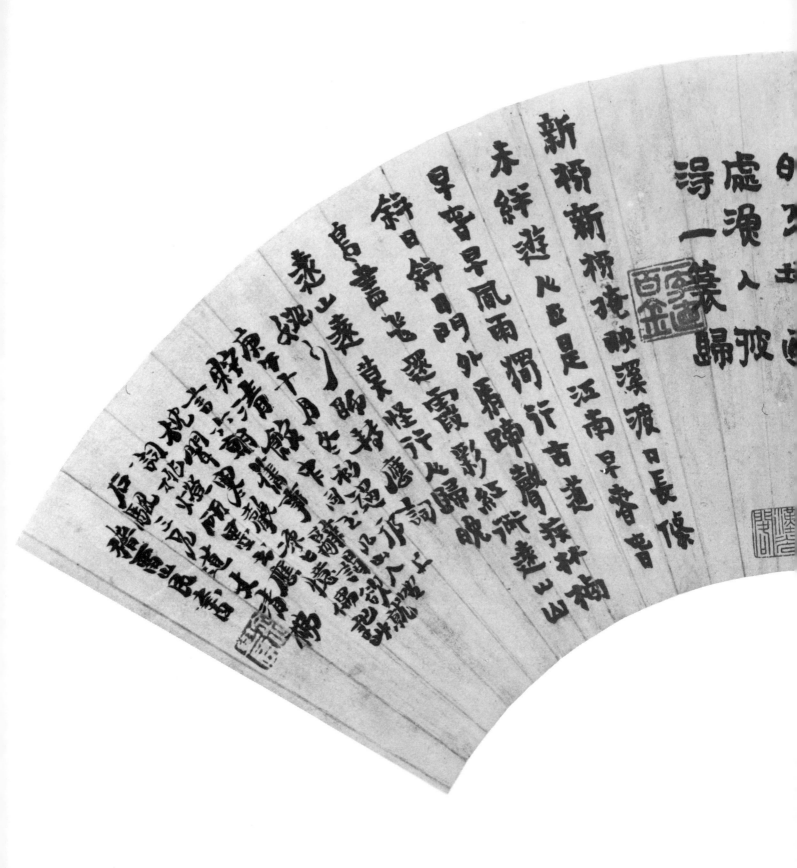

66 Chin Nung (1687–1764),
Three Poems.

金農自書詩詞扇

海國僧房浩蕩空，簷花天色又秋風。

多橋風便水殼，急管鄒郎屈士。

歌飄僧舍
茶烟漲家
灑歌樓沼
力微江上

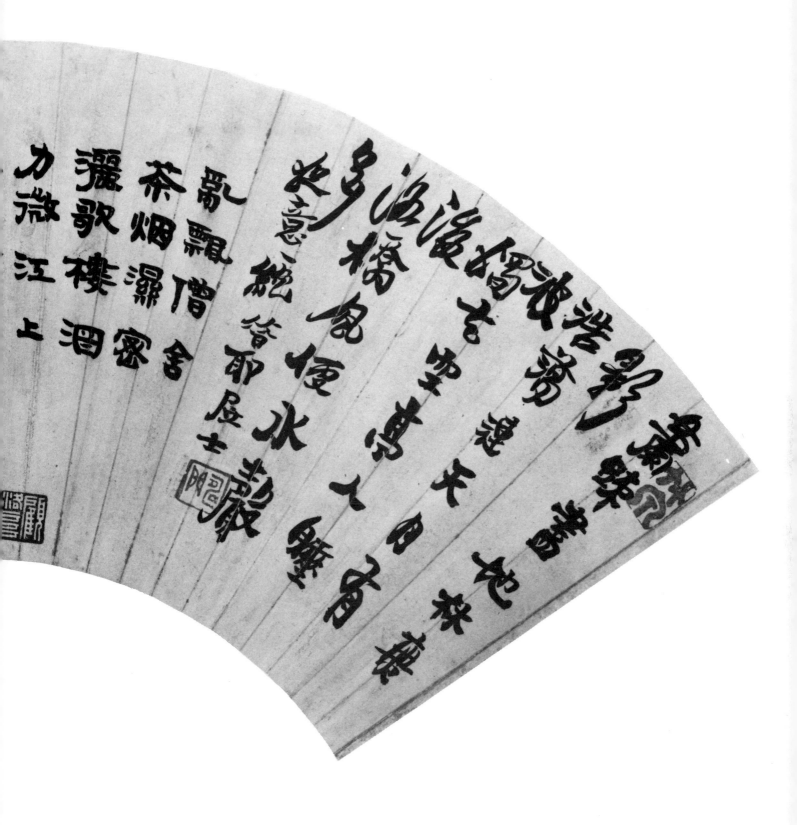

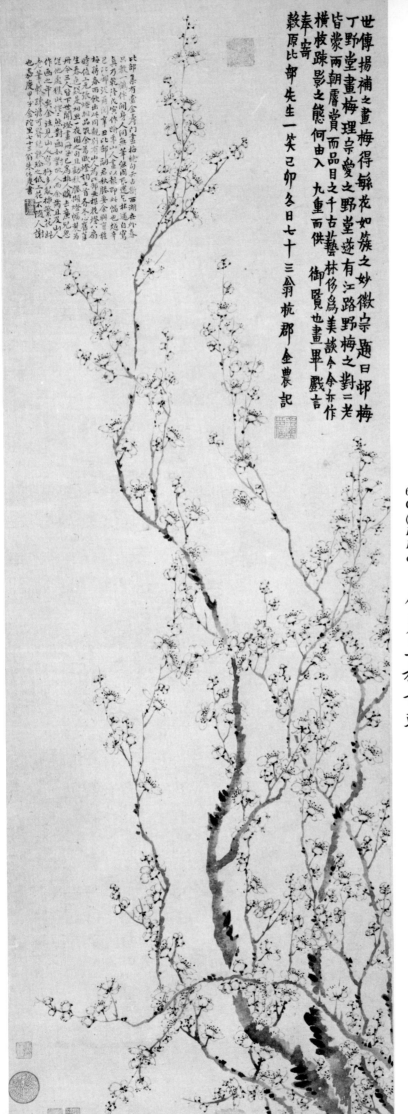

世傳揚補之畫梅得繁花如簇之妙徽宗題曰邨梅
丁野堂畫梅理宗愛之野堂遂有江路野梅之對二老
皆蒙兩朝眷賞而品目之千古此藝林修為美談今余亦作
橫枝疎影之能何由入九重而供御覽也畫畢戲言
奉寄
穀原比部先生一笑己卯冬日七十三翁杭郡金農記

此部集方畫金壽門畫梅
只欵一個什開身人間無筆傚園花遠兄林通自寫
真方乾活自寫作
己卯沈用壽御斗幅也越辛
章旦比部勘畫要金興盲群
梅禍春而飲此冊
時值元旦梅山人勒出品
生壽意是此冊一夜問者
從他處購得其為
漁陽梅隔塔其前
冊今三人實下世間越畫
他人切
作畫之餘此見此
七筆軟就給句
也各慶甲子金陀羅七十翁朱像書

67 LEFT
Chin Nung
(1687–1764),
*Blossoming
Prunus.*
OPPOSITE: Detail.

金農墨梅畫軸

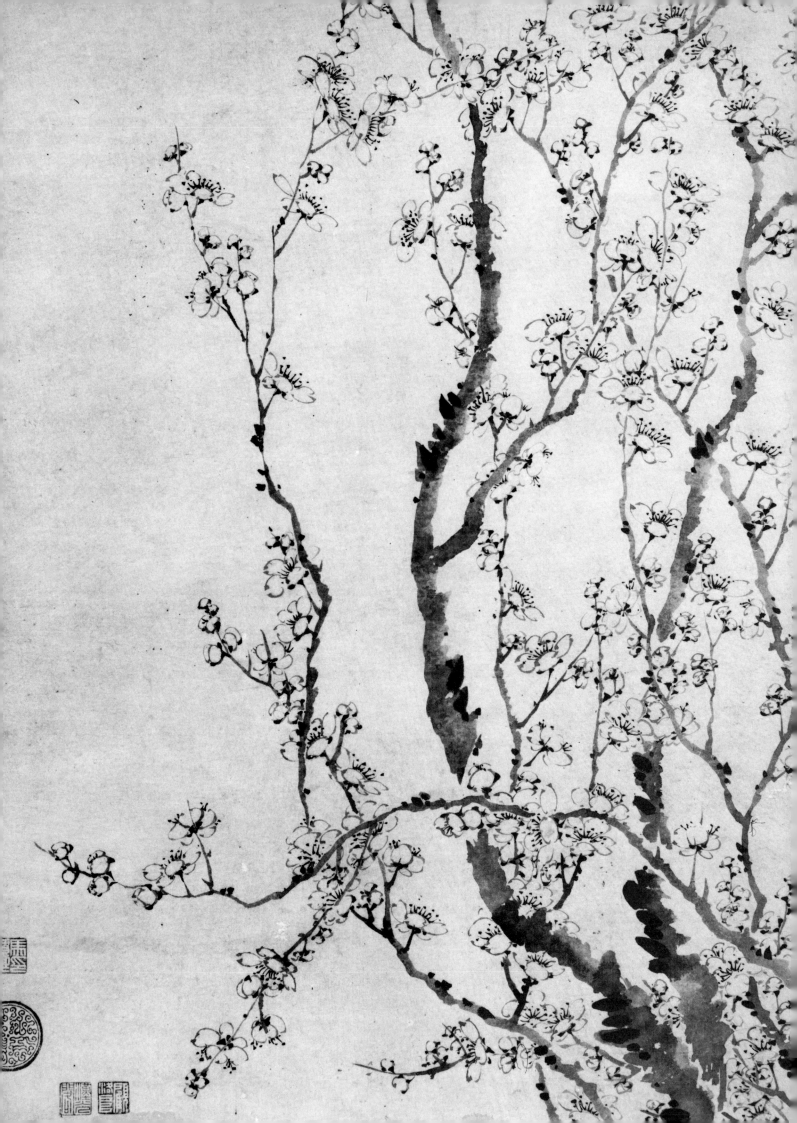

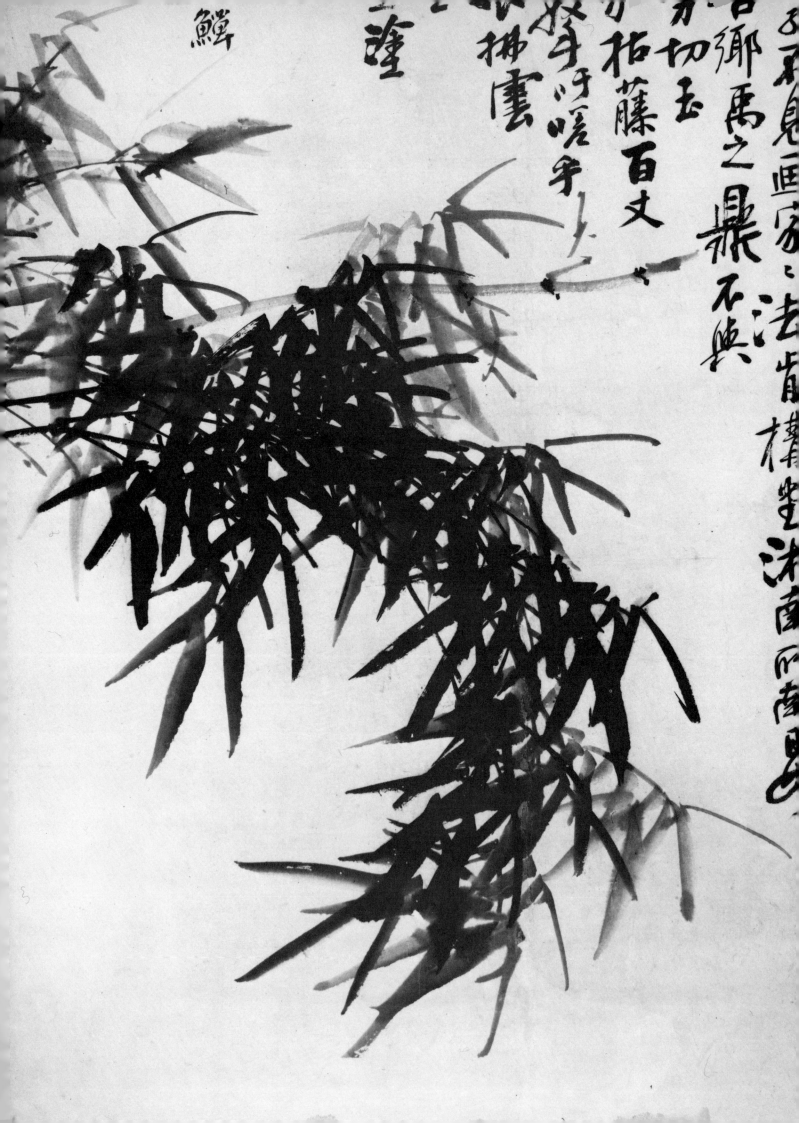

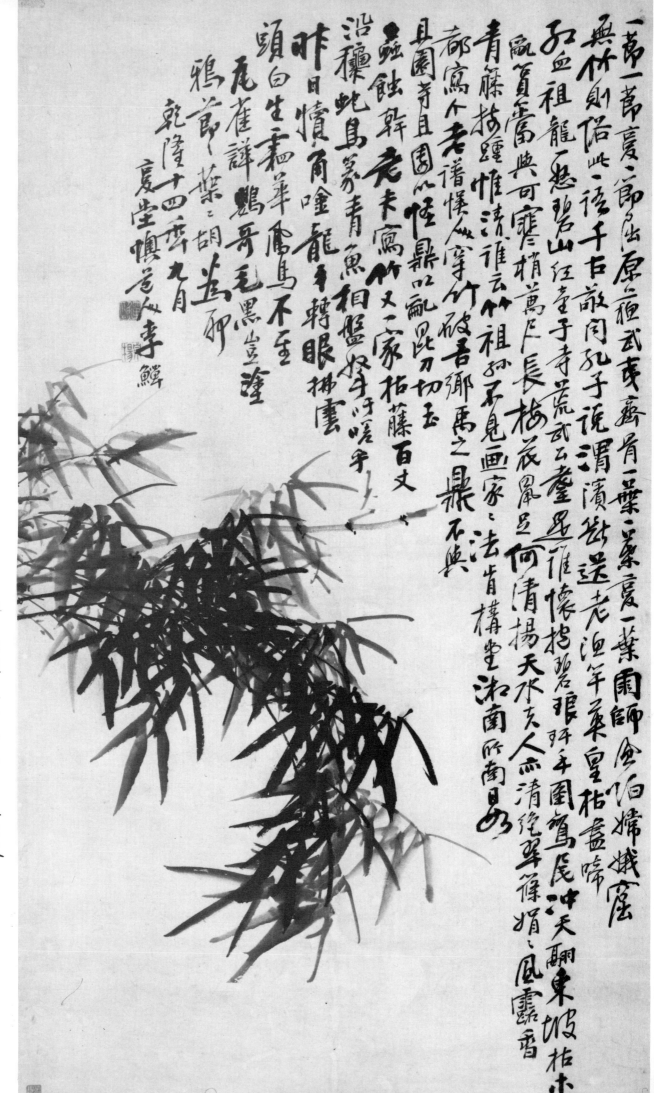

68 RIGHT
Li Shan
(1686–ca. 1762),
*Bamboo
and
Calligraphy.*
OPPOSITE: Detail

李鱓墨竹畫軸 自題長歌

草還山中
植盆盎不如留
本橋
板橋

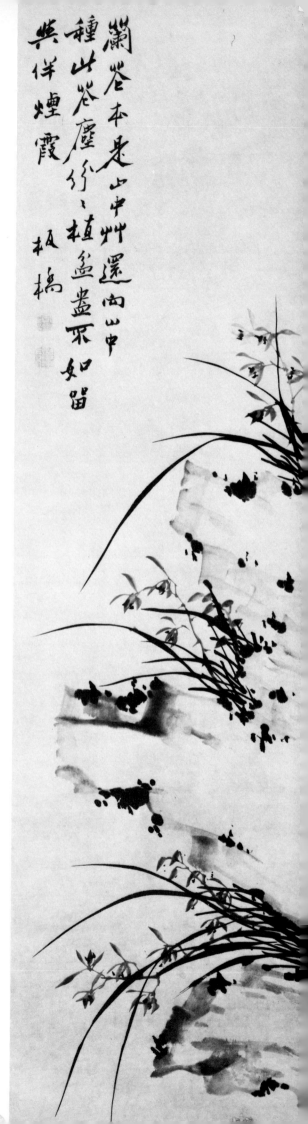

蘭谷本是山中艸還向山中
種此谷塵行〻植盆盎不如留
與伴煙霞　板橋

鄭燮蘭石畫軸

69　RIGHT
Cheng Hsieh (1693–1765),
Orchids on Rocks.
OPPOSITE: Detail.

APPENDICES

A: BIBLIOGRAPHY (*previous publications related to the JMC Collection*)

(1) Sickman, Laurence, ed. *Chinese Calligraphy and Painting in the Collection of John M. Crawford, Jr.* New York: The Pierpont Morgan Library, 1962.

A detailed catalogue of 84 items exhibited in The Pierpont Morgan Library, the Fogg Art Museum, Cambridge, Mass. and the William Rockhill Nelson Gallery of Art, Kansas City, Mo. With three essays: "Introduction" by Sickman, "Chinese Painting" by Max Loehr and "Chinese Calligraphy" by Lien-sheng Yang. In addition to these three writers, James Cahill, Richard Edwards, Achilles Fang, Aschwin Lippe and Shujiro Shimada contributed individual entries. 51 plates, including 3 in color. The major publication of this collection and one of the basic reference works in the field of Chinese calligraphy and painting.

An abridged paperback catalogue for visitors to the exhibition, containing the list of exhibited items, the essays by Sickman, Loehr and Yang and 25 monochrome plates, was published at the same time.

(2) The Arts Council of Great Britain. *Chinese Painting and Calligraphy from the Collection of John M. Crawford Jr.* London: The Victoria and Albert Museum, 1965.

Contents similar to the abridged Morgan Library catalogue, with additional notes by Michael Sullivan on 67 items included in the exhibition. 24 monochrome plates.

(3) Tseng, Yu-ho Ecke. *Chinese Calligraphy*. Philadelphia Museum of Art, 1971.

An informative introduction and detailed descriptions of 96 entries, all illustrated in monochrome plates, with 35 items from the JMC Collection. The exhibition traveled from Philadelphia to the Nelson Gallery in Kansas City and the Metropolitan Museum of Art in New York.

(4) Wilson, Marc F., and Wong, Kwan S. *Friends of Wen Cheng-ming: A View from the Crawford Collection*. New York: China Institute in America, 1974.

A detailed catalogue of 28 items with a long introduction on the cultural and art center of Suchou where Wen Cheng-ming and his friends lived and worked. All entries illustrated, with 4 in color.

(5) Giacalone, Vito. *Chu Ta: A Selection of Paintings and Calligraphy*. Poughkeepsie, N.Y.: Vassar College Art Gallery and New York Cultural Center, 1972.

A short descriptive catalogue of 19 items, of which 5 are from the JMC Collection. No illustrations.

(6) Bartholomew, Terese Tse. *I-hsing Ware*. New York: China Institute in America, 1977.

In the accompanying essay, "The World in the Teapot" by Wan-go Weng, and his notes on 8 items of painting and calligraphy, 3 entries are from the JMC Collection. All illustrated in monochrome plates. The artists were active in promoting and designing I-hsing ware.

(7) Fu, Shen C. Y., in collaboration with Fu, Marilyn W., Neill, Mary G., and Clark, Mary Jane. *Traces of the Brush: Studies in Chinese Calligraphy*. New Haven: Yale University Art Gallery, 1977.

A most valuable reference volume of in-depth scholarship and penetrating insight, with six essays on various phases of Chinese calligraphy and a detailed catalogue of 90 entries, all illustrated in monochrome plates. 12 are from the JMC Collection.

B: REFERENCE INDEX

For further reading on items included in this book, the following concordance indicates: first, the designated number of the publication in the foregoing bibliography (in parentheses); second, the entry number in that publication; and third, the page number when applicable.

The works of art are listed in the order of the item numbers in this book.

3. Kuo Hsi.
 Lowlands with Trees, (1) 7, pp. 59–61; (2) 9,
 p. 31.
4. Su Shih.
 Bamboo, (1) 9, pp. 65–66; (2) 11, p. 31.
5. Huang T'ing-chien.
 Biographies of Lien P'o and Lin Hsiang-ju, (1)
 12, pp. 69–70; (2) 13, p. 32; (3) 21; (7) 4,
 pp. 243–244.
6. Mi Fu.
 Sailing on the Wu River, (1) 10, pp. 66–67; (2)
 12, pp. 31–32; (3) 22; (7) 8, pp. 246–247.
7. Sung Emperor Hui-tsung.
 Finches and Bamboo, (1) 15, pp. 75–77; (2) 16,
 p. 32.
8. Ch'iao Chung-ch'ang.
 Ode on the Red Cliff, Part II, (1) 14, pp. 72–
 75; (2) 15, p. 32.
9. Fan Ch'eng-ta.
 Colophon to "Fishing Village at Mt. Hsi-sai,"
 (1) 8, p. 62; (7) 10, pp. 247–248.
10. A Southern Sung Emperor.
 Couplet by Han Yü, (1) 19, pp. 79–80; (3) 26.
11. A Southern Sung Emperor.
 A Seven-word Poem by Meng Hao-jan, (1) 22,
 p. 81; (2) 17, p. 32.
12. Anonymous (12th century).
 River Hamlet, (1) 28, p. 84; (2) 23, p. 33.
13. Ma Yüan.
 Plum Blossoms by Moonlight, (1) 30, pp. 85–
 86; (2) 25, p. 33.
14. Liang K'ai.
 Strolling by a Marshy Bank, (1) 33, pp. 87–88;
 (2) 28, pp. 33–34.
15. Anonymous (13th century).
 Gentlemen Gazing at a Waterfall, (1) 32, p. 87;
 (2) 27, p. 33.
16. Anonymous (13th century).
 Evening in the Spring Hills, (1) 35, pp. 89–90;
 (2) 30, p. 34.
17. Anonymous (13th century).
 Boats Moored in Wind and Rain, (1) 34, p. 89;
 (2) 29, p. 34.
18. Anonymous (13th century).
 Monk Riding a Mule, (1) 38, pp. 94–96; (2)
 33, p. 34.
19. Anonymous (13th century).
 Odes of Pin (Occupations of the Months), (1)
 36, pp. 90–93; (2) 31, p. 34.
20. Yeh-lü Ch'u-ts'ai.
 A Seven-word Poem, (1) 37, pp. 93–94; (2) 32,
 p. 34; (3) 27.
21. Chao Meng-fu.
 *Groom and Horse (First Section of "Men and
 Horses by Three Generations of the Chao
 Family")*, (1) 43, pp. 101–104; (2) 38, p. 35.
22. Chao Meng-fu.
 A Summer Idyll (Quatrain), (1) 41, pp. 99–100;
 (2) 36, p. 36.
23. Hsien-yü Shu.
 The Song of the Stone Drums by Han Yü, (1)
 40, pp. 98–99; (2) 35, p. 35; (7) 18, pp. 253–
 254.

24. Wu Chen.
 Fisherman, (1) 45, pp. 107–108; (2) 39, p. 35.
25. T'ang Ti.
 The Pavilion of Prince T'eng, (1) 51, pp. 115–
 116.
26. Ni Tsan.
 Wind among the Trees on the Stream Bank,
 (1) 49, pp. 113–114.
27. Sung K'o.
 A Seven-word Poem, (3) 37.
28. Anonymous (14th century).
 The Ta-ming Palace, (1) 53, pp. 119–121; (2)
 44, p. 36.
29. Anonymous (early 15th century).
 Mountain Landscape—the Four Seasons, (1)
 55, pp. 122–124; (2) 46, p. 36.
30. Shen Chou.
 Silent Angler in an Autumn Wood, (4) 1, pp.
 39–40.
31. Chu Yün-ming.
 Prose Poem on Fishing, (3) 45; (7) 41, p. 268.
32. Wen Cheng-ming.
 Summer Retreat in the Eastern Grove, (1) 60,
 pp. 134–135; (2) 48, p. 37; (4) 12, pp. 79–81;
 (7) 50b, pp. 271–272.
33. Wen Cheng-ming.
 The Art of Letters, (4) 14, pp. 84–87.
34. Wen Cheng-ming.
 Magnolia, (1) 61, pp. 136–137; (2) 49, p. 37;
 (4) 15, pp. 88–91.
35. T'ang Yin.
 Drunken Fisherman by a Reed Bank, (1) 62,
 pp. 138–139; (2) 50, p. 37; (4) 8, pp. 58–60.
36. T'ang Yin.
 Ink-bamboo, (1) 63, pp. 139–140; (2) 51, p. 37;
 (4) 7, pp. 54–57.
37. Wu I.
 Enjoying the Pines, (4) 17, pp. 95–97; (7) 49,
 p. 271.
38. Ch'iu Ying.
 Fisherman's Flute Heard over the Lake, (1) 64,
 pp. 141–142; (2) 52, pp. 37–38; (4) 19, pp.
 100–102.
39. Wang Ch'ung.
 Letter to Nan-ts'un, (4) 18, pp. 98–99.
40. Lu Chih.
 Brocaded Sea of Peach-blossom Waves, (4) 20,
 pp. 103–105.
41. Wen Po-jen.
 *Dwellings of the Immortals amid Streams and
 Mountains*, (1) 65, pp. 142–143; (2) 53, p.
 38; (4) 25, pp. 116–118.
42. Hou Mou-kung.
 High Mountains, (4) 28, pp. 125–126.
43. Tung Ch'i-ch'ang.
 Poem by Wang Wei, (3) 60.
44. Tung Ch'i-ch'ang.
 Landscape with Trees, after Ni Tsan, (1) 67,
 pp. 145–146; (2) 55, p. 38.
45. Chang Jui-t'u.
 Ode on the Red Cliff, Part II, (1) 68, pp. 147–
 148, (2) 56, p. 38.

46. Chang Jui-t'u.
Couplet, (3) 66.

47. Wang Shih-min.
Landscape after Huang Kung-wang, Unpublished.

48. Hsiang Sheng-mo.
Scholar in the Woods, Unpublished.

49. Fa Jo-chen.
Discourse on Painting, (1) 72, pp. 152–153; (3) 78.

50. Hung-jen.
River Scene in Winter, (1) 69, pp. 148–149; (2) 57, p. 38.

51. K'un-ts'an.
Wooded Mountains at Dusk, (1) 71, pp. 151–152; (2) 58, pp. 38–39.

52. Fan Ch'i.
Landscapes, Unpublished.

53. Kung Hsien.
Wintry Mountains, (1) 73, p. 154; (2) 59, p. 39.

54. Chu Ta.
Fish and Rocks, (1) 74, p. 155; (2) 60, p. 39; (5) 8.

55. Chu Ta.
Birds in a Lotus Pond, (1) 75, p. 156; (2) 61, p. 39; (5) 6.

56. Chu Ta.
After "The Preface to the Orchid Pavilion Gathering," Unpublished.

57. Wang Hui.
Clearing after Rain over Stream and Hills, (1) 81, p. 163; (2) 65, pp. 39–40.

58. Wang Hui.
Mountain after Rain Passes, Unpublished.

59. Yün Shou-p'ing.
After Three Rubbings, Unpublished.

60. Yün Shou-p'ing.
Two Garden Plants, Unpublished.

61. Tao-chi.
Five Poems, Unpublished.

62. Tao-chi.
Landscape on a Gold-paper Fan, Unpublished.

63. Wang Yüan-ch'i.
Fishing in a River in Blossoming Time, Unpublished.

64. Wang Yüan-ch'i.
Summer Mountains, Unpublished.

65. Kao Feng-han.
Chrysanthemums by the Rock, Unpublished.

66. Chin Nung.
Three Poems, Unpublished.

67. Chin Nung.
Blossoming Prunus, (1) 84, pp. 165–167; (2) 67, p. 40.

68. Li Shan.
Bamboo and Calligraphy, (3) Fig. 13.

69. Cheng Hsieh.
Orchids on Rocks, (6) 64, p. 102.

The writer acknowledges his indebtedness to all the published works listed in the bibliography. As a Chinese saying goes, trees planted by people in the past give shade to latecomers.

W. W.

INDEX OF ARTISTS

The numbers are those of the 69 items illustrated. See "List of Works Illustrated" for further details.

Photography (except items 52 and 62), pictorial layout and calligraphy for Chinese captions by Wan-go Weng.